Electronic Flash
Photography

Electronic Flash

CURTIN & LONDON, INC. Somerville, Massachusetts

 VAN NOSTRAND REINHOLD COMPANY
NEW YORK CINCINNATI TORONTO LONDON MELBOURNE

Photography

A Complete Guide to the Best Equipment and Creative Techniques

Ron Carraher

with

Colleen Chartier

Printed in the United States of America

Published in 1980 by Curtin & London, Inc.
and Van Nostrand Reinhold Company
A division of Litton Educational Publishing, Inc.
135 West 50th Street, New York, NY 10020, U.S.A.

Van Nostrand Reinhold Limited
1410 Birchmount Road
Scarborough, Ontario M1P 2E7, Canada

Van Nostrand Reinhold Pty. Ltd.
17 Queen Street
Mitcham, Victoria 3132, Australia

Van Nostrand Reinhold Ltd.
Mollay Millars Lane
Wokingham, Berkshire, England

Cover design: Dianne Smith Schaefer
Cover photographs: top left: Eucalyptus Trees (detail), Craig Hickman; top right: Ron Carraher; bottom left: Ron Carraher and Colleen Chartier; bottom right: Courtesy Sunpak Div., Berkey Marketing Co.
Illustrations: Laszlo Meszoly

10 9 8 7 6 5 4 3 2 1

Although the information in this book is based on industry sources and is as nearly complete as possible at the time of publication, the possibility exists that the manufacturers have made changes that are not included here. Although striving for accuracy, the authors and publishers cannot assume responsibility for any changes, errors, or omissions leading to problems you may encounter. If you have questions about the specifications or operation of a particular piece of equipment, it is suggested that you refer to the product literature or write to the manufacturer.

Library of Congress Cataloging in Publication Data

Carraher, Ronald G
 Electronic flash photography.

 Bibliography: p. 211
 Includes index.
 1. Photography, Electronic flash. I. Chartier, Colleen, joint author. II. Title.
TR606.C37 778.7'2 80-16723
ISBN 0-442-21463-4
ISBN 0-442-23135-0 (pbk.)

Contents

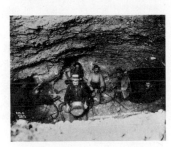
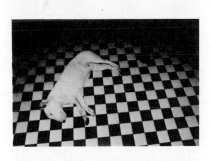
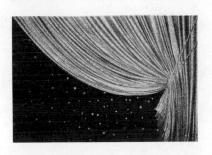

4

5

6

7

Special Applications and Techniques 115

8

Flash Maintenance and Safety 173

Preface

Literally millions of photographers now own some type of electronic flash lighting equipment. No photographic accessory has changed the possibilities of image making more dramatically than this unique, portable lighting. The light from small, inexpensive units has guaranteed perfect exposures for countless snapshots of children, weddings, parties, and pets. The same kind of common electronic flash can be used to freeze the motion of a bat in flight, reveal the true colors on the ocean floor, or stop the splash of a drop of milk. Most serious photographers eventually find some need for this versatile form of artificial light.

This book has been designed to explain the full scope of electronic flash photography. It will serve as a technical and visual resource for any photographer interested in the control and creative options offered by this important lighting tool. Three categories of photographs are reproduced in the book: (1) product photos, (2) illustrations based on the text, and (3) photographs as visual art. The book opens with a selection of works by contemporary photographers who have used flash lighting to create their photographic images. State of the art photographs throughout the book help to explore the relationship of technique and idea and to begin a definition of a flash aesthetic.

Following a short history of flash photography, flash fundamentals and the basic properties of light are discussed. Calculating exposure, lighting techniques, color, and special applications of flash are thoroughly treated in separate chapters. Various categories of flash equipment are examined and charts are used to compare operating features. Over 110 self-contained entries offer information on specific topics ranging from simple on-camera techniques to stroboscopic lighting effects. Photographs and drawings are used throughout the book to present and translate the practical information. Additional concerns, such as safety and flash maintenance, are also covered in detail. The final chapter covers the matter of evaluating and choosing your flash lighting.

A reference section at the end of the book contains an alphabetical glossary of terms, a bibliography, and a comprehensive listing of manufacturers and distributors of electronic flash equipment. The appendix includes useful tables and charts.

Introduction

Colleen Chartier, *Springer's Dog*, 1978

Previous page: The dog on the tile floor was photographed with a wide-angle lens and a camera-mounted flash unit. The photographer deliberately aimed the flash lower than the field of view to underexpose and darken the background. The frontal light minimized cast shadows, making the flattened form of the dog seem to float over the tiles. The photographer's knowledge of flash lighting enabled her to produce this unique graphic image.

Nearly every serious photographer can expect to make some use of electronic flash illumination. A knowledge of flash technique offers freedom from the limitations of existing ambient light. Even a small, inexpensive flash unit can provide significant control over photographic conditions.

Many contemporary photographers experiment with electronic flash lighting, and their distinctive visual art provides a catalog of both traditional and improvisational flash techniques. We can partly understand the meaning of their photographs by examining the role of this artificial illumination.

Flash has its strongest connotations when it is used on-camera. As the light confronts and isolates the subject, it minimizes descriptive shadows. The directional quality of the light defines the location of the camera and implies the presence of a photographer. Moving subjects are caught before they can react, as the light preserves a moment that is often beyond the range of normal vision. The dramatic falloff of the light can surround the subject with a void of darkness and control the point of view. Although the light from on-camera flash is typically harsh and flat, it can be altered or combined with existing light to achieve effects that bridge simple categories. A photographer can juxtapose two realities within the same photograph when he or she fires a foreground flash during a time exposure based on continuous light. The following pages illustrate some of the ways flash lighting can be used to serve different photographic purposes. Although the images represent the diverse concerns of fashion, scientific, documentary, and fine-arts photographers, each photographer relies on basic flash lighting techniques.

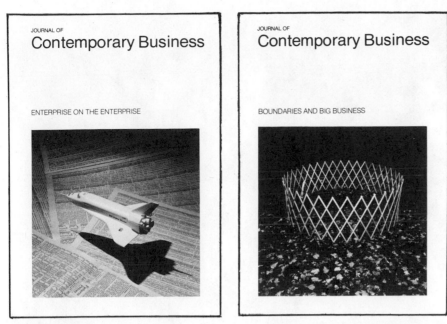

Courtesy of the *Journal of Contemporary Business*, University of Washington; Colleen Chartier, photography and design

This series of cover photographs has a visual impact that depends in part on flash lighting. Quick comprehension of each cover theme required a simplification of the background and a controlled point of view. A single inexpensive hot-shoe flash was the only lighting used to create each of these covers.

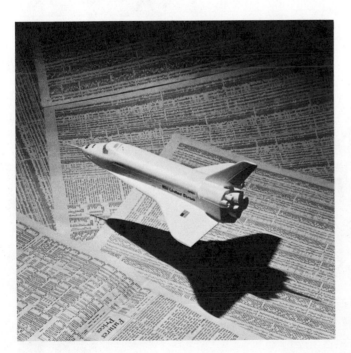

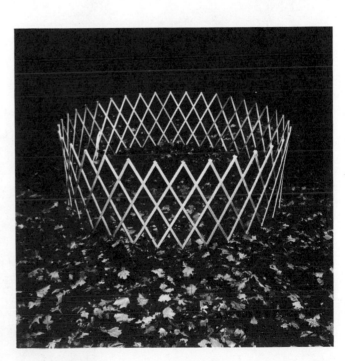

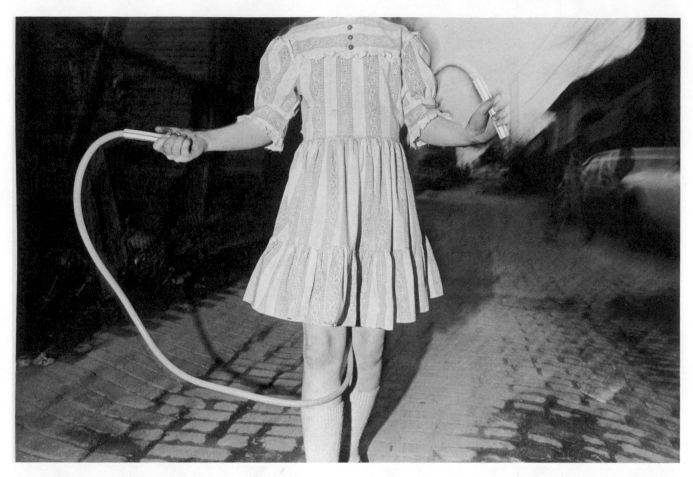

Photographer Mark Cohen has received national acclaim for his fine-arts photography. Many of his photographs incorporate flash lighting techniques. To make this image of a girl jumping rope, Cohen held the camera and flash at arm's length, which enabled him to concentrate on the action and fire the flash at a more precise moment in time. The burst of light spotlights the subject and gives seemingly ordinary events a new context.

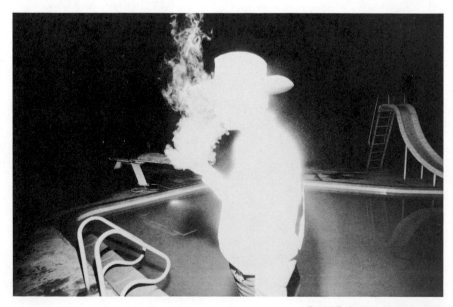

An artist who is exploring the creative possibilities of flash may break the rules to interpret a subject. Flash can be used to test visual ideas and alter image qualities. The photographer used deliberate overexposure in this poolside photograph to achieve a special visual effect.

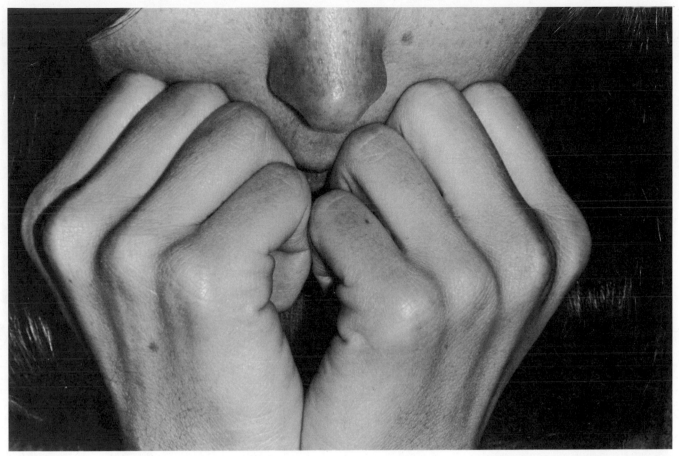

Ron Carraher, *Folded Fingers,* 1979

A single pocket-sized flash unit can produce dramatically different lighting effects. These symmetrically arranged hands were illuminated with a nearly on-axis light to minimize the cast shadows and create a subtle modeling of the subject. An understanding of close-up lighting techniques enabled the photographer to previsualize the role of the flash.

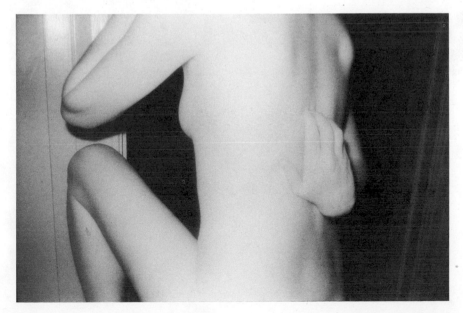

You can filter the light from a standard electronic flash unit to expose infrared film. The special emulsion records the normally invisible infrared energy. The simplification of detail in this photograph gives emphasis to the placement and gesture of the figure.

Terry Toedtemeier, *Untitled,* 1978

Traditional family-album snapshots also benefit from the predictable light of the flash. Consistently good exposures mean that with only a basic knowledge of photography, you can quickly record special moments. Literally millions of photographs are taken each day with inexpensive flash equipment.

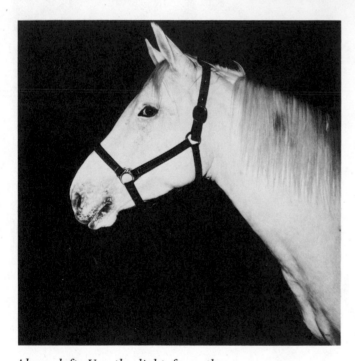

Above left: Use the light from the flash to organize the dark and light areas of a composition. The flash separates the horse's head from the background and freezes any unpredictable movement.

Above right: You can use even the simplest flash equipment to achieve professional lighting qualities. The soft wraparound light in this living-room portrait was created by bouncing the light from the flash onto a nearby white wall. Flash lighting can simulate most natural light conditions.

6

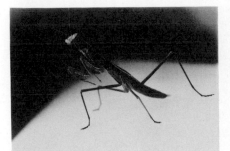

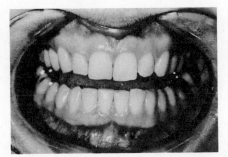

Biomedical photographers regularly use flash lighting to solve specialized lighting problems. Nature photography, too, often involves the photographer in exacting lighting requirements. Flash lighting solves many of the problems associated with photographing subjects at close range. These two close-up photographs required different lighting techniques. The intraoral photograph was exposed with a lens-mounted flash unit, while the praying mantis was illuminated with flash bounced from an umbrella to soften cast shadows and to insure accurate detail of the leg structure.

A photographer can use flash to achieve a specific lighting effect. The photographer used a bounced-flash technique to minimize reflections on this layout of forks. She created the near-shadowless north-light effect quickly and expertly with an inexpensive portable flash unit.

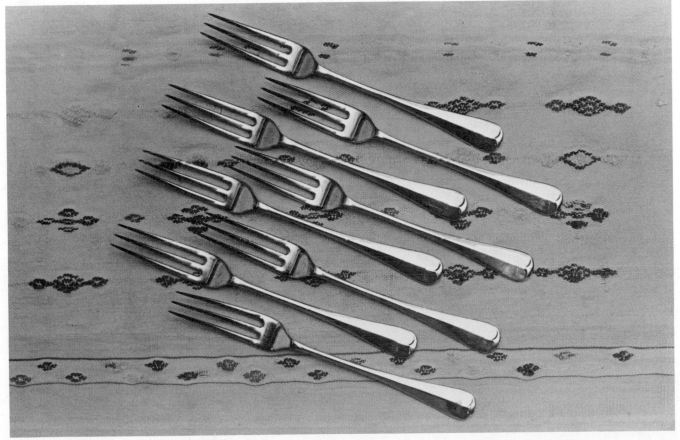

Colleen Chartier, *Meg's Forks,* 1979

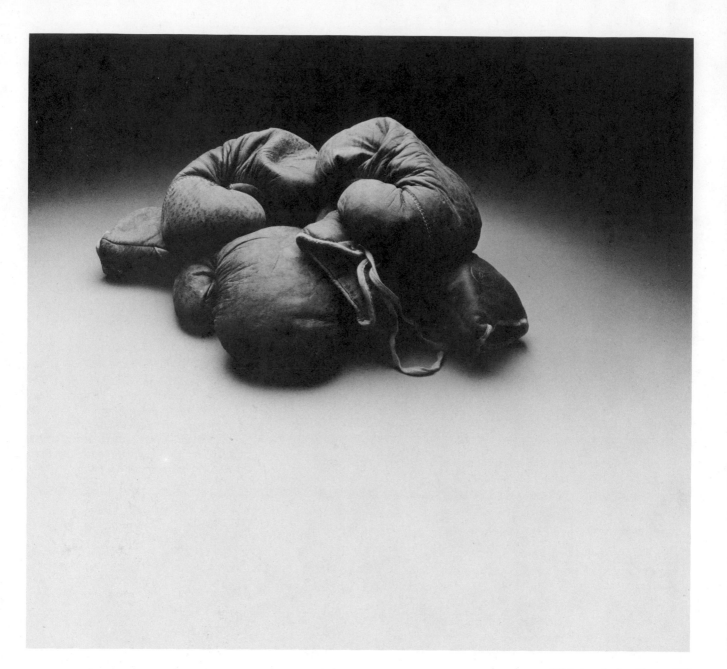

Studio photographers often use flash to simulate natural light. The photographer created the soft overhead light on these boxing gloves by aiming a single flash unit at a large diffusion panel or soft box. The lighting was carefully designed to establish a mood. It also preserved space in the composition for future typography.

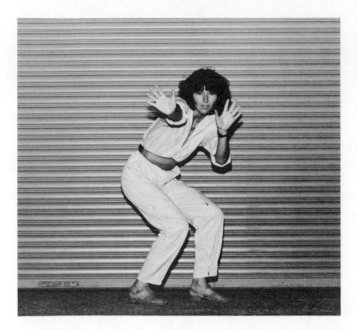

Professional photographers often use on-camera flash to simplify the lighting concept for location fashion photographs. The frontal light accurately describes the design of the clothing. The photographer can easily follow the action of the model by using a light mounted on the camera (above left and right).

Frontal light tends to minimize surface textures, for example, facial wrinkles, so is often used to make a "model" look even more perfect (left).

John Cooper

9

Flashback: A Brief History of Flash

Early Flash Inventions
Flashbulbs
Electronic Flash

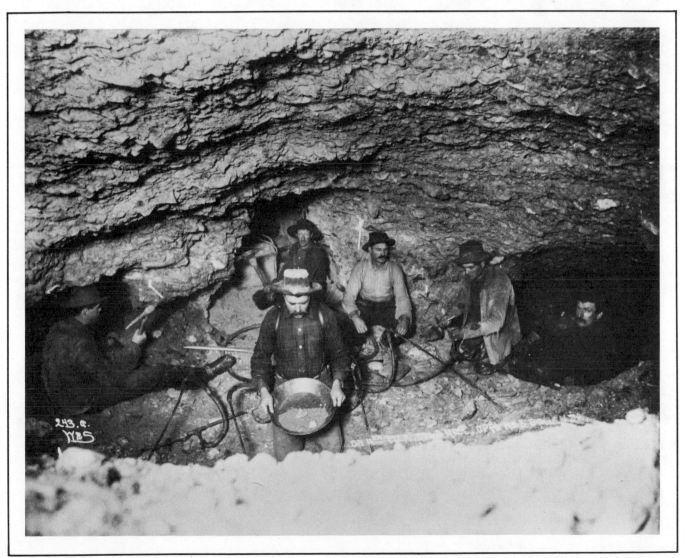

Eric Hegg, *Gold Hill, Yukon Territory,* 1897. Courtesy of the University of Washington Library, Special Collections

Early Flash Inventions

Previous page: Magnesium flash lighting enabled early photographers such as Eric Hegg to record images of frontier life during the gold rush. These underground miners paused for the camera as the light from the flash illuminated the walls of the mining shaft.

The technique of photographing a rapidly moving object using the light from an electrical spark is almost as old as photography. William Henry Fox Talbot, an early pioneer of photography, patented a method of instantaneous flash photography in 1851. Talbot attached a clipping from the London *Times* to a revolving disc. Using a spark produced by the discharge from a Leyden battery, he was able to freeze the movement and create an unblurred photographic image of the rapidly whirling clipping. The concept of electrical spark photography was further researched by Ernst Mach, C. Cranz, C. V. Boys, and others. Their laboratory photographs were generally limited to investigations of how the light from the spark could be used to illuminate the silhouette of a bullet. Spark pictures recorded both the speeding bullet and the refractions in the air produced by the accompanying sound waves.

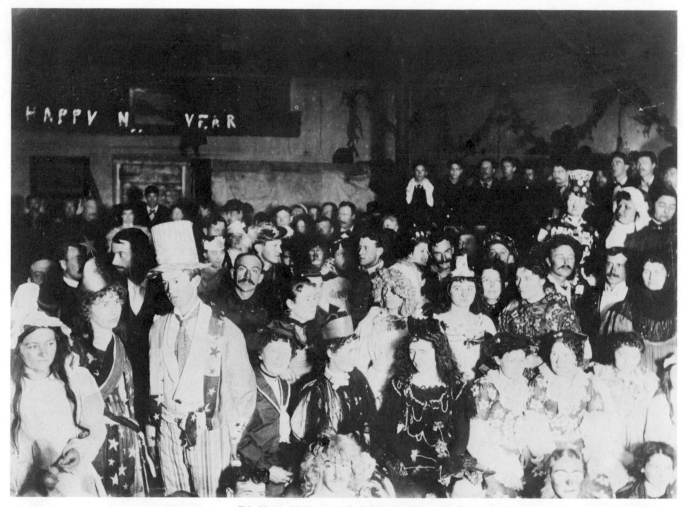

Magnesium flash powder was used to create the illumination for this turn-of-the-century photograph of a masquerade ball in Dawson City. Frontier photographer Eric Hegg feathered the flash across the room in an attempt to equalize the light on the faces of the guests. The 1/40-second duration of the light froze most of the subject movement.

Eric Hegg, *Masquerade Ball,* Dawson City, 1898. Courtesy of the University of Washington Library, Special Collections

Many of the early pioneers of photography were intrigued with the possibility of using artificial illumination. Nadar (born Gaspard-Felix Tournachon; 1820–1910) started to experiment with portable artificial lights in 1855. Using the continuous light from an arc lamp, he produced a series of exposures of the catacombs beneath the city of Paris. In 1859, Robert Wilhelm Bunsen found a new application for powdered magnesium: a tray or flare filled with this powder could be ignited to produce a sudden burst of flame and light. The intensity of the light and the duration of the controlled explosion matched the need in photography for an inexpensive portable light. By 1865, Charles Piazzi Smyth was using this new flash illumination technique to create photographs taken inside the pyramid of Cheops. The *Photographic News* of May 30, 1884, carried the first published photograph taken by magnesium light.

Jacob A. Riis (1849–1914) was one of the first American photographers to take advantage of magnesium flash lighting. While working as a police reporter for the *Evening Sun* newspaper, he read of the *Blitzlichtpulver* (flashlight powder) patented by Adolph Miethe and Johannes Gaedicke in Germany. Their mixture of powdered magnesium, potassium chlorate, and antimony sulfide burned more rapidly than did the original magnesium flare. Riis realized that this lighting technique with its 1/40 second duration would enable him to make near-perfect exposures of life in darkened tenement houses, in factories, and along nighttime streets. In 1884, he produced the first of many flashlight photographs documenting his concerns for child labor abuses and the plight of New York's poor. The work of Jacob Riis clearly defined the importance of flash photography for an entire era of photojournalists.

Early magnesium flash lighting devices incorporated a container for the flash powder and a blower for dusting the powder across an open flame or spark.

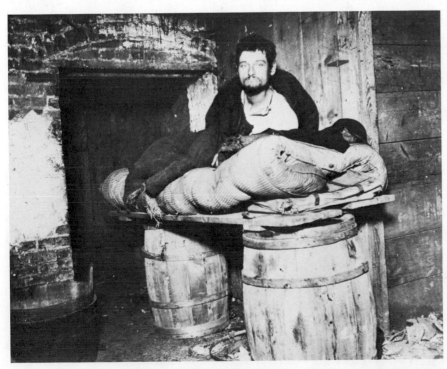

Jacob A. Riis, Collection, Museum Of The City Of New York

Flashbulbs

The images of the photographer Weegee (1899–1968) seem synonymous with the visual tradition of the newspaper photograph. Born Arthur Fellig, Weegee worked most of his life as a newspaper photographer in relentless pursuit of people in their moments of intensity. Flashbulb illumination enabled him to record the nighttime world of New York City and its murderers, dignitaries, dancers, and sleeping children. This image of singing women reveals Weegee's ability to see a moment of action, tension, and impact in a routine event.

Flash cartridges that could be fired in a flashgun were eventually designed to make flash photography a less hazardous procedure; however, accidental fires and explosions continued to plague photographers and their subjects until 1925, when Dr. Paul Vierkotter perfected the flashbulb for safer and more predictable portable lighting. Shaped like a standard lightbulb, this special lighting fixture contained oxygen and a crumpled ball of tinfoil. When an electric current was passed through a small triggering filament, the heated trigger wire ignited a primer powder, which burned furiously as it in turn ignited the foil to produce an intense burst of light. The peak of useful light from this chain reaction lasted less than 1/200 of a second.

The convenience and efficiency of the flashbulb made the technique of flash photography accessible to millions of camera owners. The simple flashbulb has endured for nearly sixty years and continues to provide the light for literally thousands of exposures each day.

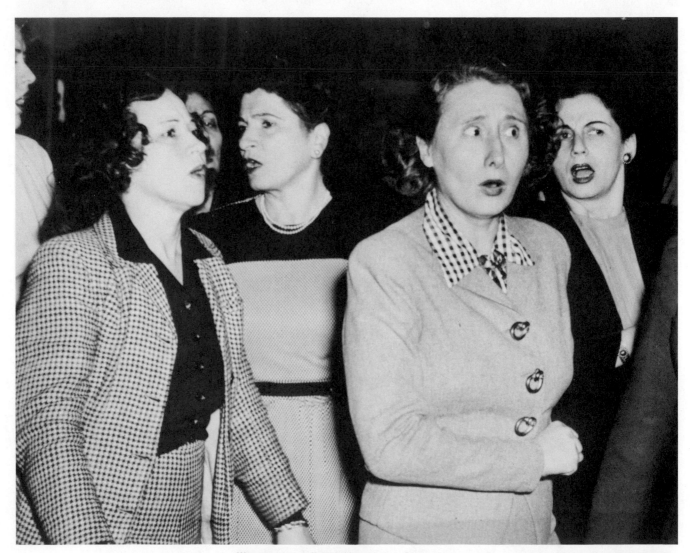

Weegee (Arthur Fellig), *Metropolitan Opera House,* n.d. Courtesy of the Center for Creative Photography, University of Arizona

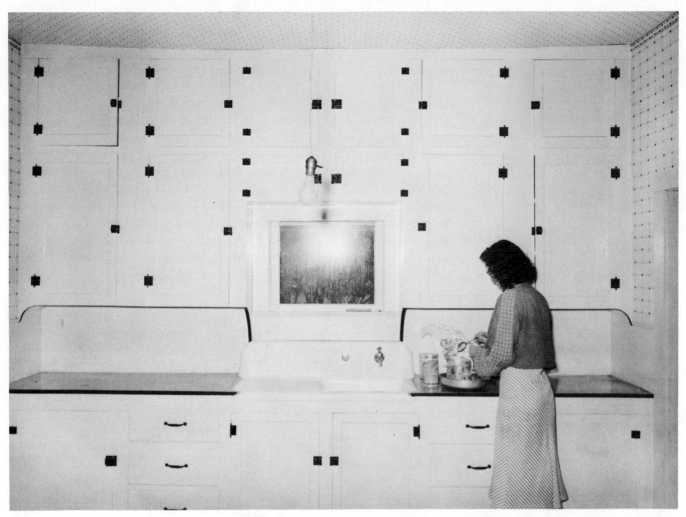

Russell Lee, *Kitchen of Tenant Purchase Client, Hidalgo County, Texas,* 1939. Reproduced from the collection of the Library of Congress

Photographers working on the Farm Security Administration documentary project of the 1930s were often confronted with subjects that required artificial illumination. The light from a flashbulb was a logical solution. This photograph by Russell Lee of a kitchen contains the unmistakable glare of the on-camera flash. No detail in the kitchen escapes delineation as the nearly shadowless light gives emphasis to the pattern of the dress and the position of each black hinge. The laboratory character of the kitchen seems clearly linked with the photographer's decision to use flash lighting.

Electronic Flash

The concept of lighting a photograph and arresting motion with an electric spark had an early beginning, but almost one hundred years elapsed before the portable electronic flash became a reality for photographers. As a graduate student at The Massachusetts Institute of Technology, Harold E. Edgerton became interested in earlier stroboscopic research. In 1931, he developed the basic circuitry and flashtube prototype for a stroboscopic light, marking the beginning of the present era of electronic flash photography. Dr. Edgerton solved the problem of storing the electricity and converting it into a nearly instantaneous burst of intense, repeating light. In 1939, he worked with the Heiland Research Corporation to design and manufacture the first portable electronic flash units. The early units weighed over thirteen pounds and required an equal complement of batteries; however, serious photographers were immediately interested in the potential of this new light source. Further refinements are now a matter of history, and the palm-sized electronic flash is as commonplace as the box camera used to be.

Dr. Harold E. Edgerton was caught by the flash as he held one of his early models of a portable electronic flash unit (1949).

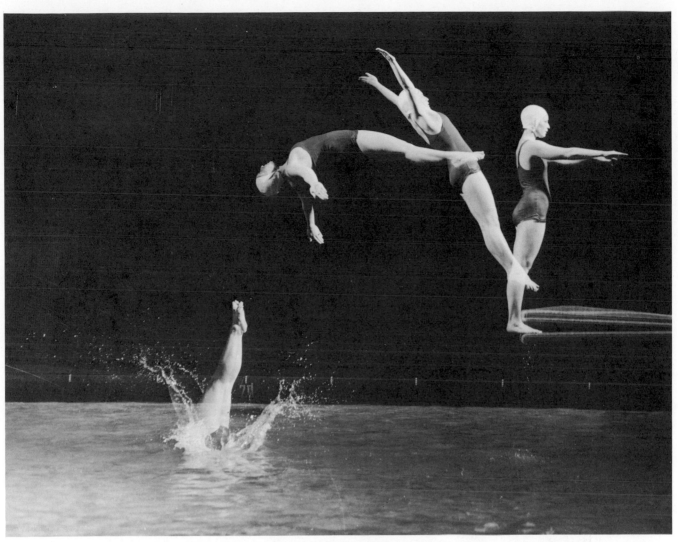

Harold E. Edgerton, *Sue Appleton Executing a Back Dive,* 1939

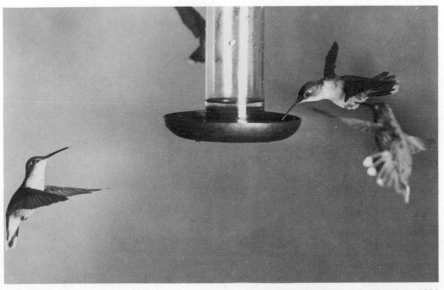

Harold E. Edgerton, *Hummingbirds,* 1936

Electronic flash was still in its infancy when Dr. Edgerton produced his first stroboscopic flash images of sports activities. For this classic time-and-motion study of a back dive, Dr. Edgerton kept the camera shutter open and used the pulsing light from the strobe to record the diver at four sequential stages of a single dive. The short bursts of light froze the action and exposed the single piece of film four times.

Dr. Edgerton made one of the first successful photographs of a hummingbird in flight in which the wings were unblurred. When the birds are hovering, their wings beat about sixty times per second; however, the wing-beat rate increases to over seventy times a second during the birds' top speed. Dr. Edgerton used a microflash unit with a flash duration of 1/100,000 sec. to freeze the motion in this photograph.

The Flash Machine: Fundamentals

How Flash Works
Powering the Flash
Synchronizing Flash and Shutter
Light Output
Exposure Aids

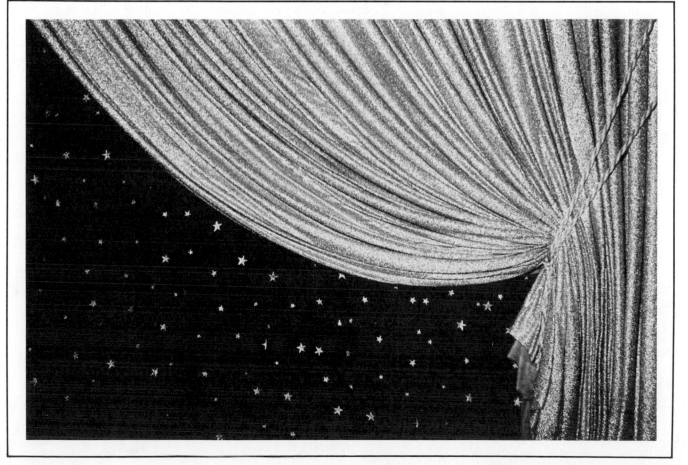

Colleen Chartier, *Stars and Curtain,* 1980

How Flash Works

Opposite page: The portability and compactness of a flash unit make it an ideal light source for nighttime street photographs, such as this one of a parade participant in Rio de Janeiro. Because of the absence of reflective surfaces outdoors, less of the light from the flash bounces back to the subject, and you may require a larger lens opening.

Although flash housings may vary in design, they each must contain similar basic components. Many units incorporate a movable lamphead, which you can aim away from the subject for bounced-flash effects while the flash unit remains attached to the camera. Some design differences are merely a consequence of styling for product identification and marketing.

Basic Design

All electronic flash (EF) units in use today are patterned after the basic design developed by Dr. Harold E. Edgerton in 1931. Even the most sophisticated EF unit relies on four main components: a flash tube, a capacitor for power storage, a power source, and a triggering circuit. An electronic flash unit can be powered by DC batteries, AC household current, or both. The power supply builds a high-voltage charge that is stored in the capacitor. When the shutter is released, the current is discharged as a brilliant spark between the two electrodes in the flash tube.

Although the function of a flash unit can be summarized in a few words, a more detailed description of the process can be of value to the serious photographer. The flash tube of heat-resistant quartz or glass is filled with inert xenon gas in a partial vacuum. Electrodes at each end of the tube deliver a high-voltage charge of electricity to the gas, and ionization in the tube causes the gas to become temporarily conductive. The electrical current forces the outer electrons of the gas atoms into higher energy orbits, creating a brilliant flash of light during the quantum energy transformation. A longer flash tube will increase the size of the spark, and a coiled tube will concentrate the light. The intense heat of the flash limits the life of the tube to a few seconds; however, since each flash lasts less than 1/500 of a second, tens of thousands of flashes can be fired before the tube fails.

Like lightning, the high-voltage spark in the flash tube requires a surge of instant power. The capacitor in the flash unit is a reservoir of portable electrical energy, since it accumulates and stores a charge of high-voltage direct current. Each time the flash is fired, all or part of this reservoir must be refilled before the tube can create the next flash of light. This refilling or recycling time is measured from one firing to the next and varies depending on battery condition, temperature, and the size of the capacitor. The typical hot-shoe flash will

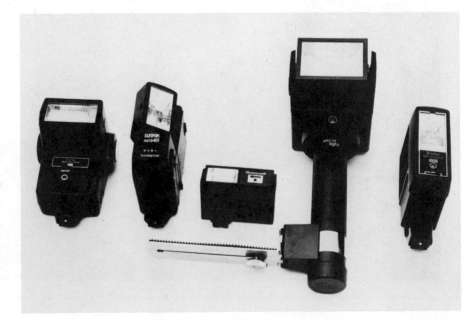

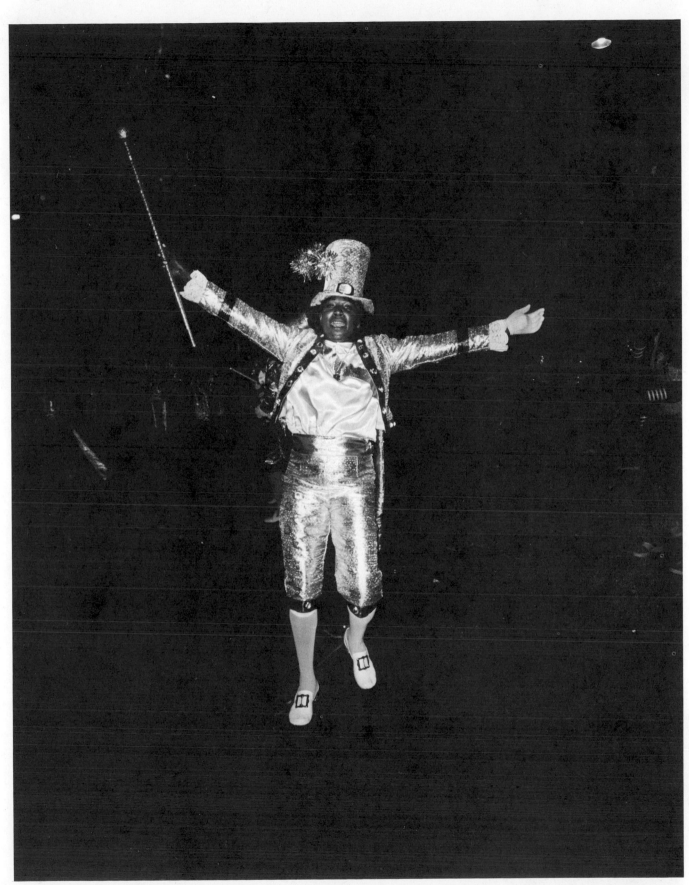

Jim Ball, *Carnival Rio de Janeiro,* 1975

21

require a recycling time of three to ten seconds between firings, while professional portable flash units can recycle in three-tenths of a second. A small neon ready light is connected to the capacitor and glows to indicate when enough energy has been stored for the next full-power firing. A recycling time that exceeds twelve seconds usually indicates weak batteries. If a capacitor is not used regularly, it may temporarily lose some of its ability to store a full charge, but it will generally "reform" and reachieve its rated capacity if it is fully charged and returned to service.

Flash Circuits

Idling Circuit. When you must keep the flash unit on in anticipation of a photograph, a monitor circuit conserves energy by switching power on and off to keep the capacitor in a charged condition without excessive battery drain. When it is not in use, a flash unit should be turned off to conserve power.

Duty Cycle. Both the power supply system and the flash tube produce heat as the unit is fired and recycled. The duty cycle defines the maximum rate and time during which you can rapid-fire a given flash without its overheating. Before using an electric motor drive for a rapid-fire flash sequence, you should determine the duty cycle for your flash unit. Some flash units incorporate a heat-sensitive switch that turns off the power if the unit becomes overheated.

Trigger Circuit. The flash tube and the trigger circuit are two gaps in the flash unit's electrical circuit which are used to control the flow of power. The xenon gas in the flash tube is not normally an electrical conductor; however, if the gas is ionized near the electrodes, the high-voltage charge of the capacitor can bridge the gap. Before the flash can fire, a triggering circuit must direct a small current through a transparent, electrically conductive coating on the flash tube. This ionizes the gas into an instant electrical conductor, allowing the full charge from the capacitor to spark across the gap in a burst of heat and light. The xenon atoms continue to emit light until the capacitor is drained or until the triggering circuit halts the ionizing process. You can use either the open-flash test button on the flash or the shutter contacts of the camera to activate the trigger circuit. You can use accessories such as a PC cord, a hot shoe, or a photo slave to electrically signal the trigger circuit that you need a burst of light.

The basic flash tube is a common element in each portable flash unit. An inert mixture of xenon gas is sealed in a partial vacuum. The electrodes at each end of the tube deliver a high-voltage charge of direct current to the chamber. A metallic coating on the glass functions as a triggering circuit. When a small triggering current passes across the surface of the tube, the gas partially ionizes and the cathode and anode deliver their high-voltage charge through the momentarily conductive gas. The diameter and length of the flash tube are important factors in determining the amount of light the tube can produce. Longer flash tubes may be coiled to concentrate the light and increase reflector efficiency.

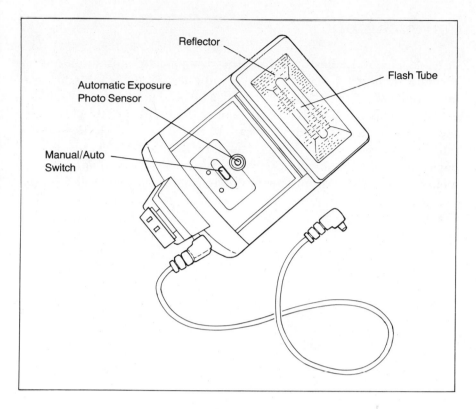

Reflector

Automatic Exposure
Photo Sensor

Manual/Auto
Switch

Flash Tube

Typical hot shoe flash (front view).

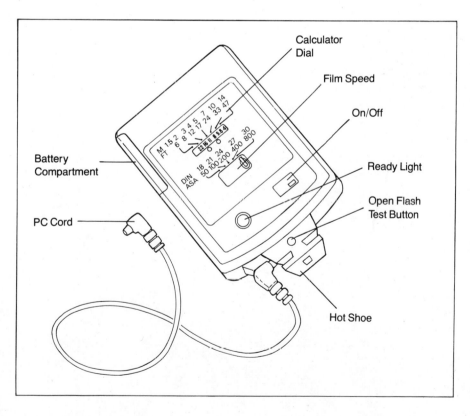

Calculator
Dial

Film Speed

On/Off

Battery
Compartment

PC Cord

Ready Light

Open Flash
Test Button

Hot Shoe

Typical hot shoe flash (back view).

Powering the Flash

Power Supply

Portable electronic flash units can be designed to operate on any of several different DC (battery) power supplies. Units designed to use interchangeable power systems may also be fired using AC (household) current. Inexpensive flash units generally require disposable low-voltage dry cells such as alkaline or carbon-zinc batteries. More sophisticated flash units often incorporate a rechargeable nickel-cadmium power pack. The high-voltage (510v) dry cell is also a common nonrechargeable power supply for professional-sized portable flash units.

All flash units require a high-voltage surge of current (350 to 500 volts) to fire the flash tube. Both the low-voltage DC and 110v AC currents must be increased in voltage before they can fire the unit.

The flash housing must include a sandwich of electrical components to modify the current from the power source. A transformer in

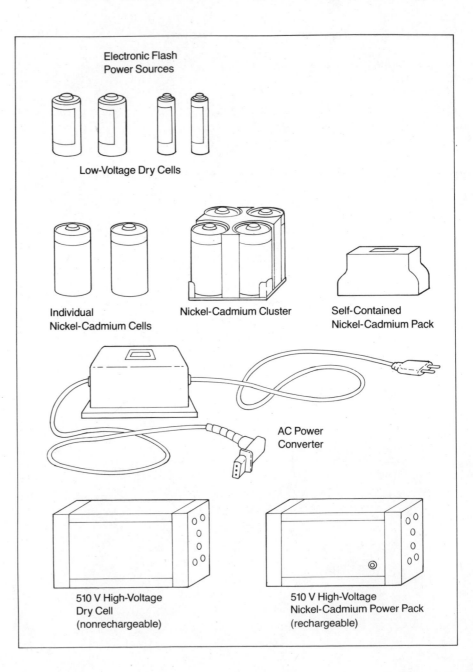

Electronic Flash
Power Sources

Low-Voltage Dry Cells

Individual
Nickel-Cadmium Cells

Nickel-Cadmium Cluster

Self-Contained
Nickel-Cadmium Pack

AC Power
Converter

510 V High-Voltage
Dry Cell
(nonrechargeable)

510 V High-Voltage
Nickel-Cadmium Power Pack
(rechargeable)

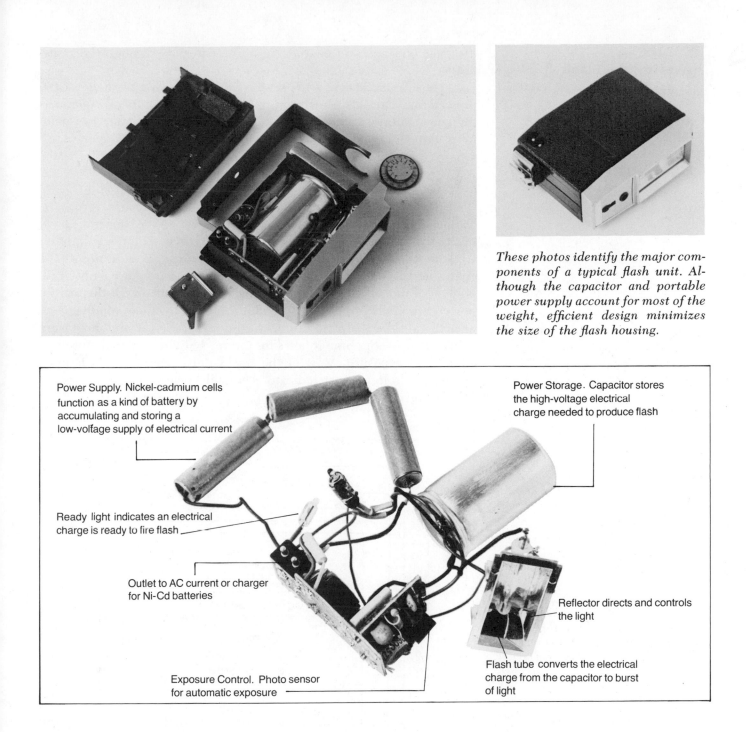

These photos identify the major components of a typical flash unit. Although the capacitor and portable power supply account for most of the weight, efficient design minimizes the size of the flash housing.

Power Supply. Nickel-cadmium cells function as a kind of battery by accumulating and storing a low-voltage supply of electrical current

Power Storage. Capacitor stores the high-voltage electrical charge needed to produce flash

Ready light indicates an electrical charge is ready to fire flash

Outlet to AC current or charger for Ni-Cd batteries

Reflector directs and controls the light

Flash tube converts the electrical charge from the capacitor to burst of light

Exposure Control. Photo sensor for automatic exposure

the flash unit steps up the voltage of any low-voltage power source. Since a transformer will only accept alternating current, a flash connected to AC household power can directly raise the voltage to the required level. A rectifier in the flash circuit converts the high-voltage AC to high-voltage DC for storage in the capacitor. The rectifier is a kind of one-way valve that eliminates the two-way flow of AC current, since a flash capacitor can store only DC current.

When you operate a flash on low-voltage DC power, there is one additional step to the electrical processing: an oscillator converts the DC current to AC before it is increased in voltage by the transformer. An audible whine may result as the oscillator rapidly builds and decays

the magnetic fields to enable the current to pass through the transformer.

Flash units designed to accept power from a high-voltage (510v) dry cell may have a somewhat simplified circuit that directly connects the power supply to the capacitor. The section on power sources compares the performance differences among the basic power sources.

Ready Light

The neon ready light on a flash unit indicates when the capacitors have built up a full charge after the unit has been fired. The ready light on some inexpensive flash units is only an approximate indicator of the charge level and will first glow when the capacitors are only at 70 percent of their full charge. If you make an exposure with this partial power, the photograph could be underexposed by about one f-stop. A general rule that helps to eliminate the possibility of underexposure is to wait twice the time it takes for the ready light to glow before you attempt an exposure. Most of the heavy-duty professional EF units feature ready lights that indicate accurately when the capacitors are fully charged.

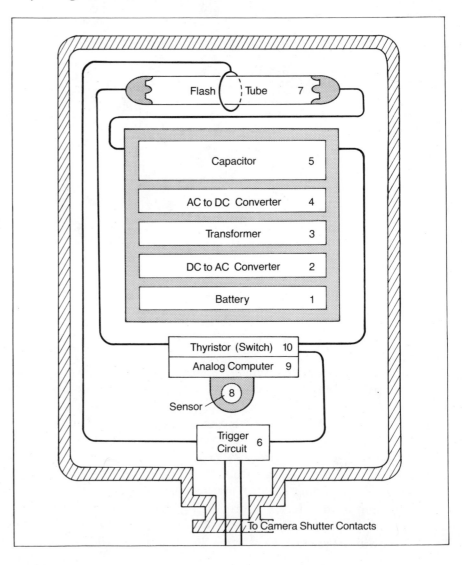

This diagram illustrates how the electrical current flows through a typical flash unit. First, the current from batteries (1) is converted to AC current (2) so that it can be stepped up in voltage in the transformer (3). This high-voltage current is then converted back to DC (4) for storage in the capacitor (5). When the trigger circuit (6) ionizes the gas in the flash tube (7), the larger charge from the capacitor flows through the gas, creating a quantum burst of heat and light. The photosensitive "sensor" eye (8) of the automatic exposure circuit monitors the light reflected by the subject. When a correct exposure is possible, the sensor uses an analog computer (9) to close the thyristor switch (10) and halt the flow of current through the flash tube. The tube ceases to glow and the remaining current is efficiently saved for another flash exposure.

One line of flash units features two ready lights. The first light glows to indicate that the capacitors have built up to 50 percent of their maximum potential. The second ready light blinks to indicate that the flash unit has reached a full (100 percent) charge. This two-stage ready light system can prove a useful design for anticipating the last few flashes in a power pack.

Recycling Time

Recycling time is the time required for the capacitor to build a full charge. The speed of the recycling time may be an important consideration for the working photographer. The advertised recycling time for a flash unit is based on optimum conditions and is sometimes difficult to duplicate under field conditions. Most portable flash units will take from three to ten seconds to recycle, depending on the condition of the batteries, the temperature, and the type of power supply. As the charge in the batteries grows weaker, the recycling time increases. Cold weather will also lengthen the recycling time. Flash units set on partial power or operated in an automatic mode will recycle faster than those set on full power or manual. The 510v high-voltage dry cell will generally provide a faster and more predictable recycling time than Ni-Cd batteries will; however, one professional-sized portable flash does use Ni-Cd batteries and offers an exceptionally short recycling time of three-tenths of a second at 50 watt-seconds of power.

The recycling time is an important performance specification, and the American National Standards Institute prescribes testing procedures that manufacturers use to rate the recycling times of their flash units. These ratings are useful when you are comparing the capabilities of different products.

Ready
Light

A neon ready light glows to indicate when the storage capacitor has been filled with enough electrical current to fire the flash tube.

Synchronizing Flash and Shutter

Shutter X Synch

Electronic flash and flashbulbs perform differently. The X and M synchronization settings on the camera are designed to coordinate the opening of the shutter with the peak of light from these two types of flash. An X or lightning-bolt symbol is used to mark the terminal that you should use with all electronic flash lighting. This mode of synchronization will insure that the shutter is completely open before you fire the nearly instantaneous light from the flash.

With a focal plane shutter, the X synch fires the flash when the first shutter curtain reaches the far side of the frame and the negative is completely revealed. This generally means a setting of 1/60 second for horizontal shutters and of 1/125 second for vertical shutters. A flash photograph that shows a partially exposed negative (half image or less)

These frames reveal how an improperly synchronized focal plane shutter will partially block the light from the flash. In the top photograph, the continuous ambient light portion of the exposure is unaffected. The lower photograph, of the same subject, was taken at the correct flash synch setting (1/60 sec. for most cameras), and the shutter was entirely open at the exact instant the flash was fired.

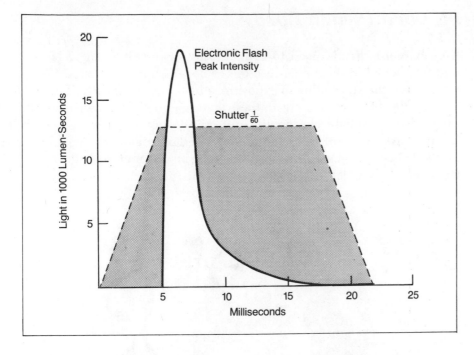

The time-light curve illustrates how a synched shutter remains open much longer than the brief duration of the flash illumination. The dotted line indicates that the shutter remains open long enough to capture effectively all of the burst of light from the flash. Progressively longer (slower) shutter speeds will synch with the flash and will accordingly record the ambient light.

generally indicates that you have set the focal plane shutter too fast for full synch. Focal plane shutters are also in full synch at all speeds slower than the X setting.

A leaf-type between-the-lens shutter opens completely at all speeds; thus, X synch is insured for each shutter setting.

The Hot Shoe

Some cameras are equipped with an accessory clip designed to receive the standardized connector found on most small and mid-sized flash units. If this clip is wired to the shutter contacts of the camera, it is called a *hot shoe*. You can fire a flash unit attached to this bracket without using an additional connecting cord.

A camera hot shoe is designed to simplify the use of flash on-camera. The hot shoe is wired to the shutter contacts and will fire the flash when an exposure is made.

PC Cord (Synch Cord)

The PC cord can be used to connect the flash unit to the X synch terminal, which links the flash to the camera's shutter contacts. When you release the shutter for an exposure, a low-amperage current travels through the PC cord to activate the triggering circuit in the flash unit. PC cords are available in lengths up to thirty feet and can be used to fire the flash on or off the camera. The standard male and female tips on the PC cord fit most cameras, although some cameras are designed for their own special locking PC cord connection.

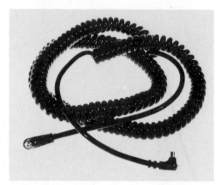

When you do not mount the flash unit on the camera hot shoe (above right), you can wire it to the camera flash synch outlet (X) with a PC cord. PC cords are available in straight or coiled configurations and a variety of lengths (above). The two wires in the PC cord (below right) carry a low-amperage current to the camera and back to the trigger circuit in the flash when the camera shutter contacts are closed. This triggers the flash unit in synch with the firing of the shutter.

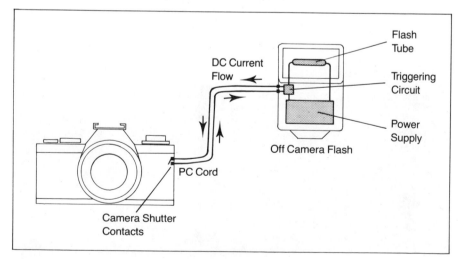

Flash Duration

The burst of light from a flash tube is so brief that it is measured in milliseconds. Specially designed flash equipment can produce a light that lasts less than 1/1,000,000 second; however, the typical hot-shoe portable flash unit produces a light with durations from 1/500 to 1/50,000 second. Flash duration describes the photographically useful portion of this burst of light.

The total light output of a single firing from a flash tube can be measured and plotted on a graph. An oscilloscopic measurement of this pulse of light, with amplitude as its height and duration as its width, reveals a wave shape. The American National Standards Institute recommends that effective flash duration for amateur flash units be measured across the width of the pulse at one-half the height of the wave form. Flash duration in other countries may be measured at one-third, one-fifth, or even one-tenth the height. The inventor of the early flash units, Dr. Harold Edgerton, defined flash duration as the time in milliseconds during which the light from the flash unit was greater than one-third of the peak. In evaluating foreign-made flash units, you should know how flash duration is being defined in the product literature.

Light Output

The typical flash duration of 1/1000 sec. will arrest most subject movement. Some of the rapidly falling dirt particles being dumped from the shovel were frozen in this manual flash exposure. An automatic flash setting would have further shortened the duration and eliminated even more of the blurred movement.

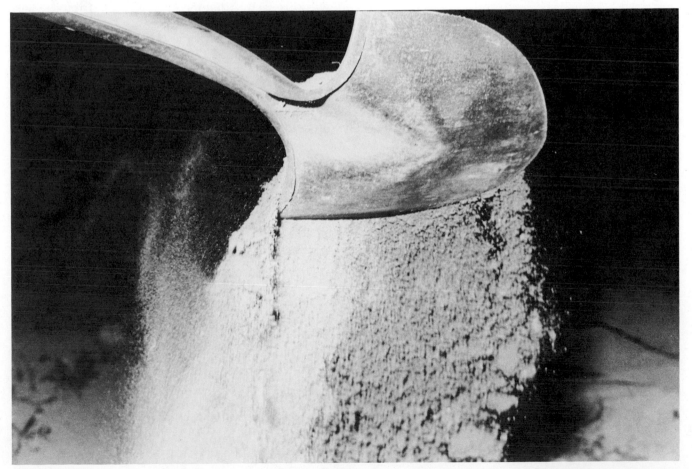

Colleen Chartier, *Shovel,* 1979

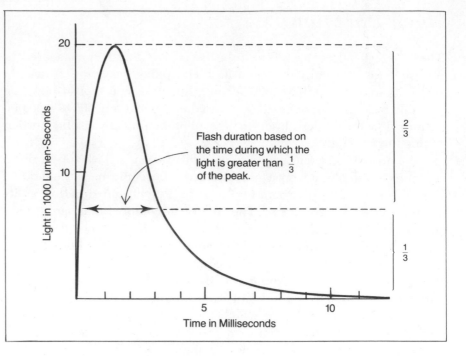

Flash duration based on the time during which the light is greater than $\frac{1}{3}$ of the peak.

The term flash duration *generally designates the portion of the flash illumination that is most useful for a film exposure. It may be stated in lumen-seconds but is also often stated as a fraction of a second (for instance, 1/1000 sec. is a typical portable flash duration).*

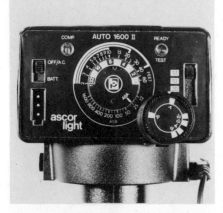

Short flash durations are possible with some variable power flash units. This flash unit is equipped with a variable power control dial. It is calibrated in f-stop increments and allows you to decrease the light output up to a −6 f-stop. This correspondingly shortens the flash duration to a minimum of 1/15,000 sec.

Controlling Flash Duration

It is possible to alter flash duration to solve a given photographic problem. The following are factors that may extend or shorten the flash duration of some portable flash units.

A Decrease in the Power. Decreasing the watt-second level of the power supply generally decreases the flash duration. For example, if the flash duration of a given lamphead and power supply is 1/1000 second on full power, it will shorten to approximately 1/2000 second when the power supply is reduced by one-half. An automatic flash unit provides an excellent example of how a decrease in the power supply shortens the flash duration. A light sensor in the flash unit monitors the light reflected by the subject. When the reflected light indicates that an adequate exposure is possible, the sensor halts the flow of electricity and terminates the pulse of light from the flash tube. If the photographer aims the automatic flash at a highly reflective subject at close range, the sensor can effectively cut the flash duration to about 1/50,000 sec.

A Variable Power Supply Dial. Some portable flash units are now equipped with a variable power supply dial that allows you to predetermine the exact ratio of energy for a given flash. This option is an ideal way of controlling the speed of the flash duration. (Additional information on using the variable power supply can be found in the sections on calculating exposure, balancing the light, and close-up with flash.) Accurate exposure and facsimile-quality color balance require a highly consistent flash duration. Inexpensive flash units may vary in light output as the battery strength or AC line voltage fluctuates. Better-quality flash units incorporate voltage stabilization circuitry to insure that the quantity and quality of light remain constant. Variations in

light output could be a serious problem when using a ringflash for extreme close-up color photography. AC power supplies are generally a more consistent power source than a Ni-Cd or dry-cell battery.

The Size (Length and Diameter) of the Flash Tube. A longer and smaller diameter flash tube, such as the ringflash, creates a longer flash duration as the electrical energy bridges the gap between the flash-tube electrodes.

Reflectivity of the Subject. A highly reflective subject may extend the useful portion of the light pulse. This additional light can be noticed as blurred or streaked light on rapidly moving reflective subject matter (for instance, bracelets on a dancer's wrists).

The Reflector

The reflector behind the flash tube is essential for flash efficiency. The average reflector will increase the light output of the lamphead by three or four f-stops. The size, shape, surface, and color of the reflector are all factors that affect the quality, quantity, and direction of the light.

 The typical hot-shoe portable flash unit has a very small but effective rectangular reflector which fits the 1:1½ proportion of the 35mm film format. Portability and compactness are primary considerations with such units. Since the rectangular flash reflector produces

The flying bits of a shiny Christmas tree ornament present a difficult stop-action problem for the electronic flash. The pieces of glass reflect more of the total flash illumination and have the effect of prolonging the flash duration.

Light Output

The typical hot-shoe flash unit has a rectangular reflector that produces a beam of light matched to the format of the 35mm film. The angles of coverage of the light are expressed in vertical and horizontal degrees. Angles that closely match the angle of view of a 35mm lens on a 35mm camera are 60° horizontal and 45° vertical.

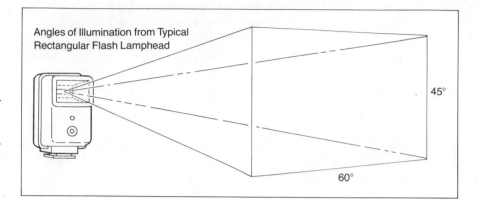

Angles of Illumination from Typical Rectangular Flash Lamphead

45°

60°

The beam of light from a standard flash unit is not designed to cover the field of view of a 28mm wide-angle lens adequately. This photograph of a trellis was taken with a 28mm lens and an ordinary flash unit. The photographer has used the falloff of the light on the edges creatively to emphasize the role of the flash and to place the subject in a special context.

an elliptical beam of light, the angle of illumination is stated as both horizontal and vertical coverage. Most flash units are designed to throw a 60° horizontal and a 45° vertical beam of light. This angle of coverage will adequately match the field of a normal (50mm) lens on a 35mm camera. Because the light beam is elliptical, you must carefully align the film and the lamphead. It is best to use a flash unit with a square or circular reflector with a 2¼ (6cm)-format camera.

Some flash lampheads can be modified or adjusted to change the

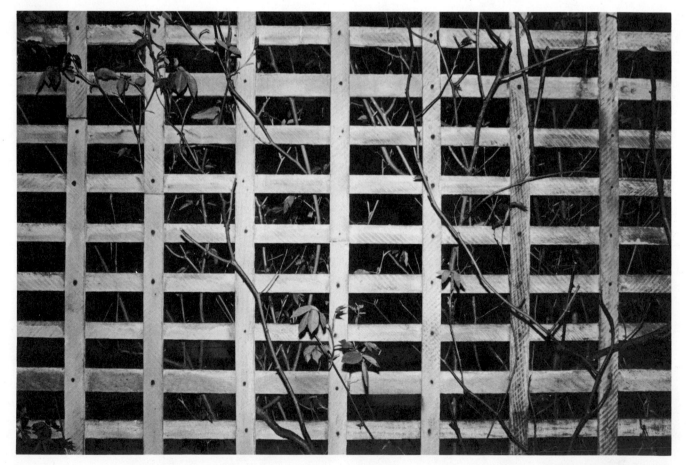

Colleen Chartier, *Trellis,* 1977

angle of coverage to match the requirements of a wide-angle or tele-photo lens. Any diffusion material placed in front of the lamp will have the effect of dispersing the light and creating a wider light beam. Many inexpensive flash units offer a snap-on plastic diffuser as a wide-angle accessory. As the beam of light spreads to cover a larger area, a corresponding decrease in the light level occurs and you must make an exposure compensation.

A more efficient variable-beam flash unit may incorporate a fresnel lens that can be adjusted to focus the light for three angles of illumination: wide angle, normal, or telephoto. The guide number will vary for each of these settings.

Some flash units have an adjustable fresnel lens which can be used to zoom the light to match the angle of view of wide-angle, normal, and tele-photo lenses. When you use the wide-angle position, you spread the light from the flash over a broader area; so you must use a smaller guide number to determine the correct flash-to-subject distance. When you narrow the beam of light for the telephoto lens, you concentrate the light as a narrow beam, so the guide number is effectively increased.

One portable flash unit uses an optical spacer and special reflector to vary the flash-to-reflector distance and narrow the angle of illumination for telephoto photography. The 15° beam of light offers a guide number of 900 with ASA 400 film and allows you to use an f/8 aperture at a flash-to-subject distance of 112 feet.

With a superwide lens such as 20mm or 17mm on a 35mm camera, the best way to match the light from the flash and the field of view is to use a bare flash tube.

The light from a properly designed reflector should be free of hot spots. A simple test will reveal the evenness of the illumination and the precise angle of coverage for a given flash unit: Aim the flash at a dark wall, using a flash-to-subject distance of about six feet. Locate the camera about six feet behind the flash for a camera-to-subject distance of twelve feet. A strip of tape on the wall can be used to measure increments of six inches to indicate the vertical and horizontal spread of light. Bracket a series of exposures to determine the performance of the flash unit.

The size of the reflector directly affects the quality of the light. Large-diameter reflectors are often used on studio lights to achieve a soft, north-light effect. You must maintain relatively close flash-to-subject distances when you are using these portrait-type reflectors.

The Norman 200B portable flash unit has an interchangeable reflector and optical spacer which can be used to create a 15° beam of concentrated flash illumination for telephoto photography.

Light Output

This series of photos compares angles of coverage and evenness of illumination for flash units representing the basic types of portable lighting. The testing setup and camera position are revealed in the last of the photographs. The circular reflector would be a logical choice for a 2¼ × 2¼ camera format.

The surface of the flash reflector is generally highly polished to provide maximum light output. The polished surface creates the traditional contrast and directional flash light. If the reflector is dulled or dimpled, the light can be noticeably softened, with a corresponding reduction of light output.

Some flash reflectors are slightly tinted with a color coating to change the color balance of the light. Since the light from the bare flash tube may seem slightly cooler than typical sunlight, you can use a gold-toned reflector to match the color temperature of the morning or afternoon sun.

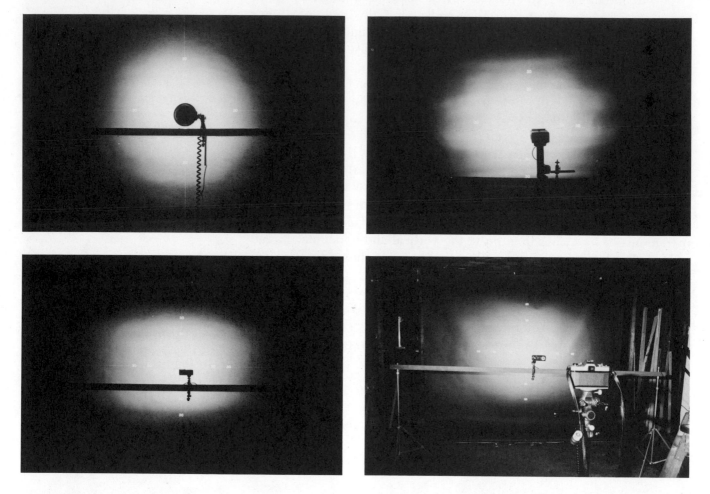

Measuring Light Output

Opposite page: The photographer used a 135mm lens for this zoo photograph of a liontail macaque. The beam of light from the standard flash reflector more than covered the narrower field of view of the lens and insured a full illumination of the subject.

Flash equipment may vary tremendously in light output. Large airborne units designed for military reconnaissance can create 80,000 watt-seconds of energy. High-speed flash units with a 0.5 microsecond flash duration and a mere 0.2 watt-seconds of power are used to "stop" the action of a bullet piercing an apple. Typical studio electronic flash lighting in a commercial photographic facility may total 10,000 to 20,000 watt-seconds. Smaller studio lighting systems range from 200

36

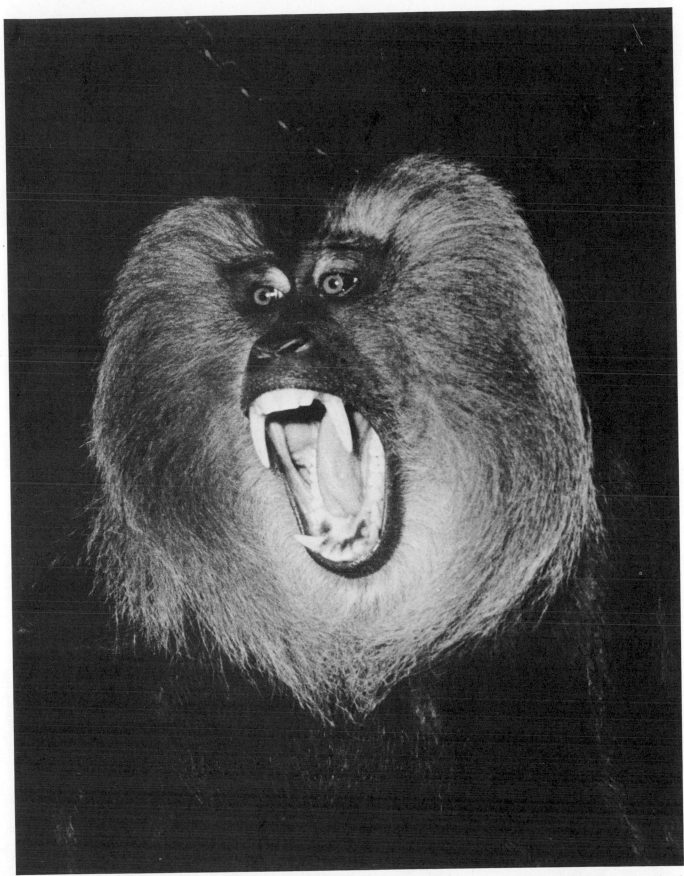

Joy Spurr, *Junior* (liontail macaque), n.d.

Light Output

This group of professional studio lights indicates some of the reflector designs that are used for specific lighting effects. Professionals generally use large reflectors to achieve soft north-light effects.

to 5000 watt-seconds of power output. Portable camera-mounted flash units can be designed for a power supply of 30 to 400 watt-seconds.

The amount of light delivered by any flash unit is directly determined by (1) the electrical power stored in the capacitor, (2) flash-tube design, (3) reflector efficiency, and (4) circuitry efficiency. Variations in any of these factors may dramatically change the performance of the flash unit. Generally speaking, the more energy the capacitor can store, the brighter the potential flash will be.

Watt-Seconds. Given the design of the power source and the size of the capacitors, one can state a watt-second (joule) rating as a flash specification. Studio EF equipment is often compared on the basis of watt-seconds of energy. Professional photographers may prefer to know the watt-second rating, since they often use different reflectors or bare-bulb lighting. The watt-seconds are a statement of the maximum electrical input for a single firing of the flash unit and do not account for reflector efficiency or circuitry design factors. All else being equal, doubling the watt-second power level is approximately equal to a one f-stop increase in light output.

BCPS. The BCPS, which stands for "beam candle power seconds," is often used as a more direct measure of the light output of a flash unit with a self-contained reflector. You determine the BCPS by firing the flash in a test environment and measuring the light using a calibrated integrating light meter. The manufacturer generally conducts the test, following guidelines recommended by the American National Standards Institute. Since European manufacturers may follow a slightly different method prescribed by the Deutsche Industrie Norm (DIN), the BCPS specifications are not completely standardized. A typical camera-mounted flash unit will have a BCPS rating of 2500. When comparing flash units, you should be aware that a doubling of the BCPS indicates a change of one f-stop.

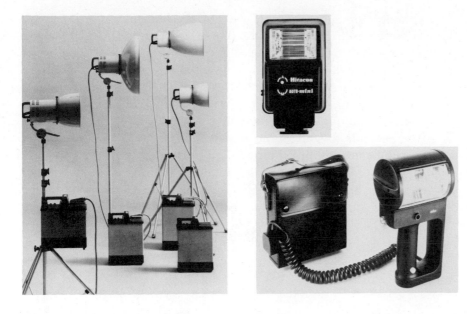

Flash lighting equipment varies greatly in size and light output. Very small hot-shoe flashes use a single AA 1.5v alkaline dry cell (above left). Handle-mount units by comparison are professional-sized and produce nearly ten times more light than the smaller flash does (below left). A professional studio flash lighting system is large enough to light an automobile showroom (far left).

Guide Number. The guide number is probably the most familiar and useful rating for comparing the light output of portable flash units. The guide number for a particular flash unit is calculated from the BCPS and is based on actual film tests by the manufacturer:

$$\text{guide number} = 0.23\sqrt{\text{BCPS} \times \text{ASA}}$$

For the photographer, the guide number is best understood as the product of a distance and an aperture which will create the proper exposure with a given film and flash unit:

$$\text{guide number} = \text{distance} \times \text{aperture (f-stop)}$$

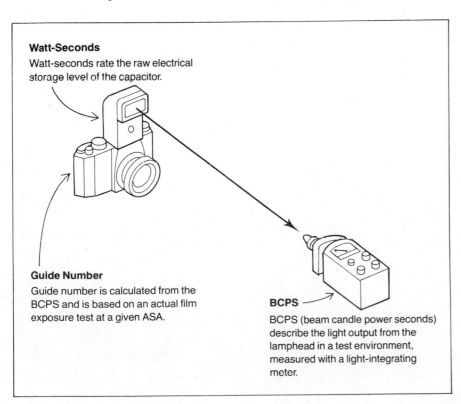

Watt-Seconds
Watt-seconds rate the raw electrical storage level of the capacitor.

Guide Number
Guide number is calculated from the BCPS and is based on an actual film exposure test at a given ASA.

BCPS
BCPS (beam candle power seconds) describe the light output from the lamphead in a test environment, measured with a light-integrating meter.

Watt-seconds, BCPS, and guide number flash ratings.

Light Output

Although the guide number is useful for determining exposure, it is what the name implies, a guide. The guide-number formula calculates an exposure for an average indoor subject in an average-sized room with light-colored walls and ceiling. Individual photographers may differ in how they expose, process, and print film. It is important to confirm the working guide number for a particular flash unit, using the actual film, techniques, and processing you most frequently employ.

Watt-seconds, beam candle power seconds, and guide numbers are all useful indicators of the potential performance of a given flash unit; however, none of the terms provides a definitive description of the "effective" light from a flash unit as it relates to optimum exposure, a specific film emulsion, and film development.

GUIDE NUMBER CHART

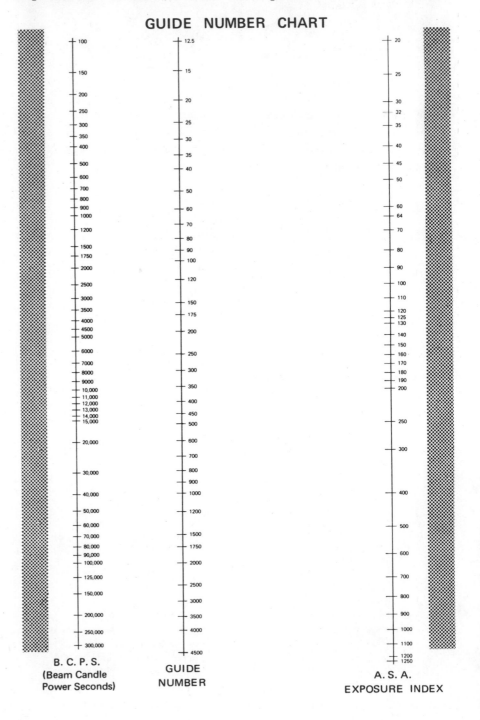

You can use the nomograph provided by Norman Enterprises to determine the guide number for a flash unit when you know the BCPS and ASA of the film. First locate the BCPS and the ASA of your film in the outer columns, then place a straightedge across these two points to intersect the guide number in the center column.

Calculator Dials and Calculator Charts

Manufacturers include a calculating dial or chart on the housing of a flash unit to simplify the problem of exposure calculation. A dial set for the ASA will compute a working f-stop based on the output of the unit and the flash-to-subject distance. In addition to this basic information, a dial may indicate the operating range for the automatic exposure sensor. Some dials are illuminated by a small neon light, which can be useful when you are working in near-total darkness.

Calculator dials on flash units are designed to assist the photographer in calculating the flash exposure. Some designs are obviously more functional than others. Too much information can clutter the design. A lighted dial is a must when you are taking photographs in a dark or dimly lit location. The information on the dial should be legible enough for quick reference.

Some flash units incorporate a digital information panel instead of the calculator dial. The film speed (ASA) is programmed into the flash computer. If the desired f-stop (or anticipated distance) is then entered into the panel, the flash calculates the missing information and illuminates all of the exposure data in an LED display. This type of exposure calculator is also easily read in low light levels.

Automatic Exposure

Many flash units are now designed for manual or automatic operation. A light-sensitive photo diode monitors the light being reflected by the subject during a flash exposure. When the lamphead has emitted enough light for a proper exposure, the sensor signals a solid-state analog computer, which turns off the light. This eliminates the need to calculate the precise exposure for a given distance range and may also conserve some of the energy in the capacitors. Energy-saving circuitry can extend the number of flashes for a given electrical supply and will shorten the recyling time.

Exposure Aids

This calculator dial is set for a film speed (ASA) of 125. You can read a choice of distance and f-stop combinations from the opposite side of the dial. By multiplying the distance and the indicated f-stop, you obtain the approximate guide number for the flash unit. For example, this dial indicates that f/11 is needed for a distance of ten feet: 10 ft. × f/11 = 110 (guide number).

The illuminated LED numerals on this flash unit replace the conventional exposure calculation dial. After film speed and flash-to-subject distance are programmed into the unit, the correct f-stop can be read at a glance.

A flash unit with automatic exposure control has a sensor that monitors the light reflected from the subject. When the light level is sufficient for a proper exposure, the light is cut off.

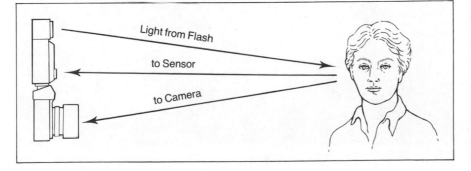

Light from Flash

to Sensor

to Camera

Exposure Aids

An automatic flash unit is designed to aim its sensor at the subject and switch off the flash tube when sufficient light for a correct exposure has been reflected by the subject. Each of these three exposures was made using the automatic setting on the flash unit. The photographer maintained a proper exposure within each of the three working ranges of the automatic flash used.

Courtesy Historical Society of Seattle and King County, Museum of History and Industry.

42

Correct Exposure Test Light

Some flash units incorporate a "confidence" light or correct exposure light as part of the automatic sensor circuit. The photographer fires a test flash at the subject, and if enough light is reflected to the sensor to indicate adequate exposure, an audible tone sounds or a small neon indicator light flashes. (A thorough treatment of determining exposure for electronic flash is contained in the next chapter on calculating exposure.)

The control panel on some flash units (as on this Ascor 1600 II) has a computer verification light that indicates before you shoot whether the flash is providing sufficient light on automatic. Make a test firing of the flash before the actual exposure. If the verification light does not glow, you must move the flash unit closer to the subject.

Below: A test firing of the flash indicated that a correct exposure could be made of this cat collection.

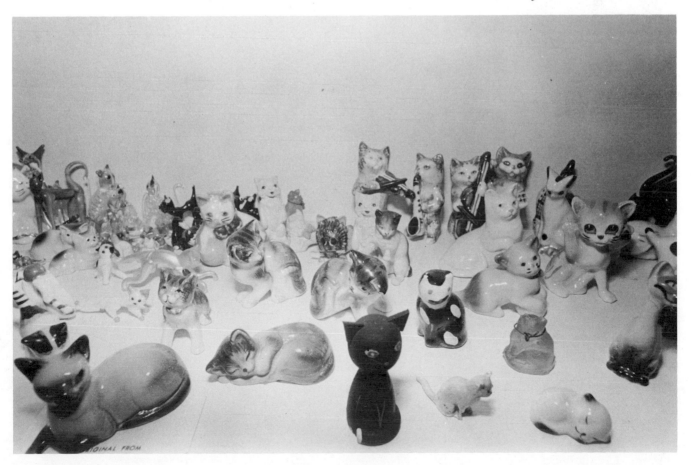

43

Calculating Flash Exposure

Light Fundamentals
Controlling Exposure
Automatic Exposure Control
Flash Meters
Special Exposure Problems

Ron Carraher, *Travis*, 1978

Light Fundamentals

A flash unit with automatic exposure control enables a person with only a limited understanding of photography to make a correct exposure. A more serious photographer, interested in the creative applications of flash lighting, will need a working knowledge of the fundamentals of light as well as information about calculating flash exposures.

The Inverse Square Law

If you look directly into a flash unit at close range and fire the flash tube, the burst of light is painful, almost blinding. Move ten feet from the unit and fire another burst of light, and the experience is much less traumatic. As the light radiates out from the lamphead, it spreads to cover a larger area. Because the amount of light is fixed, there is a reduction in its intensity as it spreads. The inverse square law precisely defines the amount of light reduction: Intensity of illumination is inversely proportional to the square of the distance from the light to the subject. This law provides a measure of the amount of light remaining on a subject at any given distance from the light source. If you position a light five feet from the subject, it is reduced as it spreads to reach that distance to the inverse square of five feet, or $1/(5)^2$, which equals 1/25. One-twenty-fifth of the original light will reach the subject at this distance.

The distance from the flash to the subject is the key to understanding a flash exposure. Since the amount of light falling on the subject is inversely proportional to the square of the distance, significant changes in the flash-to-subject distance will create predictable changes in exposure.

You can understand the photographic importance of this principle of light by moving a single subject away from a light source and observing how the illumination decreases as the distance from the source increases. The term *falloff* is used to describe any dramatic decrease in subject illumination.

This simplified diagram illustrates why the light from any point light source decreases in a constant and predictable manner. When the distance from the source (A) is doubled (A + A), a given unit of light must spread to cover an area four times as great. At twice the distance, only one-fourth the amount of illumination falls on a given area of a subject.

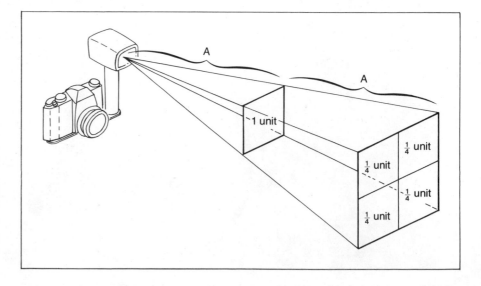

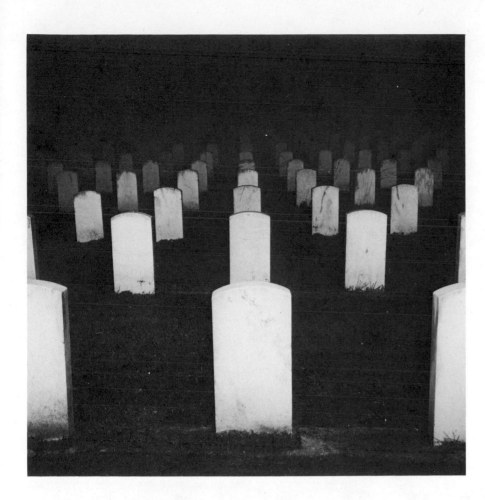

The decrease in illumination from a flash is proportional to the distance from the flash to the subject. These rows of white gravestones are equally spaced and illustrate the predictable intervals of light falloff.

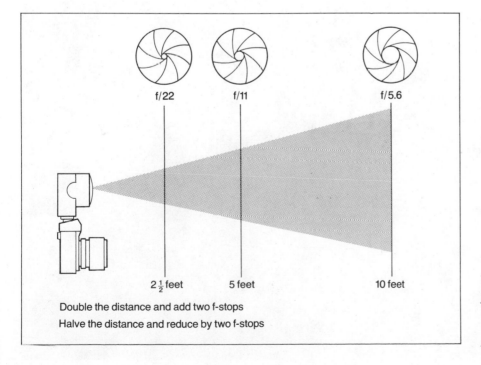

f/22 f/11 f/5.6

2 ½ feet 5 feet 10 feet

Double the distance and add two f-stops

Halve the distance and reduce by two f-stops

This chart diagrams a simple rule for flash exposures: Double the distance and open the lens two f-stops; halve the distance and close the lens two f-stops.

Contrast and Light

The three terms *contrast*, *lighting ratio*, and *reflectance ratio* describe the basic photographic properties of light.

Contrast refers to the dark-and-light comparison of any adjacent parts of a photographic subject or image. The contrast range of the subject depends upon the two variables, lighting ratio and reflectance ratio.

The **lighting ratio** mathematically states the difference between the illumination falling on the darkest and that falling on the lightest areas of the subject. On a bright, sunny day, the difference between the light and dark areas is often quite extreme. A 20:1 ratio would indicate that twenty times as much light was falling on the lighter areas. A low ratio of 2:1 would describe the soft, diffused light and minimal shadows of a cloudy day. It is important to realize that the term *lighting ratio* refers to the light falling *on* the subject. Additional light can be added to a subject to alter the lighting ratio.

The **reflectance ratio** compares the capacities of the subject's surfaces to reflect light. The black-and-white stripes of a referee's jacket would present a high reflectance ratio. A completely white cat in the snow would produce a low reflectance ratio on a sunny day.

When a high lighting ratio is combined with a subject that has a high reflectance ratio, the contrast can reach 1000:1. Fortunately, the

This photograph of a cat at a cat show presents extremes of both contrast and reflectance. The photographer calculated a manual flash exposure for the light areas of the subject and deliberately underexposed the black cat to produce a dark shape inside the cage. This placement of the exposure emphasized the animal's eyes and added ambiguity to the composition.

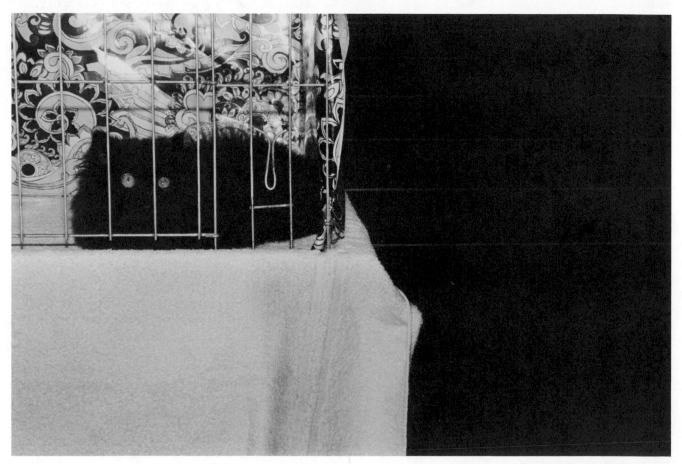

Colleen Chartier, *Show Cat*, 1976

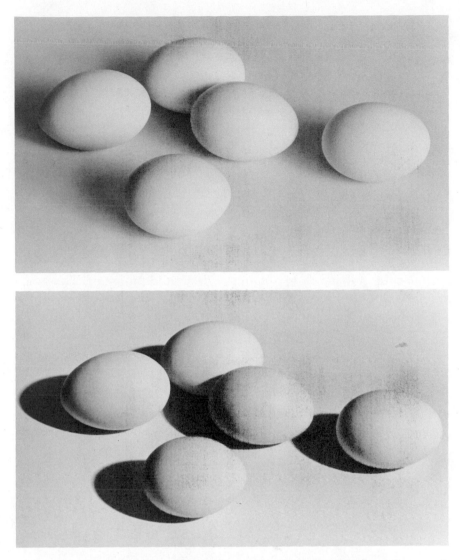

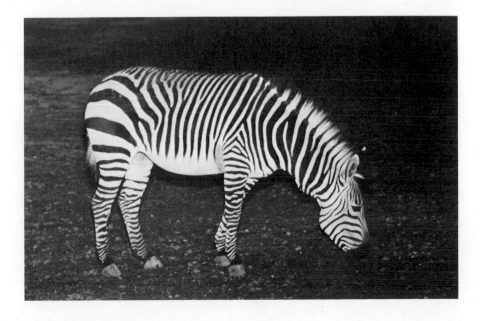

Two different lighting ratios were used to illuminate these eggs on white paper. The diffused umbrella light produced a 3:1 lighting ratio (above), while the direct flash created a high ratio of more than 20:1 (below).

average subject has a **reflectance** ratio of about 160:1 and records satisfactorily on black-and white film's 200:1 tonal range. Compression of the tonal range of the subject is often unavoidable.

This zebra provides an example of a subject with a high reflectance ratio. The frontal light from the flash reduces contour shadows and produces a high-contrast image.

Controlling
Exposure

Calculating a correct flash exposure can be a simple process. You must set the shutter speed on the X synch setting for 35mm cameras with a focal plane shutter. Leaf-type shutters are in synch at all speeds when triggered at the X setting. Once you have set the shutter speed in synch, you can eliminate this speed as an exposure variable. The basic exposure is now determined by (1) the light output of the flash, (2) the ASA of the film, and (3) the distance from the flash to the subject.

Using a Guide Number

For convenience, most manufacturers conduct a factory test with a flash unit to determine the basic f-stop and flash-to-subject distance for a given film speed. They then multiply the recommended f-stop by the flash-to-subject distance to obtain the flash guide number. The guide number (GN) can be used to calculate quickly the basic exposure at any flash-to-subject distance.

$$\text{f-stop} = \frac{\text{guide number}}{\text{flash-to-subject distance}}$$

For example, if the guide number for your flash and film combination is 80 and your flash is ten feet from the subject, f/8 would be the indicated f-stop:

$$\text{f/8} = \frac{80 \text{ (guide number)}}{10 \text{ feet (flash-to-subject distance)}}$$

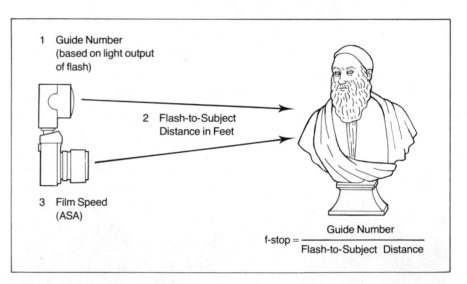

Using the guide number formula to calculate a flash exposure.

Most flash units are designed with a calculating chart or dial which you can set for a particular ASA to determine the desired f-stop for any given distance quickly. The calculator dial merely does the work of dividing for you. The inverse square law governs the f-stop requirement, so as you change the flash-to-subject distance, you must keep the amount of light reaching the film constant by increasing or decreasing the size of the aperture.

A Working Guide Number

A guide number is at best a *guide* to the correct flash exposure. This rating is generally quite reliable; however, it is based on the manufacturer's optimum testing conditions and may not be dependable for precise exposure calculations. Since even identical flash units often vary in light output, you should conduct your own exposure test to determine a working guide number for your particular flash unit.

Use a color reversal film such as Kodachrome II with a narrow exposure latitude. Select an average subject (or use an 18% gray card) in a typical indoor location and position the flash on the camera at an exact flash-to-subject distance of ten feet. Bracket a series of exposures at half-stop intervals above and below the exposure indicated by the manufacturer's rated guide number. Allow at least forty seconds between exposures for the flash to recycle completely. Keep a record of the f-stops you use, and after the film is processed, match the test exposures with the correct aperture settings. Now, calculate the working guide number for your EF unit by multiplying the best exposure by the flash-to-subject distance.

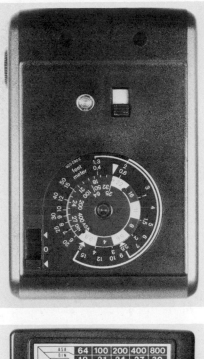

guide number = flash-to-subject distance × best exposure

Keep in mind that the reflectivity of the environment is an important exposure factor. Carry out your test in a location that approximates a typical setting.

The exposure calculator dial on your flash unit is designed to function with the guide numbers established by the manufacturer. If your tests indicate that you should use a revised guide number, you may wish to reprogram the dial. Simply divide the new guide number by ten and align the resulting f-stop with the ten-foot mark on the calculator dial. The dial will now display the proper f-stop based on the revised guide number for all flash-to-subject distances.

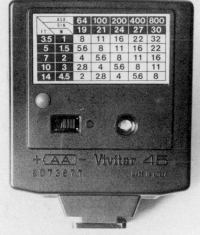

Each guide number test is based on a particular ASA. If you use the flash unit with a different film speed, you can repeat the test with the new film, use an equivalent guide number table (page 222), or mathematically calculate the new guide number with the following formula:

Calculator dials and charts simplify the long division involved in calculating the correct f-stop for a given film speed and distance. Some dials are illuminated to permit making calculations in the dark.

new guide number = old guide number × $\sqrt{\dfrac{\text{new ASA}}{\text{old ASA}}}$

A nomograph consists of three scales arranged in such a way that when a straightedge is used to connect two known values, a third unknown value can be read at the point of intersection.

You can use a flash nomograph to calculate a guide number based on the BCPS of a given flash unit and a particular film ASA. You might have to adjust the guide number to such variables as film processing or other conditions affecting exposure. Remember that the guide number calculation does not take into account the reflectivity of the surroundings or the dark-and-light character of the subject. When you use your flash outdoors where reflecting surfaces are absent, it may be necessary to increase the aperture by one or more f-stops. If you use

If you make a flash exposure of an average indoor subject, you can use the recommended guide number to accurately calculate the correct f-stop.

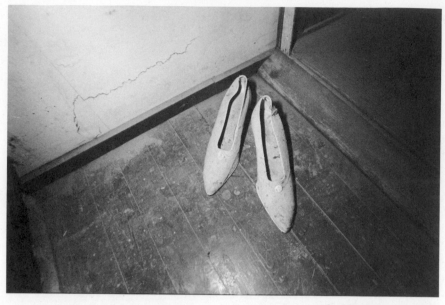

You can isolate a freestanding subject against the dark void of the fall-off with flash illlumination. In this photograph, the flash was positioned about one foot off-camera to create a visible cast shadow and add interest to the subject. Outdoor nighttime exposure generally requires a one to two f-stop increase over the f-stop indicated by the guide number.

Gay Burke, *Untitled,* 1976

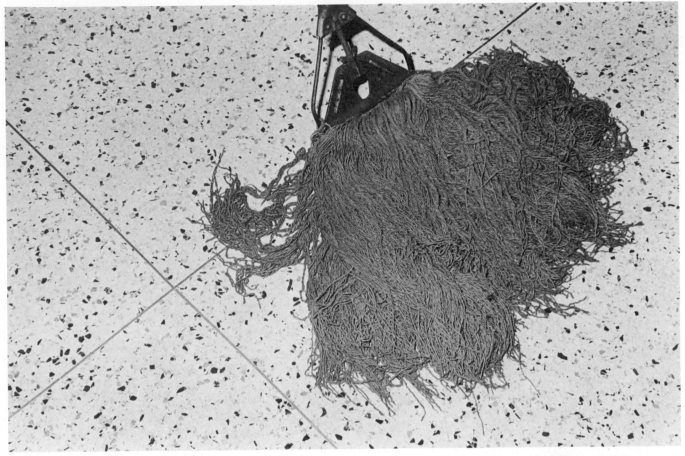

*A guide number calculation pro-
duced the correct f-stop for this gray
mop on a nearly white floor.*

*An exceptionally dark subject such
as this antique car fender will gen-
erally require an exposure increase.
Since the basic guide number calcu-
lations do not take into account dif-
ferences in subject reflectivity, the
photographer added two f-stops of
light to this exposure.*

the flash as a bounce light or indirect light source, you need an exposure increase. Calculate the exposure based on the total distance the light travels from the lamphead to the reflective surface and then to the subject. Depending on the reflectivity of the bounce surface, you may require one to three stops of additional light.

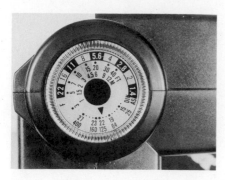

The exposure dial of this Vivitar 283 flash is typical of medium-sized automatic flash units. When you set the dial for a particular film speed, the two effective working ranges of the automatic sensor are clearly indicated by color-coded zones on the dial.

Metric Guide Numbers

Guide numbers and exposure calculations in the United States are based on feet, whereas European calculations are based on meters. Metric calculations result in numerically smaller guide numbers; however, f-stop calculations are identical for both systems. You can use the following formula to convert metric guide numbers to guide numbers based on feet:

$$GN \text{ (feet)} = \frac{GN \text{ (metric)}}{.3048}$$

Calculator Dials

Most flash units incorporate a calculator dial which can be set on a given ASA to compute a working f-stop. In addition to this basic information, the working ranges for the automatic setting on units equipped with an automatic sensor are indicated by some dials.

Illuminated dials are available on some models and can be most useful when you are working in near-total darkness. These dials are illuminated by a small neon light, which draws very little current. You can use the lighted dial as a visible focus point in total darkness: have an assistant hold the flash off-camera at the subject location as you focus on the glowing dial.

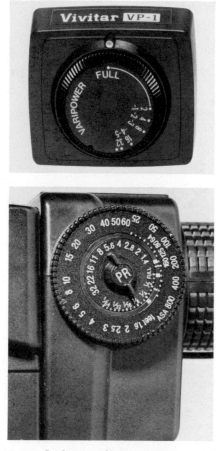

Some flash units have a built-in variable power control dial while others offer a power control accessory which is simply plugged into the flash unit.

Variable Power for Exposure Control

Some flash units are equipped with a variable power output. This feature enables you to control precisely the duration of the flash and the light output. Reducing the power by one-half results in a one f-stop reduction in the light. Each 50 percent reduction in power is similarly equal to an additional one f-stop decrease in light output. Some variable control units offer a six-stop range. Flash durations are also directly related to power output and are shortened by approximately 50 percent with each 50 percent reduction in power. Flash durations as short as 1/50,000 second can be attained with some variable power control units.

It should be noted that most studio flash equipment and some professional-sized portable flash units maintain a constant flash duration even when the power is varied to control the light output.

Automatic Flash Units

Many of the more sophisticated EF units now incorporate a sensor that measures the amount of light being reflected by the subject during the flash exposure. When the lamphead has emitted enough light for a proper exposure, the sensor automatically limits the light output. This function eliminates the need for the photographer to calculate the precise exposure for a given distance range. It also may conserve some of the energy in the capacitors. The automatic mode of a flash designed with energy-saving circuitry will extend the number of flashes for a fixed electrical supply, and recycling may require less time when the flash is operated in this automatic mode.

The light sensor on the automatic flash unit is generally equipped with aperture stops which you must preset to program the sensor for the anticipated distance. You can then properly expose subjects of varying reflectivity without further adjusting the camera aperture.

Although most automatic flash units rely on a thyristorized design, some do not utilize energy-saving circuitry. Ideally, the flash should be cut off when the proper light level is reached so the remaining current is left in the capacitor for the next exposure. However, some circuits divert or dump the excess electrical energy, which cannot be recovered.

Dedicated Flash and Programmed Flash

The terms *dedicated flash* and *programmed flash* describe flash units that are designed to operate on a particular camera. These special camera-and-flash partners are joined to provide sophisticated automatic exposure control. The camera hot shoe is wired to carry information

This chart illustrates how an automatic exposure flash unit conserves power as you bring it closer to the subject. As you require less of the current stored in the capacitors for an adequate exposure, you shorten the recycling time and increase the number of firings.

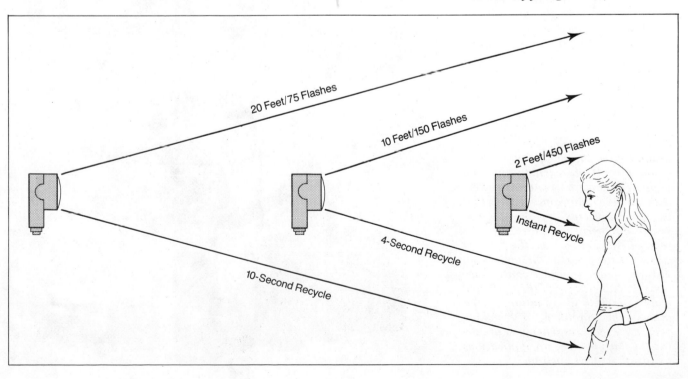

20 Feet/75 Flashes

10 Feet/150 Flashes

2 Feet/450 Flashes

Instant Recycle

4-Second Recycle

10-Second Recycle

Automatic Exposure Control

between the flash and the camera shutter and/or aperture. Various versions of the dedicated flash concept are based on two exposure control systems:

1 The flash automatically sets the shutter for synch and automatically sets the aperture when the camera is focused.

2 A through-the-lens meter in the camera monitors the light from the flash exposure and halts the light from the flash when enough light has reached the film for a correct exposure.

Originally designed solely for hot-shoe operation, dedicated units that you can operate off-camera by using a special connecting cord attached to the hot shoe are now available. You can also use most dedicated flash and camera pairs in a normal automatic flash mode.

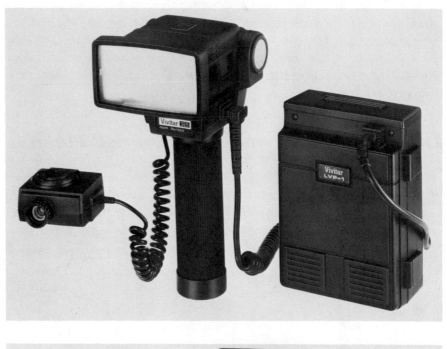

A remote light sensor provides an accurate automatic exposure reading. This unit has a sensor that you can carefully aim at the most significant part of the subject. You can adjust the lens on the sensor to match the response angle of the sensor to the angle of light output of the lamphead. This type of sensor is ideal for bounced-light applications or close-up subjects, and you can place it close to the subject when space is limited.

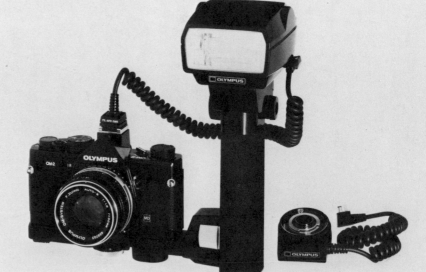

A dedicated flash unit simplifies the problem of accurately measuring the amount of light reaching the film plane. The camera's metering system monitors the light from the flash that is being reflected by the subject. When a correct exposure level is reached, the circuit in the camera turns off the light in the lamphead. This automatic exposure control system provides through-the-lens control of the flash illumination. It simplifies the problem of making accurate exposures when you are using the flash in close-up applications or in off-camera positions.

The Automated Flash Lens

Some lenses are designed to simplify the problem of calculating a flash exposure. A guide number scale is coupled with the aperture ring. You set the lens with the flash guide number, and as you focus the lens on the subjects, the aperture automatically adjusts for the correct exposure. You must position the flash on the camera with this lens system.

The Limits of Automatic Flash

Unfortunately, the automatic flash sensor cannot cope with every flash-lighting problem. Since the automatic flash exposure is based on the reflected light from the subject, the eye of the sensor must be accurately aimed at the subject. If you use the flash to bounce light on the subject, you must position the sensor independently to read the light correctly.

Some automatic flash units feature a sensor that can be connected with a cord when you use the flash off-camera. You can then mount the sensor on the hot shoe of the camera to ensure that the camera lens and the sensor are aimed at the same area of the subject.

The following lighting problems may require a manual flash operation:

1 Subjects beyond the optimum range (generally twenty-five feet) of the automatic mode.
2 Subjects too close for an accurate sensor response. The sensor will create a very short flash duration at close range. With some color films, this may result in a reciprocity problem. Move the flash slightly away from the subject and use the manual mode to avoid this color shift toward blue.
3 A white-on-white subject, which is difficult for the sensor to interpret. Underexposure is generally the result with automatic flash.
4 A small, dark subject on a large, light area which will cause the sensor to overreact and prematurely shorten the exposure.
5 The angle of view of the lens, which may not adequately match the angle of view of the sensor. The typical sensor has a measuring angle of about 11°. There are some sensors that are designed with a variable angle of view; however, a manual flash mode may prove best with extremely long or short focal-length lenses.
6 Using two or more EF units off-camera; the sensor may overreact to the cross lighting.
7 Essential parts of the subject that are at significantly different distances from the flash. The foreground subject may dominate and limit the light before the more distant part of the subject is properly exposed. Use the manual mode and move the light away from the subject to increase its depth.
8 Highly reflective surfaces in the subject area.

Since the main subject was well beyond the range of the automatic sensor of the flash, the photographer used a manual setting. The 17mm wide-angle lens included more of the arena than the flash could illuminate, so she aimed the light from the flash at the foreground and bounced it onto the skater. The ambient fluorescent lighting was bright enough to contribute a linear pattern in the final composition.

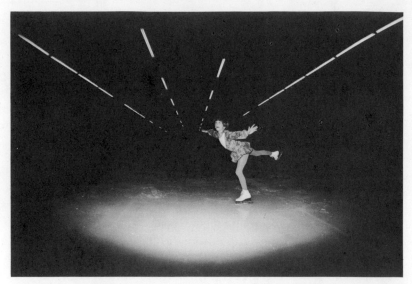

Colleen Chartier, *Ice Skater,* 1977

The automatic sensor of the flash reads the light reflected by the closest parts of the subject. You must use a manual flash setting if your photographic concept requires an overexposed foreground area.

David Dubuque, *Untitled,* 1978

The photographer used an off-camera flash in this exposure to avoid reflection of light in the car windshield. Photographing subjects in near-total darkness requires a preset focus and f-stop. An outdoor subject may also require an increased exposure of about one f-stop to compensate for the limited reflective surfaces.

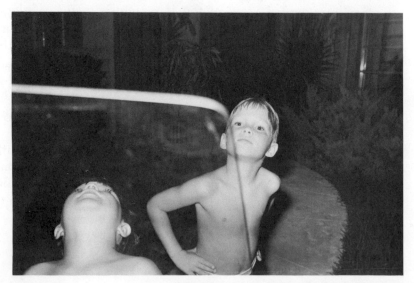

Dave Read, *Michael and Stephen Derrickson,* 1977

58

It is relatively simple to calculate a flash exposure based on the light from a single flash unit by using the guide number formula. It becomes more difficult to determine the proper exposure when you use two or more flash units, when you use cumulative flashes to build an exposure, or when you bounce the light onto the subject. Since ordinary hand-held light meters and built-in camera meters are not usually designed to measure the brief, intense light of the flash, you may at times find it practical and necessary to use a flash meter for accurate light measurement.

Flash meters in both the needle-movement and the digital designs are similar in size and operation to conventional light meters. Some meters read either incident or reflected flash illumination. Several of the more sophisticated flash meters provide a cumulative light reading from successive firings of the flash lighting. Some meters are designed to respond to both the flash and the existing ambient light when you must calculate a combined lighting exposure.

Taking a flash meter reading requires test-firing the flash lighting. A meter designed for one-hand operation incorporates a test-firing switch and a PC trigger cord which connects to the PC outlet of the flash unit. An incident or reflectance reading then registers as you fire the flash lighting conveniently from the meter position.

Flash meters are also designed for cordless operation. In this mode, you switch on the meter and aim it for the light reading. The meter remains on for a brief period while you fire the lights.

The operating and design features of some of the current models of flash meters are further described in Chapter 9.

Flash Meters

Some flash meters are designed for use with or without a triggering cord. With a cord, you can fire the flash lighting from the meter location in a one-hand operation. The cordless mode frees the photographer to move about but requires a separate triggering action.

Special Exposure Problems

Determining Exposure for Multiple Flash

All flash units in a multiple lighting setup should be set on the manual mode. You should always consider reflectivity of the subject and the environment, but you can calculate a basic exposure for the flash that is largest and closest to the subject. There is very little cumulative effect when several flash units of equal output are aimed at the same subject from different locations. Using matched EF lights may simplify the exposure calculation. Adding a second flash unit of equal power at the same flash-to-subject location will add one f-stop of illumination. A third EF unit will add another half f-stop for a total of three times (one and one-half f-stops) more illumination.

Adding a second light to a main light will have little or no effect on the basic exposure in the following situations:

1 Back lighting
2 Bouncing the second light against the wall or ceiling
3 Using a second light with one-half the power of the main light
4 Covering the second light with a handkerchief or covering one-half the lamphead with your hand

When you synchronize several different flash units with different guide numbers to illuminate separate parts of a large subject such as an interior, you should choose a basic f-stop and divide each guide number by this f-stop to determine the flash-to-subject distance for each flash. A quick-developing test exposure (such as Polaroid) is also useful for evaluating a multiple flash exposure, since it enables you to check light levels and light positions quickly; however, an electronic flash meter is the ideal instrument for determining the exact exposure for a multiple lighting setup.

Building the Light and the Intermittency Effect

When you fire a flash unit repeatedly from one position to build the light for a single exposure, there may be some loss of light due to the intermittency effect, because of the increments of exposures. Theoretically, if one flash firing provides an exposure of f/8, a reduction of the aperture to f/22 should require eight times more light or eight firings of the flash unit. In practice, you will find that two additional flashes, for a total of ten firings, are needed. The two added flashes compensate for the intermittency effect. This effect varies with different film emulsions and you should conduct tests to determine how many additional flashes are required for a given exposure.

Flash Direction and Light Level

The light from the flash lamphead is highly directional, so the angle made by the lighting axis and the camera axis is an important deter-

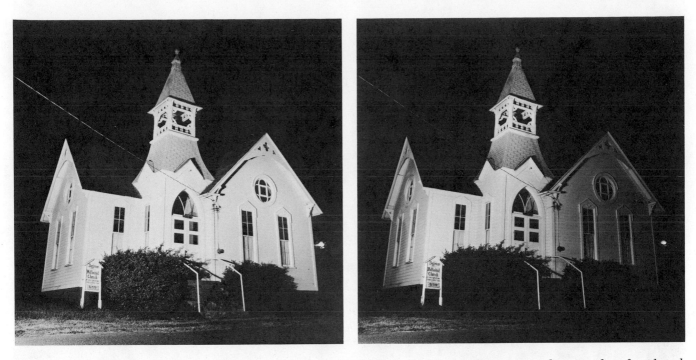

minant of a flash exposure. The basic guide number exposure calculation assumes a frontal or near-frontal lighting position. As you move the light source off-camera and away from the camera axis, you must increase exposure accordingly. An additional half stop is needed when the light falls on the subject from an angle of 45° to 80°. A 90° angle (side lighting) will generally require at least a one f-stop increase, while 180° or back lighting can mean a two f-stop increase.

Reciprocity Failure

The proper exposure for any photographic emulsion is defined by the reciprocity law: exposure = intensity × time. With abnormally long or short exposures, this reciprocity formula may not apply. One unit of light exposing the film for one hundred seconds does not produce the same exposure as one hundred units of light falling on the film for one second, although mathematically these two exposures would appear to be equal. *Reciprocity failure* is a term used to describe the exposure extremes for which the reciprocity law may not apply.

A typical electronic flash firing illuminates the subject with a powerful light for about 1/1000 second and seldom causes a reciprocity problem. Even shorter flash durations, up to 1/50,000 second, are possible with EF units operated in the automatic mode. These brief durations can result in negatives that are underexposed and low in contrast. If you cannot lengthen the flash duration of a single firing, you must increase the exposure by opening the aperture, use a faster film, add supplementary light, or increase development time. Repeated firings of the flash are not an efficient way of solving the reciprocity problem, because extending the time of exposure without increasing the light intensity makes reciprocity failure more likely.

Colleen Chartier, *Ship,* 1978

This photograph of a ship's prow illustrates how frontal-flash illumination is affected by changes in subject position. Surfaces of the subject that are perpendicular to the lighting axis reflect the most light. Since the light is directed away from the camera as the subject bends away, you can use flash on-camera lighting to produce a soft dark-to-light rendition of a curved subject.

Using Flash with Color Film

Color Temperature
Special Color Problems

Richard Nicol, *Untitled*, 1979

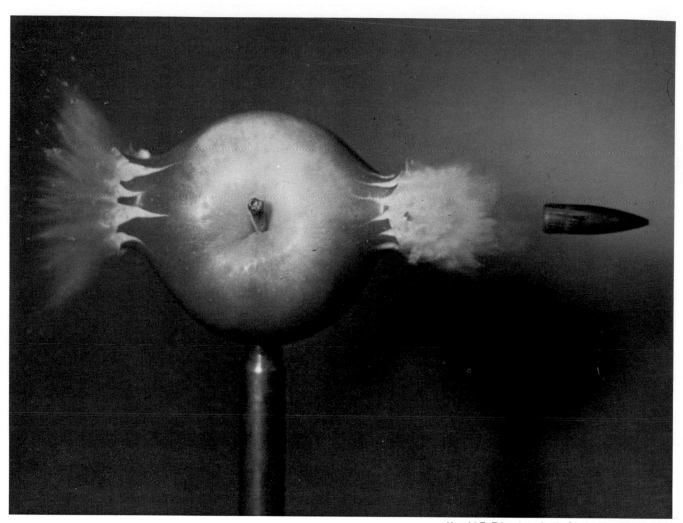

A high-speed microflash stroboscope was used to arrest the movement of this bullet blasting through an apple. The flash duration of 1/3 microsecond froze the 900-meters-per-second speed of the bullet. The photographer used a sound-triggering device and a microphone to synchronize the burst of the flash with the precise position of the projectile. You can vary the distance from the microphone to the rifle to control the timing of the flash. Dr. Edgerton's bullet photographs are classic examples of how electronic flash extends the limits of natural vision.

Since most underwater photographs require artificial light for an accurate color exposure, flash lighting has become the preferred tool of underwater photographers. You must understand special techniques before you can achieve predictable results with flash illumination in water.

64

Craig Hickman, *Untitled*, 1978

The photographer used a combination of flash and ambient sunlight to expose this pair of peeling eucalyptus trees. The color temperature of the flash illumination generally matched the color of the daylight; however, the flash lighting created a unique light direction which would have been difficult to obtain with existing natural light.

Craig Hickman, *Untitled*, 1978

This photograph shows how the descriptive, sometimes medical, connotation of the on-camera flash technique reinforces the photographer's point of view. Fill flash eliminated the usual cast shadows of the hair on the back and created a nearly clinical contrast between the color of the skin and the hair.

65

Anne Wertheim, *Intertidal Nudibranch,* 1979

A small portable flash unit was used for this tide pool close-up photograph. The flash was positioned off camera and aimed at a 45° angle with the water surface to minimize reflections.

Richard Nicol, *Untitled*, 1979

Above: These miniature horses are one of a series of photographs of plastic toys by photographer Richard Nicol. Since he photographs his subjects as he finds them, he uses the flash to overcome the limits of low-level lighting and to insure a strong rendition of color. The single light source often places the image in a documentary context.

Richard Nicol, *Untitled*, 1979

Left: On-camera flash lighting and color film can be an effective combination with subjects that offer distinctive color shapes or patterns. The frontal lighting in this photograph of yard sculpture flattens shapes and emphasizes the color contrast between the grass and the deer.

Craig Hickman, *Untitled*, 1978

The intricate detail of the hair on this baby's head required a simple on-camera flash technique. The flash minimized additional shadows to keep attention and interest on the pattern of the shirt and the strands of hair. The illumination level also insured an adequate depth of field.

This interior color photograph illustrates how you can filter basic flash lighting to match the color temperature of fluorescent lighting. The photographer taped green filter sheets over the flash lampheads. He needed a CC30M (magenta) filter on the lens to correct the inherent greenish cast of the fluorescent lights. Because of the size of the room, he used two 1200-watt power packs and fired the units three times to build the needed cumulative exposure. A relatively slow one-second shutter speed allowed for a full exposure of the fluorescents. The photographer shot at night to avoid the problem of daytime ambient light. The flash lighting was bounced off the ceiling to approximate the softness of existing artificial lights.

Bill Aston, *Interior*, 1978

68

 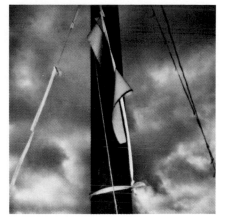 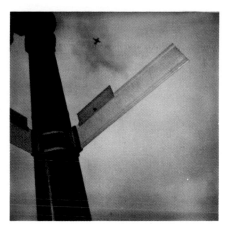

This set of three out-of-door SX-70 color photographs combines both the late day ambient light with the foreground light from the on-camera flash. The automatic exposure control system of the camera produced a near perfect balance between the exposure of distant and foreground areas of the composition. The final set of prints was copied on color film and reprinted to alter slightly the original colors.

 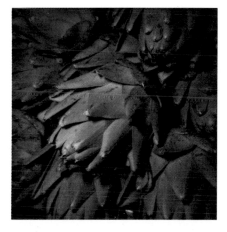

This series of photographs taken at Seattle's Pike Place Market demonstrates the effectiveness of the fully automatic exposure controls of the Polaroid SX-70 camera and flash. The circuitry of the flash and camera are linked to monitor the light from the flash. The accurate exposure system produces fully saturated color of subjects that vary in hue and reflectivity.

Electronic flash lighting is preferred by most portrait studios. A high light level can be achieved without the uncomfortable heat associated with tungsten lighting. Lighting arrangements require fewer lights when bounceboards are used. Photographers often use a large umbrella to eliminate harsh shadows. The contemporary style of these portraits depends on an informal pose and the creative placement of a single main light.

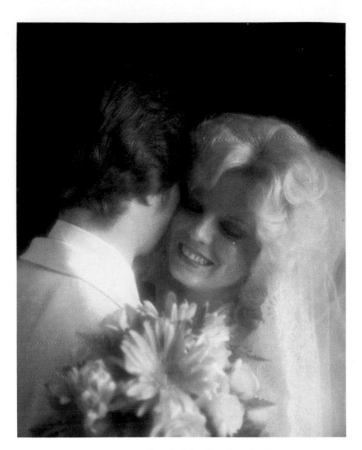

Courtesy of Yuen Lui Studios, Seattle, Washington, 1979

Courtesy of Yuen Lui Studios, Seattle, Washington, 1979

Courtesy of Yuen Lui Studios, Seattle, Washington, 1979

An accurate color photograph depends on the mixture of various wavelengths of light that were used to illuminate the subject when the photograph was taken. Color temperature is a measure of the wavelengths in a light from a given source. Since the color of the light varies with the temperature of the source, color temperature is measured on a scale that begins at absolute zero (−273°C) and is stated in degrees Kelvin (K), named after British physicist Lord Kelvin.

The filament of a lightbulb emits light as it is heated by electricity. The hotter it gets, the whiter the light it emits becomes. Sources of photographic light range from the relatively warm glow of a candle (2000 K) to the intense blue-white light of a welding arc (6600 K). The overhead noonday sun provides a light of about 6000 K.

Most flash units are designed to produce a light of 5600 K to 6000 K, which matches the requirements of daylight color films. Since flash and sunlight are similar in temperature, you can effectively combine flash with sunlight for a single exposure. The terms *synchro sun* and *fill flash* are commonly used to describe such combined lighting exposures.

Filters to Modify Color

It is possible to modify the color balance of the light from the flash by using filters either on the camera lens or over the face of the lamphead.

There are three basic types of filters that you can use with flash and color film exposures:

1 *Color Compensating Filters* (CC filters) are available in a choice of densities in any of six colors. The CC filters change the overall color balance of the photograph by compensating for specific deficiencies in the light.
2 *Conversion Filters* are designed specifically to change the color temperature of a standard known light source (for example, tungsten, daylight, fluorescent, or photoflood) to match the requirements of a particular color film.
3 *Light Balancing Filters* are designed to change the color quality of the light by adjusting the entire spectrum of the light toward either a warmer (yellow) or cooler (blue) color temperature.

You can place any of these filters directly over the lamphead of the flash if the flash is the primary light source. You can also use filters in combination by placing one filter on the flash and another on the camera lens.

The CC10 series filters normally require a one-third f-stop increase (refer to the Kodak *Data Guide for Color Films*, publication E-77). The numbers in the filter designation indicate the density of the particular color, and the final letter in the code number indicates the color (cyan, magenta, green, yellow, red or blue) of the filter. Thus, a filter listed as a CC10Y is a .10 peak density yellow color compensating filter.

Color Temperature

The final color quality of a particular exposure depends on both the characteristics of the emulsion and the spectral balance of the light produced by a particular flash unit, plus any lens filtration. Facsimile color quality may require testing a specific film emulsion and the unique color balance of a given flash unit (with lens filter, if used). Identical models of a particular flash unit may differ slightly in the color temperature of their light output.

Try to use the minimum number of color correction filters over the lens to avoid excessive exposure increases and loss of sharpness associated with additional air-to-surface relationships. (Additional data about Kodak filters can be found in Kodak publication B-3, *Kodak Filters for Scientific and Technical Uses.*

Color Temperature Chart

SOURCE	COLOR TEMP (°K)
Candle	2000
100-watt incandescent bulb	2850
Photoflood bulb	3400
Clear flashbulb	3800
Electronic flash	5500–6000
Daylight (high noon and clear)	6000
Arc welding light	6600

Modeling Lights and Color Balance

Studio flash lampheads generally incorporate a tungsten or quartz continuous lightbulb which the photographer uses to approximate the direction and quality of the flash lighting. Unfortunately, the color temperature of this continuous lighting does not match the higher color temperature of the flash. If you make exposures on color film with slow shutter speeds, the light from the modeling lamps, in addition to that of the flash exposure, may register on the film. The problem is negligible if you consistently leave the modeling lights on or off for all of the exposures. You can also avoid the problem if you always use a shutter speed that is fast enough to eliminate the effect of the modeling lights.

Color Crossover

Color film combines three separate emulsions. A normal exposure should accurately render both the color and the value of the subject. Very brief or extended exposure times may produce deviations in the characteristic response of the individual color layers of the film. The term *color crossover* is used to describe this color shift in areas of over- or underexposure (such as shadows or highlights). It is difficult to correct the color shift without affecting the colors in the properly exposed areas. Most manufacturers can supply information on the exposure limitations for their color films that details the limits on light duration and shutter speed for a given emulsion.

Reciprocity Failure and Color

Color films are generally more subject than black-and-white emulsions to reciprocity failure. An electronic flash duration of less than 1/20,000 second can affect the three color emulsion layers differently, and you may require compensating filters to maintain an accurate color balance. An increase of blue in a color photograph may occur when you are using an automatic flash unit close to the subject. As the sensor drastically decreases the flash duration to achieve a proper exposure, a slight reciprocity effect may occur. You can sometimes solve this particular problem by setting the flash on manual and using another method to decrease the light output. (Kodak data charts on reciprocity exposure corrections are included in the reference section.) Tests with a given flash unit and film emulsion may also be necessary to eliminate subtle color shifts.

Flash Duration and Color Shift

The flash tube normally contains xenon gas, which must be ionized to create a light of the desired color temperature. As the triggering current ionizes the gas, it creates the blue portion of the spectrum first. Flash units equipped with automatic exposure circuitry may at times pre-

Special Color Problems

A *typical studio flash lamphead incorporates a modeling light with the flash tube. Although the flash and modeling light have different color temperatures, the relatively low illumination level of the modeling light generally has no effect on the flash exposure. Critical color work at slow shutter speeds may sometimes require you to turn off the modeling light before you make the flash exposure.*

maturely reduce the current density (flow) to the flash tube and halt the ionization before the full spectrum has been achieved. This spectral emphasis on blue is seldom a problem; however, it can occur when you are using an automatic flash unit in an extremely close flash-to-subject setup. Use of a manual flash setting will avoid the color shift.

Ultraviolet

The ultraviolet energy emitted by an electronic flash unit may cause some color shifting toward blue with subjects that tend to concentrate or reflect this portion of the spectrum. For instance, a black suit made of synthetic material may acquire a distinctively blue appearance in a flash color photograph.

A related color aberration may occur with subjects that absorb ultraviolet radiation and reemit the radiation in the form of short-wavelength, visible blue. This ultraviolet fluorescence is typically demonstrated with black-light posters. White fabrics that contain synthetic brighteners may also acquire a blue cast when photographed with the light from an electronic flash.

These ultraviolet effects are not generally visible when you are taking the flash photograph, but they appear in the final print or transparency. You can sometimes avoid the potential problem by conducting a simple visual test with an ultraviolet lamp. An ultraviolet filter placed over the flash lamphead will also eliminate most of the problem.

Mixed Lighting and Flash

A particular color film is usually balanced for one color temperature. Combined lighting sources are best avoided unless you plan a special effect. You may want to experiment with corrective filters on the light sources, the camera lens, or both to achieve the desired match.

When using fluorescent light, you should fit all of the fixtures with one type of fluorescent tube (daylight, warm white deluxe, or cool white deluxe). Fluorescent tubes have a noncontinuous spectrum and are not a first choice for color photography, but you can use them in combination with electronic flash if you add filtration.

Techniques with Flash

On-Camera and Off-Camera Flash

Even at close range, an on-camera flash can prove to be an appropriate lighting technique. Here, the depth of field was essential and the low-level natural light would not have allowed a small aperture of f/16. The directional light of the flash captured the important detail of both the skin and the background clothing. The brief duration of the flash effectively froze any camera or subject movement.

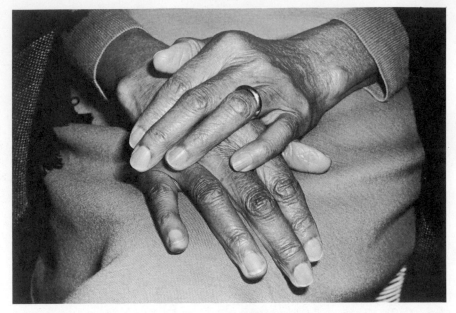

Colleen Chartier, *Elizabeth Cotton's Hands,* 1978

The hot-shoe bracket on the camera provides the most popular and convenient mount for a flash unit. This on-camera position puts the flash nearly on an axis with the lens for a typical frontal lighting direction. It flattens form and minimizes distracting shadows; however, the image of the flash is more likely to produce undesirable reflections on flat, shiny surfaces. This flash position is most useful when you can redirect the lamphead for bounced-flash effects.

A hot-shoe extender is a small device that increases the height of the flash a few inches for a slight off-camera lighting direction. If you move the flash to a higher over-the-lens position, the light will more

An off-camera side lighting is useful for a subject with interesting surface relief or texture. The light from the flash was also feathered across the bathmat and tile floor to insure a more even illumination.

closely approximate the effect of sun or ceiling light. Off-camera lighting angles increase the illusion of depth and form. The highlights and shadows dramatize important surface textures.

An off-camera technique may require a shutter synch cord that connects the flash and the camera. A small electrical current from the flash power source serves as a trigger current. Normally, synch cords up to thirty feet in length will perform quite well; however, it is best to test the synch cord by shorting the contacts.

As off-camera flash positions increase the angle between the lens axis and the lighting direction, the subject reflects less light back to the camera. Side lighting usually requires one additional f-stop of light, while back lighting may necessitate an aperture increase of two to three f-stops for a proper exposure.

Colleen Chartier, *Silver Shirt*, 1977

The photographer used off-camera flash to emphasize the dark folds of this reflective shirt fabric. Because of the shiny surface of the cloth, she needed no increase in exposure for the oblique angle of the lighting.

77

Bounced Flash

Bounced or reflected light is often a part of an indoor flash exposure. You can use the technique of bouncing flash to change the highly directional light usually associated with EF photography.

Bounced flash differs from direct flash in several ways. Bounced flash is less intense. Some loss of light is inevitable because the light is generally traveling a longer distance to reach the subject and a certain percentage of the bounced light is lost and scattered by the reflecting surface. Bounced flash is a softer light. Shadows lose their distinct edges, and the overall contrast of the lighting accordingly decreases.

Bounced light may also assume some of the color of its reflecting surface, so it is important to consider the color of the environment when planning a color flash photo. Reflecting walls and ceilings should be neutral enough to prevent an undesirable color shift. You can use bounced flash to control glaring reflections that often are unavoidable with direct flash, such as those from eyeglasses, mirrors, windows, and polished surfaces.

There are many standard techniques for bouncing the light from the flash. You can aim any EF unit at light-toned walls or ceilings to create an indirect lighting effect. Some units have swivel heads for easy bounce positioning, and others incorporate accessory bounce-card holders.

These diagrams and photos illustrate some of the techniques for controlling the quality of the light from a single portable flash.

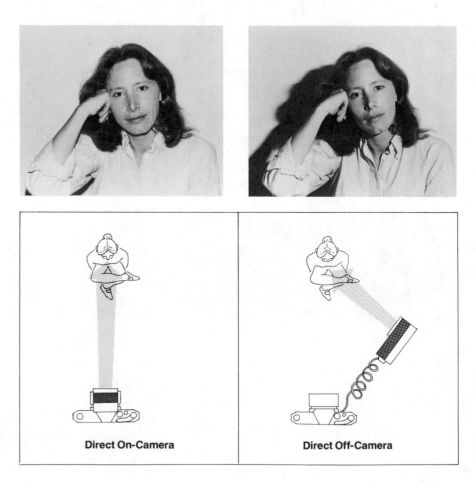

Direct On-Camera **Direct Off-Camera**

78

This office portrait combined outdoor ambient light, interior fluorescent office lighting, and a bounced-flash fill light. The photographer bounced the flash from a white ceiling to eliminate reflections in the eyeglasses and to maintain a soft lighting effect.

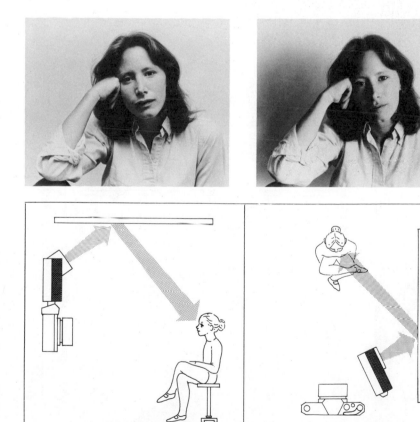

Bounced Off Ceiling

Bounced Off Wall

Bounced Flash

Right: Two flash units directed at the ceiling provided the bounce lighting for this large group portrait. This technique insured even light for each face.

Below: Keep in mind that the bounced light from the flash must eventually find its way onto the subject. These illustrations diagram the most effective way to bounce the flash lighting from a ceiling or wall. The texture and color of the reflecting surfaces will also directly affect the quality and quantity of light.

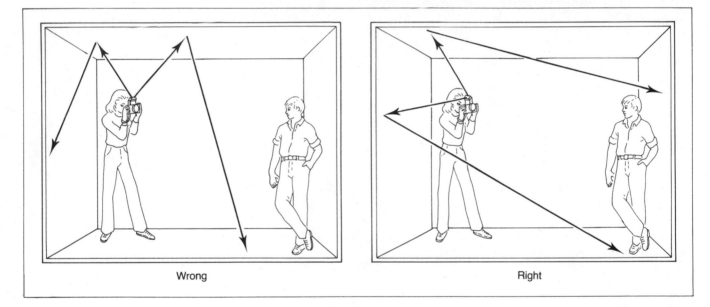

Wrong

Right

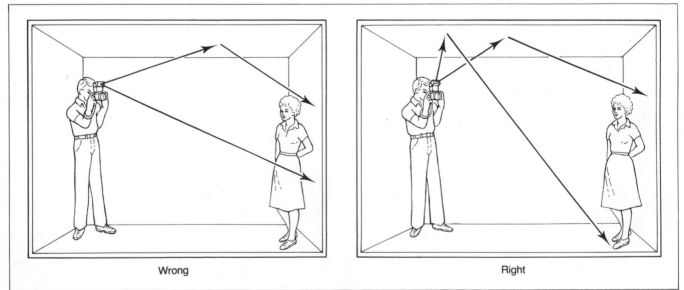

Wrong

Right

How to Calculate Exposure for Bounced Flash

Calculating an exposure for bounced flash can be difficult owing to the variety of possible reflective surfaces. Always try to fire the flash when it is at its maximum power. Test the reflectivity of several common surfaces. Bouncing light from a white living-room wall or ceiling will generally require two or three stops more light than a direct flash exposure will. Remember that the flash-to-subject distance is measured from the lamphead to the reflective surface and then to the subject.

A remote sensor on the flash unit can simplify the exposure calculation. It is imperative to aim the sensor at the subject and not at the reflective surface. Many flash units are now designed so that the lamphead can be swiveled and directed for bounce lighting while the automatic sensor remains on axis with the camera lens. Keep in mind the angle of acceptance of the sensor and direct the sensor toward the center of the composition.

Some flash units are designed with a swivel lamphead which can be directed toward a nearby wall or ceiling for bounced-flash lighting.

Three photographs of pumpkins compare the effects of direct on-camera flash, bounced ceiling flash, and bare-bulb flash.

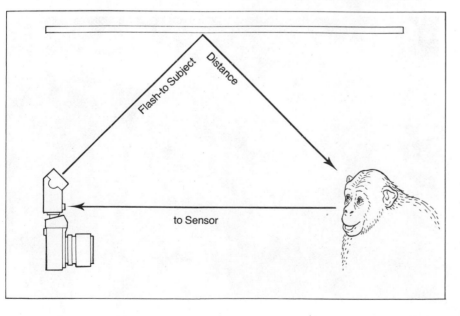

The light-sensitive photo cell of an automatic flash must remain aimed at the subject when you use a bounced-flash technique. Set the sensor for the flash-to-subject distance and not for the sensor-to-subject distance. A lamphead that can be aimed independently of the sensor is essential for automatic bounced flash.

81

Synchro Sun

Various situations may require combining sunlight and the light from an electronic flash for a single exposure. *Synchro sun* or *fill flash* describes the technique of controlling the flash for a predetermined sun and flash lighting balance.

An indoor subject illuminated with flash may also include patches of sunlight or a sunlit view through a window. An outdoor subject in bright sunlight may require additional light to reveal detail in the shadow areas. You can use the same synchro-sun technique to solve either of these lighting problems:

1 Exposure is based on the sunlight. Use a standard light reading to determine the basic exposure for the sunlit subject based on X synch shutter speed.
2 Set the ASA of the film on the flash unit's calculator dial.
3 Locate the f-stop for the sunlight exposure on the dial and note the flash-to-subject distance that is indicated. Position the flash at this distance to balance the flash illumination and the

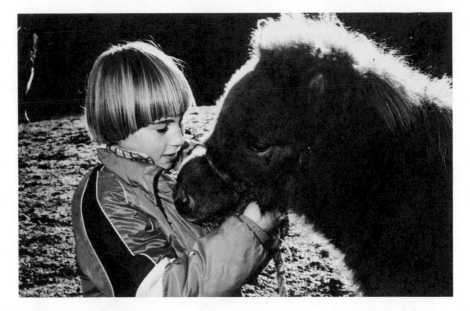

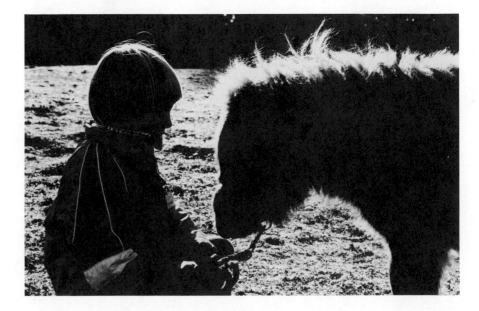

The photographer added the light from a flash unit to the backlit daytime exposure of the boy and the miniature horse to create detail in the shadow areas. The halo of light from the sun is maintained in the flash exposure. The light from the flash has no effect on the more distant background areas of the subject. This exposure required the photographer to set the flash on the manual mode and position it at a distance of five feet from the subject.

sunlit areas in a near 1:1 lighting ratio. (Guide numbers are based on indoor exposures, so outdoor flash may have a slightly reduced effective light output.)

4 For a 2:1 lighting ratio, position the flash at the distance indicated on the dial for the next larger f-stop.

If your flash unit has a variable power control, the procedure for using fill flash is further simplified:

1 Set your camera to the correct f-stop for the brightest parts of the subject, keeping the shutter on the X synch setting.

2 Set the ASA of the film on the flash unit's calculator dial.

3 Locate the f-stop and flash-to-subject distance on the variable power dial to find the exact power setting needed for a 1:1 synchro-sun exposure. Reduce the power setting by one f-stop for a 2:1 lighting ratio.

These photographs taken in a concrete irrigation pipe compare standard back lighting with the effect of on-camera fill flash. Exposure of the sunset is unaffected by the flash. The circular surface of the pipe created some bounce light. The photographer used a 28mm wide-angle lens and a standard flash at a distance of twelve feet.

Synchro Sun

You can best select an outdoor lighting ratio after evaluating the daylight conditions (overcast or crisp sunlight), the type of film you are using, and the lighting effect you require for the photograph. The brighter the sunlight, the greater the need for fill-flash lighting. If sunlight is the key light source, the light from a flash unit can act as fill light to create the desired lighting ratio. If you use the electronic flash as the key light source, the sunlight may function as support lighting in the darker background areas or as fill light.

Although a 3:1 lighting ratio is often used for portraits, soft shadows or a hazy or overcast sky may require a 5:1 ratio to maintain the more delicate dark–light balance. A simple way to produce a 5:1 lighting ratio is to double the guide-number of the flash before calculating the flash-to-subject distance. This will result in a two-stop underexposure for the flash when you make the proper sunlight exposure.

The ratio between sunlight and flash is ultimately a matter of personal preference. Color films often require a ratio of 2:1 or 3:1, particularly if you intend to reproduce the photos. Once you select a synchro-sun flash distance for a specific lighting ratio, the camera-to-subject distance cannot be changed if the flash is camera mounted. You can change the lighting ratio and maintain the original composition if you simply change the focal length of the lens. This method will require a more powerful flash unit for the increased flash-to-subject distance.

A fill-flash lighting technique lightened the disruptive shadows of the leaves across the figure. Excessive light from the flash would have washed out the basic daylight exposure.

The final lighting ratio of a synchro-sun exposure remains a matter of personal preference. The first exposure (above left) was made without flash, while the on-camera flash position of the second exposure (above right) resulted in a moderate fill effect. The flash-to-subject distance of eight feet indicated a difference of one f-stop between the sunlight exposure (f/16) and the indicated flash f-stop (f/11). The photographer made the final flash-plus-sun exposure (left) by detaching the flash from the camera and moving it in for a flash-to-subject distance of 5.6 feet and an indicated f-stop of f/16 for both the flash and the sunlight.

Flash units rated between 2100 and 4100 BCPS are ideal for creating 3:1 or 5:1 synchro-sun lighting ratios. With longer 85mm, 105mm, or 135mm lenses, the increased camera-to-subject distances will require a larger flash in the 3100 to 8000 BCPS range.

Flash as the Key Light

Depending on the quality and quantity of the sunlight, you can also use fill flash to create other combined lighting effects. If you use a

between-the-lens shutter to control the sunlight, you can position the flash to dominate the lighting ratio.

When the weather is gray, you can use the flash to simulate the sunlight. The natural daylight becomes the fill light.

1 Use a standard light reading to determine the basic daylight exposure.

2 Close down the aperture one additional stop.

3 Set the ASA on the flash calculator dial.

4 Locate the reduced f-stop for the sunlight exposure on the dial and note the indicated flash-to-subject distance. Position the flash at this distance to use the flash as a key light.

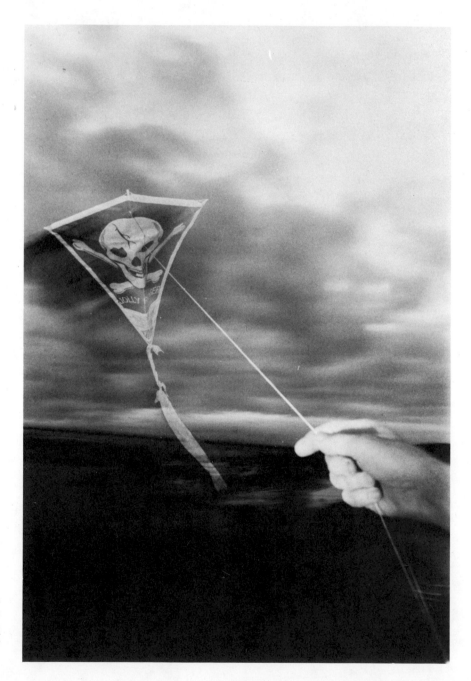

The main light provided by the flash stops the movement of the kite while the slow shutter speed also records the existing daylight as a slurred or double image.

The term *depth of light* is used to describe the zone from the nearest to the farthest parts of the subject that are evenly illuminated by the main light source. You must minimize the depth of light when attempting to darken the background of a portrait, while several rows of people in a group portrait may require you to extend the depth of light to insure that one f-stop will properly expose both near and far faces.

The flash-to-subject distance determines how much of the total light created by the flash will reach the subject. As the light spreads from its source, it decreases or falls off relative to the square of the distance. The inverse square law defines how much of the light remains to illuminate the subject. If a light must travel five feet from the flash to the subject, only $1/5^2$ or 1/25 of the light will reach the subject. A second subject at a flash-to-subject distance of seven feet will receive only $1/(7)^2$ or 1/49 of the same primary light source. Since the 1/25 light level is approximately double the 1/49 light level, the second subject receives one f-stop less light than the first subject does. The falloff of the light has created an exposure dilemma. The depth of light in this example would be inadequate for a single correct exposure of

Depth of Light

Controlling depth of light: (a) A subject at five feet from the light source receives 5^2 or 1/25th of the light from a point source (below left). (b) A subject at seven feet from the same light source receives 7^2 or 1/49th of the light, which indicates a one f-stop difference in exposure (below right). (c) If the light is moved an additional five feet away from the subjects, the exposure difference is reduced to one-half f-stop (bottom).

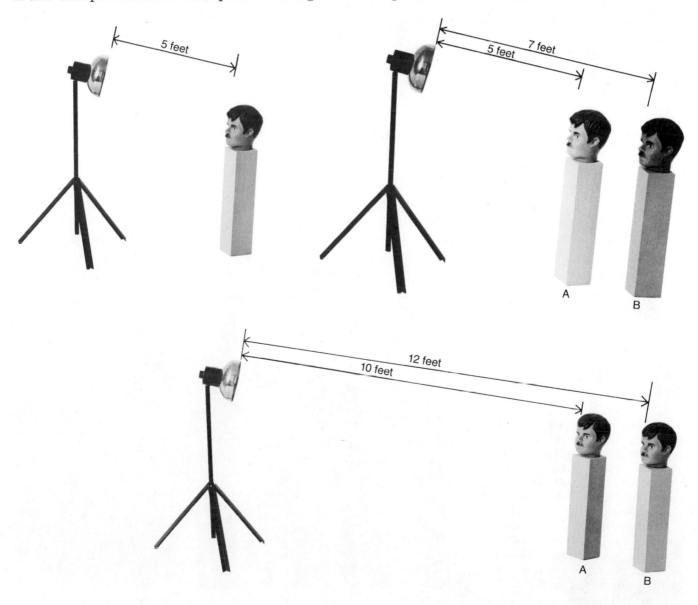

Depth of Light

both subjects. (Condensed from *The Battle Between Depth of Light and Depth of Field*, by Bill Norman.)

The depth-of-light problem can be solved in several ways:

1 Move the subjects closer together to minimize the falloff.
2 Feather the light away from the near subject, which increases the light on the farthest subject.
3 Move the light farther away from both subjects. (The illumination difference between the two subjects in the preceding example, at five feet and seven feet from the light, will be reduced one-half stop if the light is moved away an additional five feet to create ten-foot and twelve-foot light-to-subject distances.)
4 Bounce the light into an umbrella to increase the light-to-subject distance.
5 Use an additional light to boost the light on the second subject.

When you solve the depth-of-light problem by increasing the light-to-subject distance, you must increase the f-stop to maintain the same exposure. The larger f-stop means less depth of field and may present a focus problem. The light level can be increased to restore the smaller f-stop.

A one f-stop increase of illumination will require that you do one of the following:

1 Double the watt-second power level of your flash unit.
2 Mount a more efficient reflector on the lamphead.
3 Add a second flash unit of equal power.

Some situations may require a decrease in the depth of light. For example, the background may present a problem when you are photographing a low-key portrait. To minimize the effect of the main light on the background, move the light closer to the subject (the background will become darker as the depth of light is decreased), or move the subject closer to the light and farther away from the background.

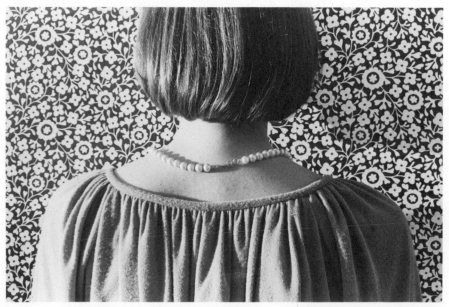

The photographer achieved a correct exposure for both the background and the figure by increasing the flash-to-subject distance and increasing the depth of light. Since the space was limited, she bounced the flash into a large nearby mirror to redirect the light. The exposure calculation was based on this extended flash-to-subject distance. The shoulders and the wallpaper were within the range of an f/11 exposure.

Colleen Chartier, *Jo's Neck,* 1977

The light from the flash can be diffused in a number of ways. You can purchase accessories for a flash unit that can be fitted over the lamphead to scatter the light. There may be a one f-stop light loss with these devices, but they are useful for:

1 Softening the light from the flash when there is no nearby wall or ceiling for bounced flash.
2 Increasing the angle of light output from the lamphead to match a wide-angle lens.
3 Eliminating a hot spot in an uneven flash pattern.
4 Reducing the light output from the flash.

Diffusion devices may also be improvised. You can tape a plastic cup or white plastic spoon over the lamphead, or separate the plastic eggs sold at Easter to make two diffusers. A basic white handkerchief folded into various thicknesses efficiently controls the quality and intensity of light. Exposure is decreased by one f-stop for each thickness of cloth. Conduct a few tests to determine how much light is lost for a given diffusion material.

Diffusing the Flash

You can hold a translucent material such as a handkerchief, lens tissue, or Styrofoam cup over the flash lamphead to diffuse the light.

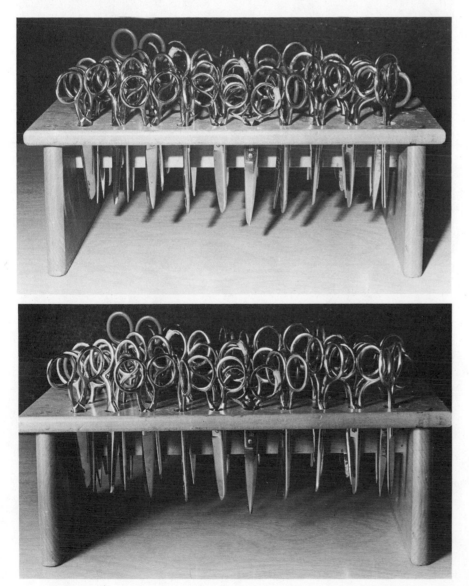

The photographer made exposures of this rack of children's scissors with direct on-camera flash and a piece of lens tissue over the flash to soften the shadows. The diffused flash required a one f-stop increase in exposure.

89

Umbrella Reflectors

You can soften and diffuse the harsh, direct light from an electronic flash unit by aiming the lamphead into a white umbrella and bouncing the light onto the subject. The umbrella serves as a portable and easily adjustable surface that has a predictable reflectivity. It is primarily a studio accessory, since even a gentle outdoor breeze can overturn the average light stand.

Photographers often use an umbrella to simulate the soft-edged shadows of north light. The wide, even coverage of umbrella light makes placement of the light less critical. Umbrella light works particularly well when you must quickly change camera angles.

Umbrella techniques are ideal for small or cramped shooting areas. The umbrella becomes a portable wall extender when you use it to increase the flash-to-subject distance. The amount of light on the subject is reduced, but the depth of light is increased. The umbrella eliminates hot spots, red eye, and heavy shadows.

Umbrellas are manufactured in a variety of styles and surfaces, each designed to solve somewhat different lighting problems.

The photographer illuminated this portrait with a single thirty-inch curved white umbrella at a distance of six feet. The north-light effect is easily achieved with a sufficiently large umbrella. Although the light is soft and has some wraparound effect, it is still directional and delineates the small surface detail of the skin. The soft effect depends on the diameter of the umbrella-to-subject distance, and the surface of the umbrella.

A small-sized, highly reflective umbrella will produce a more direct and harsh light.

Umbrella Shapes

The round umbrella is the most popular. It produces round catch lights and its curved ribs create a stronger wraparound effect than the square umbrella does. The angle of coverage is more precise and enables you to feather the light with more control.

The square umbrella produces a square catch light which may simulate the reflection from a rectangular window. The flat ribs of the square umbrella produce the widest angle of coverage. Partially opening some square umbrellas controls the angle of coverage and light output. Opening the umbrella to its full extension creates the widest angle of coverage and the lowest light output.

Hexagonal umbrellas are also available. The hexagonal shape combines advantages of round and square umbrellas.

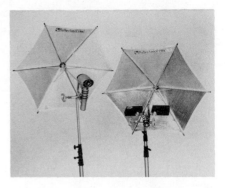

These Reflectasol-Hexumbrellas demonstrate how brackets can accommodate different lighting units.

Bringing the umbrella relatively close to the subject heightens the wraparound lighting effect.

Fabric and Color

The fabric covering on the umbrella governs the light it reflects or transmits. White translucent cloth is a good all-purpose covering. It produces a softer light than does a silver umbrella of the same size. The light loss with a typical white umbrella when compared to direct EF light with an average reflector is about two f-stops. The translucent fabric can serve as a diffusion screen when you aim the flash directly through the umbrella toward the subject, but this translucence may also pose a problem if the directly filtered light causes lens flare.

Silver fabric is available in several types of reflective surfaces. Silver surfaces are generally more reflective than white fabrics, and their light is accordingly harsher than that of a white umbrella of the same size. Because the silver reflects more light, its light loss is only about one-half to one-and-one-half stops less than direct light. Silver umbrellas do not transmit light.

Silver umbrellas are sometimes tinted with a cool or a warm tone to alter the color balance of the reflected light. Portrait photographers often prefer the warm tone.

Umbrella Size

The larger the umbrella, the softer the light: a large umbrella literally envelops the subject in light that is without cross shadows. A large umbrella requires a large EF light source. Since you must place the lamphead at an optimum distance from the umbrella in order to utilize the light fully, the light output must be adequate for the diameter of the umbrella. If the lamphead is too close to the umbrella, there will be less coverage and the light will be harsher.

Small umbrellas generally produce a harsher light than do large umbrellas. If an umbrella is too small for the lamphead, the EF unit's reflector will block the bounced light, creating a void in the beam of reflected light; you will lose a significant amount of light. A black shadow in the center of the catch lights may indicate that the umbrella is too small.

Advantages and Disadvantages of Using an Umbrella

ADVANTAGES	DISADVANTAGES
Controls direction and reflection of light	May require a higher light output from the EF unit than you need when using the light directly
Creates a soft and even light	
Minimizes lighting equipment	
Minimizes blemishes and related re-touching	May lack the controls offered by barn doors, snoots, spotlights, etc.
Assures a predictable and correct color balance	Hard to use outdoors on windy days
	Modeling lights may be too dim for use with umbrella

Using the Umbrella

The ideal position for the umbrella is on an axis with the reflector on the flash lamphead. For this reason, some reflectors are designed with a hole so that the photographer can attach the umbrella handle at a nearby perpendicular angle with the reflector. When you use an umbrella outdoors, you must mount it on a stand that is heavy enough to resist the push of even a slight breeze.

A round umbrella with curved ribs may cause the bounced light to converge on a focal point. If you have positioned the subject at this focal point, you may partially lose the soft effect of the umbrella. Highly reflective silver umbrella coverings are most apt to produce this problem. Test various positions with your umbrella and EF light to determine if the umbrella is creating a focal-point problem.

Bounce-Board Reflectors

A bounce board is simply a sheet of stiff white or silvered cardboard that you can use as an adjustable, portable reflective surface. The bounce board redirects light from the main flash to add fill light to the shadow areas. The closer the bounce board is to the subject and the farther away the flash is, the more distinct the shadows will be. The bounce-board light is more directional than most umbrella light.

Calculating Umbrella Exposure

When you bounce the light from the flash onto the subject, a predictable loss of light always occurs. The umbrella increases the flash-to-subject distance and spreads the light over a larger area. Depending on the surface and color of the umbrella, you must add two f-stops of light to the basic flash exposure.

Since the umbrella is not a point light source, an electronic flash meter is the only completely accurate way of determining the exposure. Tests with quick-developing film can also be useful in selecting the proper f-stop. Try to establish a constant distance between the flash lamphead and the surface of the umbrella. Some studio photographers mark the shaft of the umbrella with tape and tie a string to the shaft to simplify positioning the subject at the correct distance.

Suggested Exposure Factors for Umbrellas*

SHAPE	DIAMETER (In Inches)	FABRIC	LIGHT DIRECTION	LIGHT REDUCTION
Round	28	White/translucent	Bounce	2 f-stops
Round	44	White/translucent	Bounce	2 f-stops
Round	56	White/translucent	Bounce	2 f-stops
Round	72	White/translucent	Bounce	2 f-stops
Square	27	Silver	Bounce	1½ f-stops
Square	36	Highly reflective silver	Bounce	½ f-stop

* With most studio lights using a 60° reflector.

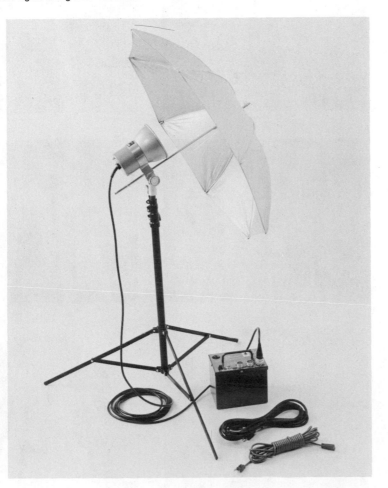

It is important for the light stand to be designed so that it can adequately support the typically top-heavy assembly of an umbrella-equipped flash unit. You may at times need to attach a weight to the legs of the light stand to counterbalance the umbrella.

Painting with Flash

You can fire a flash unit repeatedly from different locations to build or paint a single exposure. This "painting with flash" technique is often used to illuminate a large subject at night or to light a large interior space evenly.

The procedure is simple. Mount the camera on a sturdy tripod located on a solid, vibration-free floor. Do not wire the flash unit to the camera, but instead hand-hold it and fire it with the test button. Reduce or eliminate ambient light during the flash exposure to avoid an overexposure of normal light sources. To minimize possible camera movement, do not replace the lens cap between flashes. If an assistant fires the flash, you can protect the lens from stray light between flashes with a piece of black cloth. For uniformity of exposure, fire each flash at about the same distance from the primary subject or walls. To avoid flare, do not fire the flash on a direct line of sight with the camera.

You should fire two flashes from each flash location to compensate for any intermittency effect or slight change in reciprocity due to interrupted exposure. With black-and-white photography, this effect is negligible. With color film, a slight increase in exposure may be needed (generally not more than a third of a stop).

The daylight photograph of a water tower can be compared to a series of nighttime images that illustrate various techniques of painting with flash. The form of the tower changes as the photographer uses different groupings of flash firings: (top left) one firing of the flash on full power; (top right) four firings of the flash on full power; (middle left) painted from four positions inside the center area; (middle right) painted from the sides and rear; (bottom left) four repeat firings from a single flash position, showing camera position used for this series; (bottom right) daylight exposure.

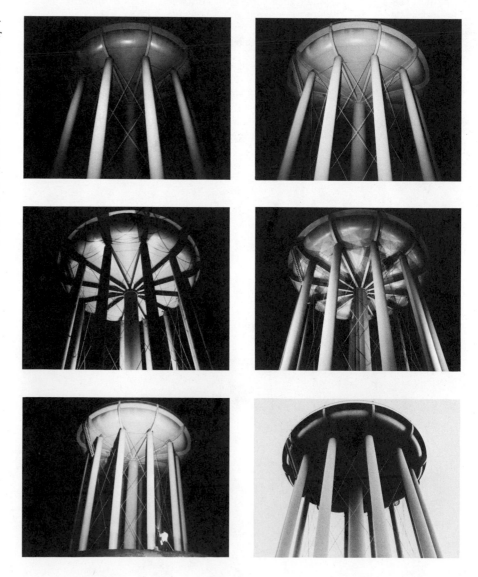

94

A flash meter that will record cumulative flashes is the most accurate way to determine exposure. You can also make an exposure test with quick-developing film. If you use a consistent flash-to-subject distance for each flash firing, you can base the basic exposure on the light from one of those lighting positions. This calculation will require adjacent areas of illumination to be carefully feathered. The bare-bulb technique, discussed below, can be an effective way to blend the repeated firings.

Dark surfaces and reciprocity failure may combine to produce very underexposed images. The problem is more extreme when the surfaces of the subject are not facing the light source. An oblique lighting angle can cause a sizable loss of reflectivity.

Night photography requires special exposure consideration. Outdoor space generally does not offer the reflective advantages of indoor locations, and the exposure adjustment may amount to two stops more light, depending on the reflectivity of the subject.

Exposure Calculation for Cumulative Flashes

Freshly painted lines on a parking lot are the subject of these two flash-illuminated photographs. The first is a single on-camera flash exposure. For the second, the photographer held the camera shutter open on a B setting while making repeated on-camera flash exposures from different locations for an overlapping multiple exposure.

Combining Open Flash and Ambient Light

A combination of open flash and time exposure may extend the lighting possibilities. Ambient light with a time shutter setting can reveal the detail of a night sky or nighttime traffic activity. At some stage of the time exposure you can fire the flash unit, using the open-flash button. The EF unit does not have to be wired to the camera for this combined lighting.

These two photographs combine ambient daylight and ambient artificial light with the light from the flash exposures. The photograph by Richard Margolis required a slow shutter setting to record both the initial flash exposure and the broader effect of the ambient light from the sunset. Since the camera was tripod-mounted, the skyline remained sharp. The calf moved during the exposure, so what appears to be a shadow beside the calf's head is actually a backlit silhouette that almost coincides with the frontal flash illumination.

Alida Fish, *Greenhouse Plants,* 1976

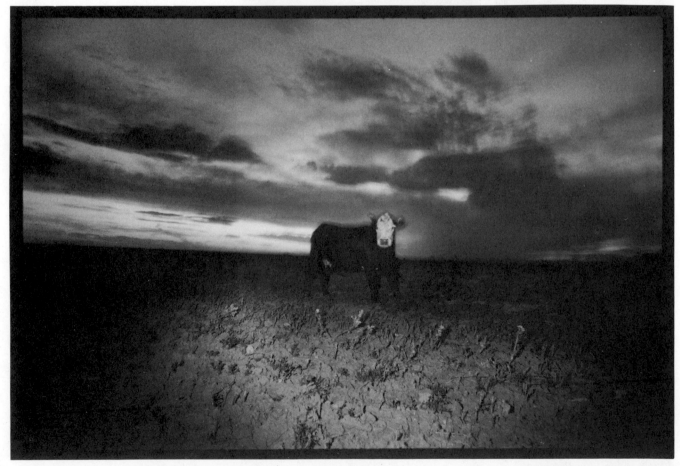

Richard Margolis, *Oklahoma,* 1974

96

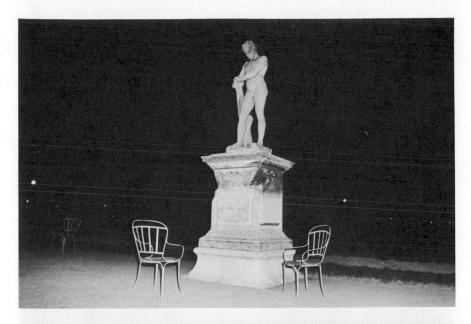

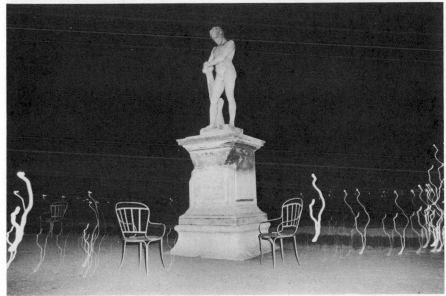

The photographer used a two-second time exposure to streak the ambient city lights. The on-camera flash was fired at the beginning of the exposure. A second photograph of the same subject illustrates a standard flash exposure with a 1/60 sec. shutter speed.

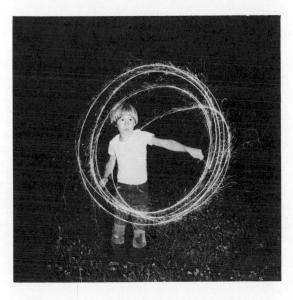

You can combine the light from a flash with the light from any ambient source. Here, the photographer set the shutter on B and held it open for several seconds to record the path of a sparkler. The single firing of the flash illuminated and froze the boy in action.

Bare-Bulb Flash

These two photographs compare the difference between direct flash and bare-bulb flash lighting. The direct flash creates a shadow with a distinct edge. The bare-bulb technique creates a soft, omnidirectional bounced light.

Bare bulb is a technique that you can use to create a soft, omnidirectional, interior electronic flash effect. This technique can be used only with flash units that have removable reflectors, units that offer interchangeable heads, or units that have an outlet for an additional flash tube. The light from a bare bulb in an interior location provides a 180° angle of illumination. It is the only single-flash technique that adequately covers the field of short focal-length, fish-eye lenses. Bare bulb functions best in situations where you can bounce the light from light-colored walls and ceilings. If you use this technique outdoors, the absence of reflective surfaces may result in a harsher or more conventional flash lighting effect.

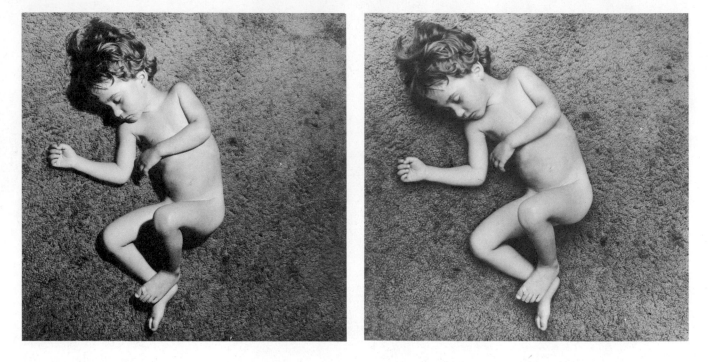

A bare-bulb interchangeable lamp-head can be used on the Ascor Light 1600 II flash unit to match the angle of light output to the angle of view of a superwide lens.

The efficiency of the flash unit is drastically lowered when you remove the reflector for bare-bulb lighting, and you must compensate for the loss of light by increasing the exposure two or three stops. You should make test exposures with a given EF unit and location to determine a working aperture.

In general, use the manual setting with the bare-bulb technique, since the direct light from the flash tube may interfere with the function of the exposure sensor. One flash unit, the Ascor Light 1600, does permit an automatic bare-bulb exposure because you can direct the bulb to a 60° or 90° angle to protect the sensor from its direct light.

Bare bulb is an ideal technique for painting with flash. The soft light is less apt to create a hot spot as the successive firings of the flash are feathered into one another. Avoid firing the flash near the camera's field of view, where the light may spill into the lens and cause flare.

Reducing the Light

A *wide-angle closeup may require a reduction in the light output of the on-camera flash.*

Some situations require a reduction in the amount of light created by the flash. Since each technique of light reduction offers both advantages and disadvantages, you can use the following checklist to determine which method of light reduction is most appropriate:

1 Place a neutral-density filter on the camera lens or over the flash lamphead. (The 0.3 filter equals a one-stop decrease, a 0.6 filter equals a two-stop decrease, and a 0.9 filter reduces the light by three stops.)

2 Place a white handkerchief over the flash lamphead to reduce the light output by one f-stop. Two layers of lens tissue have the same effect.

3 Bounce the flash off a nearby light-colored wall or ceiling to reduce the light by two to three f-stops. Bouncing also increases the flash-to-subject distance.

4 Tape or block a portion of the flash lamphead with black masking tape or lightproof material. Covering one-half the lamphead will reduce the light output by about one-half. (Be sure to remove any tape, as it may bake onto the lamphead with the heat of repeated firing.) In a pinch, simply cover part of the lamphead with your hand to get the same results.

5 Increase the angle of light output. This is only possible with units that feature a variable angle of illumination. The level of illumination decreases when the same amount of light spreads over a larger area.

6 Use an umbrella to increase the flash-to-subject distance.

7 The flash duration of an automatic flash can be artificially shortened to reduce exposure. Tape a piece of white paper or reflective material beside the automatic sensor. This scoops light from the flash directly into the sensor and prematurely shortens the flash exposure.

8 Move the subject away from all adjacent reflective surfaces. There is usually a one f-stop loss of light when you move a subject from an indoor to an outdoor location.

You can equip this flash unit with an adjustable mask (light valve) which can be used to reduce the light output. (Courtesy Norman Enterprises)

Reducing the Light

You can hold a double thickness of lens tissue or a handkerchief over the lamphead for a two f-stop reduction of the light.

Hold or tape a piece of paper in a position that will scoop some of the light from the flash into the automatic sensor. The false response of the sensor reduces the flash exposure and creates a short flash duration.

9 Add another lamphead to the power source to decrease the power of each lamphead by one half. Position the second flash off-camera and aim it away from the subject.

10 Relocate the flash or the subject to increase the flash-to-subject distance. Increase the distance by a factor of 1.4 to decrease the light by one f-stop.

Some subjects may require the use of two or more flash units arranged in a multiple lighting setup. All of the flash units in such a setup must be synchronized with the camera shutter to fire simultaneously. You can accomplish this with standard PC connecting cords, which link all of the flash units to one another and in turn plug into the synch outlet on the camera. You may also fire the off-camera flash units in the setup by equipping each flash with a remote wireless trigger called a photo slave. Each of these triggering methods has advantages and limitations.

Multiple Flash Synchronization

Multiple PC Cords and Multiple Flash

A simple three-way or Y connector can join two or more PC cords, which connect the flash units to the shutter contacts of the camera. The PC cords are less expensive than photo slaves, but they do restrict camera movement and limit the flash-to-camera distance. The individual flash unit and the condition of its batteries determine the maximum

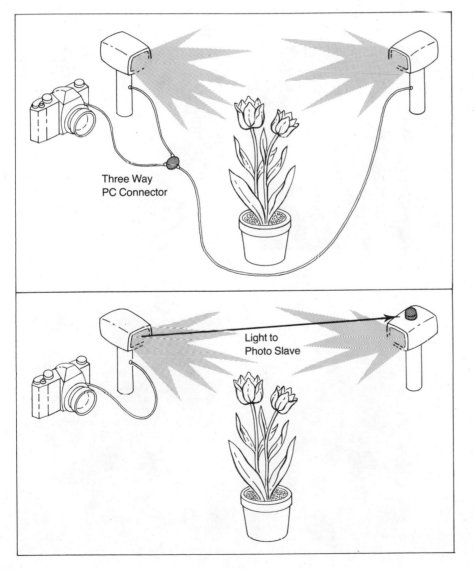

Three Way
PC Connector

Light to
Photo Slave

To fire two flash units in synch, use either a three-way PC connector which attaches to the PC cord from the camera, or a photo-triggering cell (slave) that you can attach to one of the flash units and aim at the master flash, which remains connected to the camera.

Multiple Flash Synchronization

Use a photo-slave triggering device when you must fire a second flash unit in synch with the master flash. A slave unit can be attached to any flash unit that has a PC cord. You can use slave units positioned or aimed at the light from the master flash to fire any number of supplementary flash units.

operating distance of a PC cord. Since the triggering amperage is quite low, the PC cord should not exceed twenty to thirty feet in length.

For best results, use identical-model flash units to ensure that the polarity of the units is matched. Note that some manufacturers do not recommend the use of three-way connectors with their equipment.

Photo Slaves

A photo slave is basically a light-sensitive remote trigger for synchronizing two or more flash units in a multiple lighting setup. The slave's internal switch remains open under normal light levels, but a sudden burst of light from a camera-connected master flash will instantly lower the resistance of the silicon photo diode switch and permit a small current to pass through, instantly triggering the remote flash unit. Any number of EF units equipped with slaves can be fired in synch with the camera-mounted flash.

There are three types of electrical connections used on slaves and flash units: PC cord, hot shoe, and H plug. Most slaves are designed for use with a standard PC cord which is connected to the PC outlet of the flash. Some slaves are designed with a hot-shoe bracket and

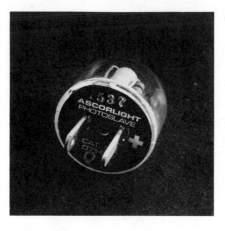
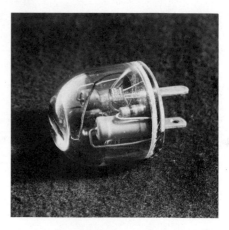

These two views of the Ascor Light photo slave picture both the light-gathering lens mounted in the top of the unit and the polarity markings on the H-plug.

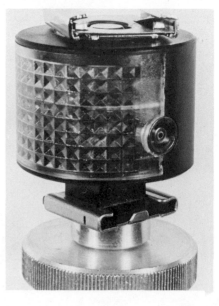

Photo-slave triggering devices are similar in function, although they do differ in their physical appearance. Some designs incorporate a light-gathering lens or reflector to increase the effective triggering range. Slave units may be designed for either a PC cord or a standard H-plug connection.

102

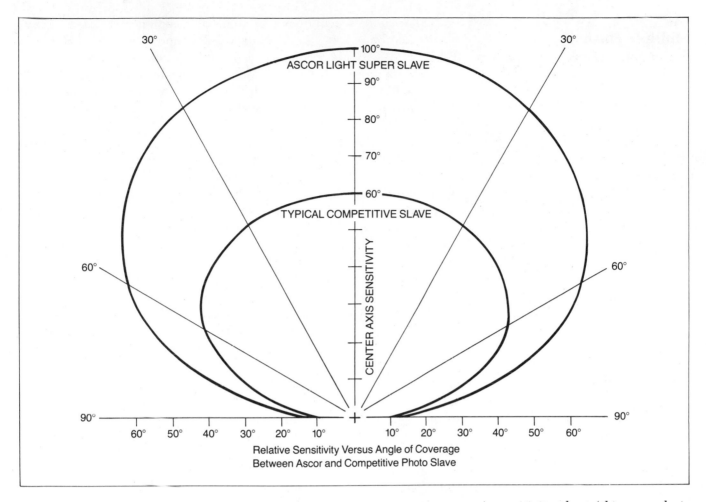

Relative Sensitivity Versus Angle of Coverage
Between Ascor and Competitive Photo Slave

tripod socket. The flash clips onto the slave, and you then mount the slave and position it on the tripod. Professional flash units (both studio and portable) generally have an H-type receptacle, which requires a slave designed with the H plug.

Regardless of the connecting method, it is important to match the slave and flash unit in polarity. A reverse polarity problem will cause the EF unit to misfire rapidly or totally fail to function. You can test and mark the H plug to indicate which prong is positive. Other types of slaves must be matched in polarity by the manufacturer of the flash. Most slaves and amateur flash units are designed with a positive polarity. One professional-quality photo slave is hermetically sealed in plastic. If you incorrectly insert the H prongs in the flash, a small neon light in the slave blinks a warning. (More information on polarity can be found in Chapter 8, "Flash Maintenance and Safety.")

Photo slaves are generally sensitive to infrared radiation and can be effectively triggered by an infrared flash unit. You can use an infrared flash unit on the camera to trigger noninfrared EF lighting units equipped with standard slaves. Aim the eye of the slave at either the master flash on the camera or one of the EF units in the lighting setup. Most slaves perform up to a distance of about fifty feet. However, sensitivity varies greatly among products. Better-quality slaves used with a 200 watt-second flash unit can trigger lights at a 300-foot distance from the camera. The power of the master flash is a key factor in determining the maximum operating distance for a given slave.

A sensitivity chart (this example is based on the Ascor Light Slave) indicates the slave's consistency and angle of response. It is always best to run a series of tests with a given slave and flash unit combination before you begin your final photography. Factors such as the strength of the triggering circuit, the distance from the master flash to the slave, the reflectivity of the environment, and the ambient light level may have a direct effect on the performance of a slave unit.

Multiple Flash Synchronization

Slave units usually have an angle of acceptance or angle of sensitivity of about 180°. Some units have a more selective 45° angle. Those with the wide acceptance angle permit greater freedom of camera movement; however, the wide angle can be a problem in cases when another photographer's flash could accidentally trigger your lighting. Black tape or a cardboard snoot help to make a slave more directional.

The level of ambient light in the environment is also a consideration in working with a slave. Some slave units are designed to function in bright sunlight, while others are intended for low-level light or bounced-flash triggering. Several models are available that have a switch for selecting a high or low range. A piece of photographic equipment may vary from its advertised performance when you use it under actual field conditions. It is essential to test a photo slave with your specific EF lighting in a location that approximates the expected environment.

The care and maintenance of a photo slave are simple. Keep it free of dust and moisture. If you inadvertently expose the slave to a strong ambient light, its operation might be temporarily affected. You may have to store the unit in total darkness for about ten minutes to restore its normal sensitivity. If you remove a shadow from a slave unit, the sudden change in ambient light may accidentally trigger the slave. For best results, always use the manual mode on the flash unit when triggering a flash with a slave unit.

The optimum operating distance for most slave units is considered equal in feet to the guide number of the master flash (with flash rated for ASA 25). Some flash units are designed with a built-in slave unit that you can switch on for use as a remote light. One slave is designed with a small lens that effectively gathers light and increases the sensitivity. Two flash units can be simultaneously triggered by another slave unit, which is equipped with both a PC outlet and H prongs.

You can rotate the head and handle of some professional-sized flash units independently to facilitate aiming the slave at the master triggering flash. Be certain that the slave is plugged in to match the polarity of the unit. If the H prongs are incorrectly positioned, the slave will cause the flash to misfire.

The Red-Eye Effect and Animal Eyeshine

The eyes of a subject in a color flash photograph may seem to have glowing red pupils. This red-eye effect results when the light of the flash illuminates the blood vessels of the retina of the eye. The problem is at its worst when the flash is on the camera, and the lamphead, the camera lens, and the subject's eyes are all on a nearly direct axis. A low-level ambient light may also contribute to the problem by causing the pupils of the eyes to dilate. You can also observe the effect in black-and-white photographs, where the normal black of the pupil is rendered a middle gray.

Several steps will eliminate red eye:

1 Offset the lamphead of the flash from the axis of the lens by at least six inches.
2 Raise the general light level of the room to contract the pupils of the subject's eyes.
3 Make a preliminary open-flash firing of the flash lamp to contract the pupils, then follow up quickly with the intended flash exposure.

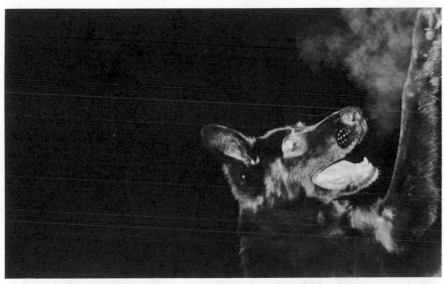

Robert Muffoletto, *Wild Dog of Heath Street,* 1976

Some animals' eyes reflect and magnify the light from the flash or from other artificial illumination. This eye-shine effect is due to a special light-gathering reflective tissue called tapetum which lines the back of the eyeball. The tapetum amplifies an animal's nighttime vision by redirecting the light back through the eye. The dramatic glow is similar to the effect of light striking an automotive reflector.

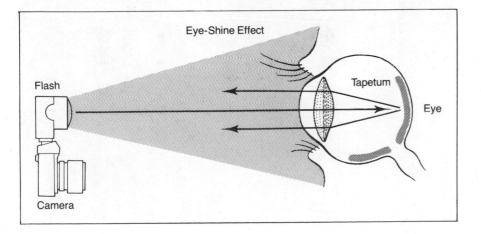

The Ready Light

If you fire a flash unit before its ready signal glows, the light output may not match the exposure calculations, which were based on the indicated guide number. Do not fire the flash until the ready light indicates that the capacitor is fully charged. Premature firing will result in underexposed negatives: A good rule of thumb is to allow twice the time it takes for the ready light to glow between firings. Many flash units are not totally charged when the ready light first glows. Most studio lighting has more accurate ready lights which indicate that the capacitors are 100 percent charged and truly ready for the next exposure.

Ghosting

The term *ghosting* describes the appearance of a slurred or secondary image in a flash photograph. This effect may occur when a strong ambient light falls on a rapidly moving subject and the shutter speed is too slow. The light from the flash freezes part of the movement, while the secondary image from the existing light is superimposed on the same exposure.

A second kind of ghosting may occur when parts of a subject are highly reflective and the subject is moving rapidly. The reflective areas prolong or extend the effective duration of the flash and produce a trail or streak of light that tracks the movement of the reflective surfaces. This may also be described as flash decay.

The only remedies to ghosting are to use a faster shutter speed and/or to lower the level of ambient light. Unfortunately, it is impossible to increase the speed of the focal plane shutter beyond its synch setting. Luckily, not all ghosting is undesirable.

This portrait of Dr. Harold E. Edgerton illustrates the ghosting effect. Dr. Edgerton deliberately stepped backward after the flash was fired. The 1-sec. shutter speed recorded the ambient light and his blur of movement. This tactic made ghosting a logical and descriptive visual ingredient in the final image.

Reflections

Reflections are images of the light source on the surface of the subject. Distracting reflections are sometimes difficult to avoid in a flash photograph. Fortunately, reflections are fairly predictable on highly polished surfaces: if you cannot see the lamphead reflected in the surface, it will generally not appear in the photograph. More complex reflective surfaces are not as easy to control, although you can diffuse the light source by placing a white handkerchief over the lamphead, which will soften the edges of the reflective glare. Irregular wet surfaces are most difficult. Keep the subject dry.

A reflective surface should *not* be perpendicular to the axis of the flash. You can avoid most reflections by placing the flash off-camera (right, left, up, or down) at a distance at least as great as the width or height of the reflective subject. It may also be necessary to cover the camera and tripod with a black cloth to eliminate the reflected image of the equipment in the photograph.

Reflections can seriously alter the response of an automatic sensor. The photoelectric eye reacts too quickly to the burst of light from the reflection and quenches the flash before an adequate exposure can

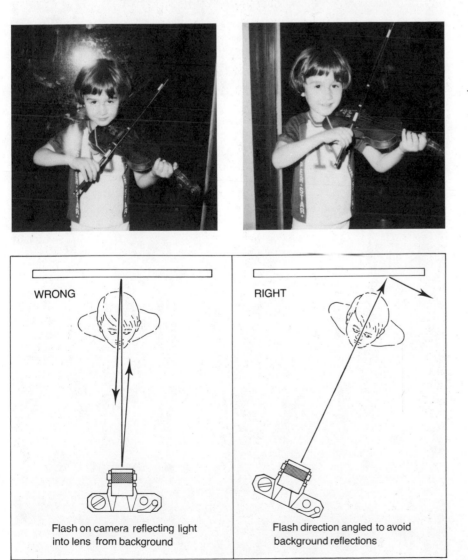

WRONG

RIGHT

Flash on camera reflecting light
into lens from background

Flash direction angled to avoid
background reflections

The most common reflection problem with flash occurs in photographs where the subject is posed in front of a glass or polished surface. If the flash is on-camera, a predictable image of the flash will appear very near the center of the image. To avoid it, simply pose the subject to cover this spot or move the flash off-camera to at least arm's length.

You can totally eliminate a daytime reflection in a glass window by simply photographing the window at night using off-camera flash lighting.

be made. If you anticipate reflections, set the flash for manual operation.

It is more difficult to control reflections with wide-angle lenses. Placing a telephoto lens at a slightly oblique angle to the reflecting surface helps eliminate most glare from the flash.

Taking a photograph through glass, such as a store window, requires careful positioning of both the camera and the light source. As the light passes through a glass surface, a predictable loss of illumination occurs. The amount of light you lose depends on the angle at which the light strikes the surface: the more oblique this angle is, the more light you will lose. Again, wide-angle lenses are not a wise choice when you are planning to photograph with flash through a sheet of glass.

Since the reflections are the image of the light source, you can reduce the size of the reflections by increasing the flash-to-subject distance. Use a flash with a telephoto setting (narrow angle of coverage) with a telephoto lens to reduce greatly the relative size of the reflections.

Totally bounced flash may also effectively eliminate the reflections on some subjects. The ceiling or walls of a room become an enveloping light source that reduces the concentrated hot spot of the flash lamphead. This diffusion technique is the basis for the use of a light tent to photograph highly reflective metal objects such as jewelry. The subject is literally surrounded by the light source in order to reduce the possibility of glare. The larger the light source, the softer the lighting effect.

You can use an ordinary flashlight or penlight to anticipate undesirable reflections from on-camera flash. In a reduced light level, aim the flashlight to simulate the position and direction of the intended flash exposure. Your eyes, at the camera position, will detect the unexpected potential reflections. Move your eyes or the flashlight until the reflections are eliminated. You can easily correct problems caused by mirrors, windows, glass-covered pictures, and even eyeglasses with this method.

You can use a flashlight to test the direction of electronic flash lighting. To detect undesirable reflections, observe the effect of the light from the camera position.

Flash Parallax

The angle of coverage of the typical flash unit is closely matched to the angle of view of a normal lens. If you do not carefully aim the flash lamphead to match the view through the lens, you will get a partially illuminated subject. Always test-fire the flash to make certain that the direction and angle of coverage of the light match the view through the camera.

Rectangular lampheads generally create a rectangular light pattern. It is important to match the format of 35mm film with the format of the light source. Take care in using a rectangular lamphead as a swing light with a 2¼-format camera. The angle of coverage of the flash may not cover in all positions.

As you bring the camera and flash closer to a subject, you may find it necessary to adjust the position of the flash visually. Aim the light at the subject to avoid a parallax problem.

To align the flash unit and the camera, fire the unit against a flat, light-colored wall. Ideally, you should make a series of tests with a particular flash unit, flash holder, and camera to determine the degree of parallax. Parallax can be a particular problem with handle-mount flash units because the lamphead is set about twelve inches from the camera.

The beam of light from a standard flash unit predictably does not match the angle of view of a superwide 17mm lens. The photographer has deliberately relied on this mismatch to isolate the dog in the spotlight of the flash. She needed a precise alignment of the flash to insure that the light and the subject were both centered in the composition.

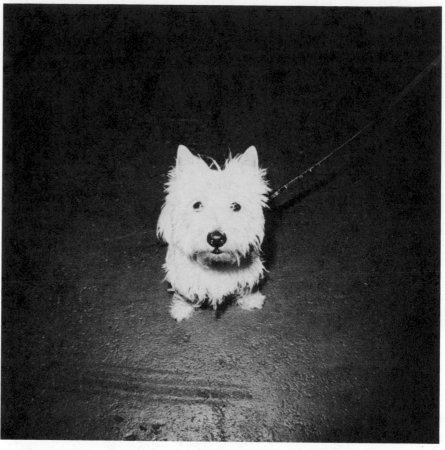

Colleen Chartier, *Small Dog,* 1977

Weather and Flash

Flash and rain do not mix. Moisture in any form presents a serious hazard to the effective operation of a standard flash unit. Before attempting to use a flash outdoors in adverse weather, you might be wise to consider using a flash unit designed for underwater use.

Falling snow presents a unique problem when it is illuminated with the light from an electronic flash unit. If the lamphead is near or on axis with the lens, the individual snowflakes reflect the light, creating an array of aperture images on the film. Snowflakes directly in front of the lens often appear as overexposed blobs of light. To eliminate some of the effects of snow, use the flash off-camera and light the subject from the side. Try to keep the camera lens back from the immediate foreground snow.

A flash photograph of falling snowflakes or rain may also demonstrate a slight slurring of the precipitation, as the highly reflective

snow or rain tends to prolong the usable light portion of the flash. Snowflakes gradually fade to a comet shape as the flash decays.

Fog and smoke are similar atmospheric problems. The light from a flash must pass through the air both to and from the subject. Airborne particles will obviously disrupt the direction of the light, lowering contrast and reducing sharpness. If the particles of fog are sufficiently dense, the fog will reflect most of the light directly back into the lens. In smoke or fog, you can best use flash in an off-camera position.

The smoke from cigarettes may pose a difficult problem for indoor flash photographs. Tests indicate that even the smoke from one cigarette can alter the color of the reflected light in a typical living room,

The photographer illuminated this falling snow with an on-camera flash. The flakes in the immediate foreground produced hexagonal shapes as the large burst of light reflected the aperture of the lens onto the film. More distant flakes are recorded as indistinct blobs of white.

111

Even a small amount of cigarette smoke can keep the light from reaching the subject. Although the smoke in this picture is not particularly heavy, the particles were dense enough to reflect the light from the flash and create an overexposed glare across the face.

causing a shift to yellow-green. The only solution to this problem is to wait for the smoke to clear.

Remember that extremely cold temperatures will greatly reduce the current capacity of Nicad batteries. Carry the batteries in a warm pocket and insert them in the flash unit just prior to your outdoor exposure.

Synch Shutter Setting

Most focal plane shutters are in synch with the flash exposure at a maximum shutter speed of 1/60 or 1/125 of a second. Faster shutter settings will result in partially exposed images; slower shutter speeds will generally allow the flash to fire in synch with the exposure. The shutter speed selector button is usually marked to indicate the X or flash synch setting. You can easily identify the problem of an out-of-synch shutter: a partially opened focal plane shutter will block part of the exposure.

A between-the-lens shutter is in synch with flash at all speeds when the shutter is set for the X synch. A focal plane shutter will synch with flash at the speed designated X or "strong synch" and at all slower speeds. You must set focal plane shutters or Copal metal leaf shutters at the X synch speed (generally 1/125 or 1/60) before the shutter will be open when the flash fires. Slower speeds are also in synch with the focal plane shutter. Forgetting to set the camera on this X synch is the most common flash mistake photographers make.

Because of the short duration of the light from the flash, you can make an exposure in daylight that excludes the sun and relies entirely on the light from the flash. This creates a day-for-night effect. A reasonably powerful flash unit (guide number 50 for ASA 25) and a between-the-lens shutter are the key tools you need to produce this effect. Since the leaf shutter is synched at all speeds, it is possible to use a fast shutter speed to underexpose the sunlight while you maintain a correct aperture for the flash exposure.

Day for Night

These two photographs were exposed at the same time of day. They illustrate how a between-the-lens shutter can be increased in speed to eliminate the ambient light and create a day-for-night effect using flash. The flash-to-subject distance was based on the f/16 setting, but the shutter speed was increased to 1/500. This technique requires a between-the-lens leaf shutter.

Special Applications and Techniques

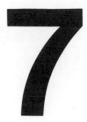

Portraits with Flash

Commercial photography studios specializing in portraits are often equipped with electronic flash lighting. EF lighting consumes far less electricity than tungsten lights and provides consistent color-balance illumination. The sitter is not subjected to the heat and glare of conventional filament lights, so he or she is more apt to relax the face muscles and keep the eyes open. Reflex blinking usually occurs after the flash.

A basic system of electronic flash lighting can simulate most natural lighting effects. Traditional lighting arrangements using key, fill, and background illumination are relevant to EF technique. You can easily substitute electronic flash units for tungsten lighting in most lighting setups.

The model in this photograph was positioned to face the light from a large umbrella. The photographer spilled some light behind the subject to provide better separation of the hair and background. Portraits are often most effective when the viewer can quickly comprehend the location and direction of the light source.

Wm. J. Murray III, *Lisa,* 1977

A single off-camera flash unit can create many effective portrait lighting effects. Bounce the light from the flash from an umbrella or bounce card onto the face to make a soft key light. Keep the flash and bounce surface as close to the subject as possible. Place a second bounce-board reflector surface opposite the shadowy side of the face to fill the dark areas for the desired lighting contrast. (Bounce boards should be white or light-toned.) Actual placement will depend on the light output of the flash and the type of reflecting surfaces. You can control the intensity of the fill light by varying the distance from the

116

secondary bounce board to the subject. Vary the value of the background to match the mood of the key lighting.

A single off-camera flash can be used to create different lighting effects with the same subject.

Courtesy Tracy Moore as Chester

Catch Lights

Catch lights are reflections of the main light source that may appear in the eyes of a photographic subject. This glint of light in the eyes often adds a certain energy and interest to a photographic image. You can position a subject to take advantage of existing catch lights; however, EF studio lights provide complete control of the size, shape, and position of such reflections.

Portraits with Flash

The following list presents some of the basic catch-light shapes.

1 Natural light from windows
2 Bounced flash with no catch light
3 Spoon held on lamphead to add catch light to bounced flash
4 Square umbrella
5 Round umbrella
6 Ringlight
7 Standard hot-shoe flash on camera

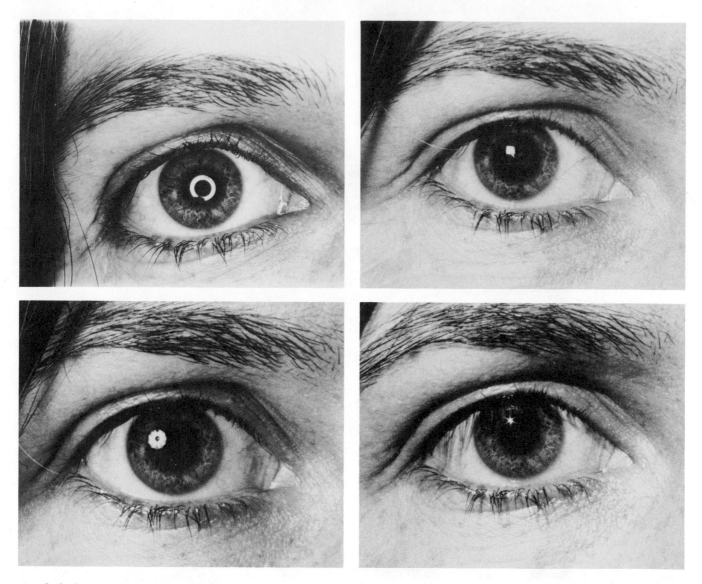

Catch lights are an important element in most portraits. The dark pupil of the eye acts as a wide-angle reflecting surface, mirroring the size, shape, and location of the lighting. These close-up photographs compare some of the more typical light sources and their catch-light reflections: ringflash (top left), square bounce-board (top right), umbrella (bottom left), and standard hot-shoe flash (bottom right).

Bounced-flash lighting does produce a soft, even light, but it may also eliminate the catch lights from a subject's eyes. To restore the catch light, tape a small card of white paper to the side of the lamphead. This reflective card will direct a part of the bounced flash directly back to the subject's eyes. You can create a more defined catch light by holding a polished teaspoon against the side of the flash unit, using the bowl of the spoon as a miniature reflector. Another technique is to use a hexagonal umbrella, an all-purpose tool that compromises the differences between the catch lights created by round and square umbrellas.

More than one catch light per eye can be distracting. Commercial photographers often use photo retouching to simplify the catch lights. A distracting secondary catch light may also occur when a subject is wearing glasses. You can adjust both the subject and the lighting to minimize or eliminate unnecessary reflections of the light source.

Improvising a reflecting device is a simple way to improve the flat light of most bounced flash. You can attach a spoon or paper plate to the flash unit with a rubber band to deflect part of the bounced flash to the subject's eyes and restore the catch lights.

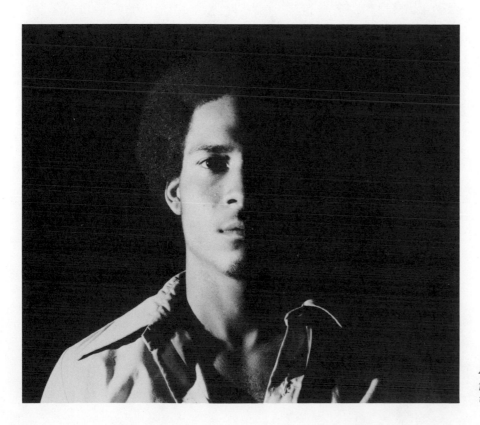

A single flash used as a side light still produces a discernible catch light in the subject's eye.

119

Close-up with Flash: Close-up Equipment

Electronic flash lighting solves a number of problems that confront the photographer who is attempting to take a close-up photograph. At short working distances, standard tungsten lights are generally too hot for the comfort of either the photographer or the subject. The physical size of conventional lights may pose an additional problem when you are focusing at close range. You may also need the high light level of flash to compensate for lens extension and to insure adequate depth of field. A short flash duration freezes undesired camera and subject movement. It is difficult to imagine a more versatile or appropriate lighting technology than flash for close-up photography.

You can use flash lighting with any camera and lens close-up system; however, it will be useful to review the basic lens and close-up accessories before considering the techniques of flash lighting.

Supplementary Close-up Lenses

The supplementary close-up lens provides one of the least expensive and simplest methods of taking a close-up photograph. Mount this type of lens on a standard camera lens to magnify the subject. Since you can magnify the image without extending the actual focal length of the lens, you generally will not require additional light for a proper exposure.

Supplemental lenses are available in varying strengths of magnification. Magnification is measured in diopters, which are the reciprocal of the focal length in meters; for example, a 1-diopter or +1 lens

The photographer held the flash slightly off-camera in this exposure to minimize the possibility of glare on the metal buckles. The flash-to-subject distance of 24 inches permitted him to fire the flash on an automatic setting.

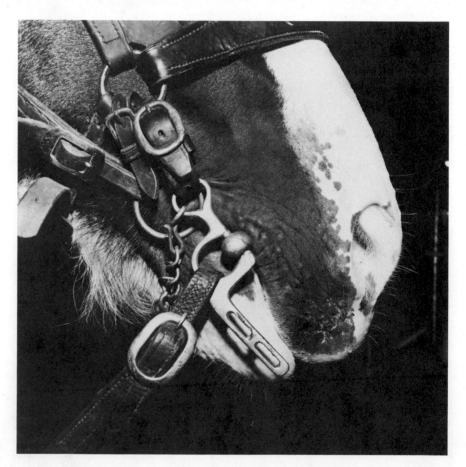

has a focal length of one meter (forty inches). You can use two close-up lenses in combination if you place the one with the highest power next to the camera lens.

When you use a supplemental lens with a normal lens, magnification ratios down to almost life size are possible. You should accomplish greater subject magnification with extension tubes or extension bellows.

Extension Tubes and Bellows

Extension tubes are designed to fit between the camera body and the lens to extend the focal length of the lens and magnify the image. They mechanically change the lens-to-film distance to increase image size and correspondingly reduce the amount of light striking the film, as the image is spread over a larger area.

The extension bellows is similar in function to the extension tubes; however, you can continuously vary the bellows to achieve a specific image size and focal length. The variable focal length macro lens has become the most popular piece of equipment for close-up photography. Since the macro lens will generally not produce the range of magnification possible with an extension bellows, photographers often use a special extender to achieve a 1:1 reproduction.

Extension tubes are available in different lengths and are used singly or in combination to provide changes in the working range from the normal focusing distance of the lens to extreme close-up. Automatic extension tubes maintain the automatic operation of the lens diaphragm and permit focusing with the lens wide open.

An extension bellows is the most versatile close-up accessory. When used with a short-mount or short-barrel lens, it enables you to photograph subjects from infinity down to approximately four times life size. You can also use standard camera lenses on the bellows, although flat-field lenses are preferable. Most camera manufacturers supply a bellows that is designed for use with their camera. The T-mount reversible lens ring permits you to turn the lens around on the bellows to increase magnification.

You can attach a focusing rail bellows accessory between the

Electronic flash lighting works effectively with any of the standard close-up photographic systems. The supplementary close-up lens attaches over the standard camera lens and does not require a change in exposure since the image and the light are magnified. Extension tubes attach between the lens and camera body and are used to increase the focal length of the lens to permit focusing. Since this equipment spreads the same amount of light over a larger area, you must calculate some increase in exposure.

121

bellows and a tripod head. Since the magnification of the image is determined by the bellows extension, only one focus point exists for a given degree of magnification. The focusing rail moves the entire bellows and camera system into this position of exact focus.

Macro Lenses

Macro lenses have become the most popular piece of close-up equipment. These lenses incorporate a variable extension tube to permit continuous focusing from infinity down to eight inches or less. Macro lenses are commonly available in 50mm and 100mm focal lengths for the 35mm film format. They are designed to focus on a flat field, with optimum focus usually at a 1:10 image size. Most current macro lenses will reproduce a 1:2 image size, but require an accessory extension tube if you need a 1:1 or larger image size. As you focus the lens, a magnification scale on the macro lens indicates the exact ratio of image size. This type of lens also permits full use of the camera's internal light meter.

Flash Equipment for Close-Up

Although you can use any type of electronic flash lighting to illuminate a subject for close-up photography, certain sizes and designs of flash

Even at close flash-to-subject distances, the small flash units approximate a point light source. The strong directional light accentuates the surface texture and detail of the bird's feathers in this Robert Holmgren photograph. The predictable light from the flash is ideal for spontaneous action and evasive close-up subjects that may require a preset focus and a basic aperture. Working with a predetermined flash-to-subject distance is a good way to simplify exposure calculations.

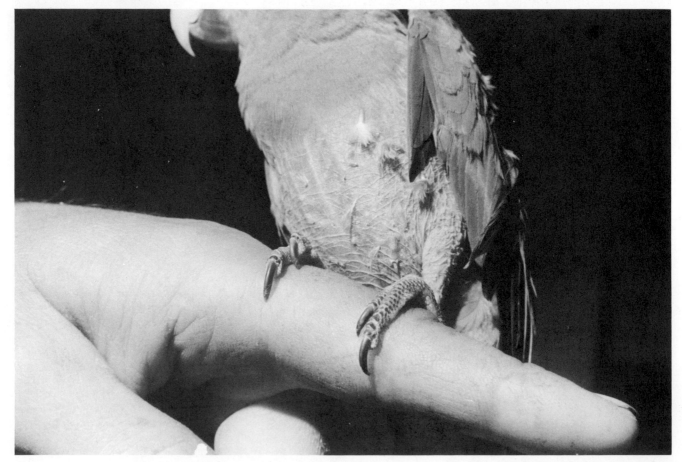

Robert Holmgren, *Bird on Finger,* 1977

equipment work best for controlling the light at close flash-to-subject distances.

Lens-Mounted Flash and Off-Camera Flash. The standard hot-shoe portable flash unit works well as a point or directional light for off-camera or lens-mounted flash photographs. The lens-mounted flash requires a special bracket that attaches to the lens and is designed to rotate 360° to position the flash for a precise lighting angle. The bracket aligns the flash as closely as possible to the axis of the lens and allows the flash to travel with the lens as the photographer sizes images.

Off-camera flash involves a more conventional placement of the flash, generally at a 45° angle to the camera–subject axis. The flash position must be precisely calculated, but is usually between twelve and twenty-four inches from the subject. At such close range, slight variations in flash-to-subject distance can dramatically affect exposure.

You can also achieve off-camera close-up flash with a matched pair of flash units mounted on adjustable bracket arms and positioned to create a particular lighting balance. A compact flash unit with a guide number of 40 to 50 (based on ASA 25 film) works best with all these close-up systems.

You can use an automatic flash in a single-flash setup if the au-

A compact pocket-sized flash enables the photographer to position both the lighting and the camera within inches of the subject. At close range, the flash casts unique shadows which give special emphasis to the tabletop position of the camera.

Christopher Rauschenberg, *Untitled,* 1979

Close-up with Flash: Close-up Equipment

This rotating bracket for lens-mounting the flash unit has been designed with click stops to simplify positioning the light at various points around the lens. This feature is particularly useful when you are making intraoral photographs. You can quickly reposition the light for lighting opposite sides of the mouth.

A basic ringflash should be large enough in diameter to mount on a standard lens without vignetting the image in the viewfinder. You can power some ringlights from either a battery pack or household AC current. The power supply features full, one-half, and one-quarter settings.

The photographer used a ringflash to illuminate this close-up photograph of a rooster's head, and the circular flash tube is predictably mirrored in the bird's eye. The contrasting textures of the comb, the feathers, and the beak are flattened by the nearly shadowless light source. The falloff of the light insures a dark background.

tomatic sensor is designed for remote use and can be carefully aimed to read the light reflected from the subject. Remember that the automatic circuitry will compensate for changes in flash-to-subject distances, but it will not always compensate for differences in exposure caused by changes in the lens-to-film distance. When you use two flash units to light a single subject, or when you need an accurate single-flash exposure, operate the flash units in the manual mode.

Flash lighting for lens-mounted and off-camera photographs is easier to control if you use a 100mm macro lens or 100mm short-barrel lens on an extension bellows.

Ringflash. The ringflash is an electronic flash unit in a class by itself. A circular flash tube is mounted around the lens to create a flat, diffused, nearly shadowless lighting. Although the flash was originally developed to meet the demands of close-up medical photography, photographers now use it to solve a variety of lighting problems. Fashion photographers often employ a ringflash with a 1200 watt-second power capacity to light the model's full figure.

The standard ringflash is designed for close-up work and has a relatively low light output. A guide number in the 12 to 30 range makes

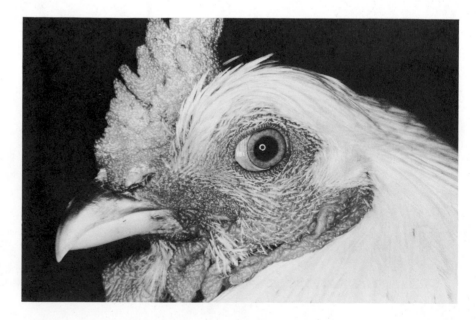

124

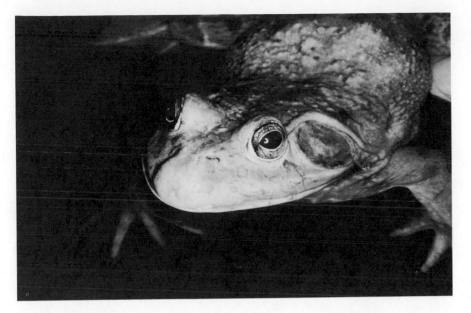

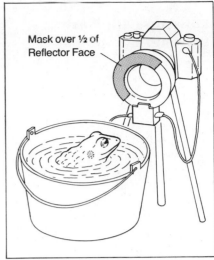

You can detect the reflection of the ringflash in the eye of this frog. To mask the light from a ringflash and produce a more directional on-axis illumination, tape a semicircle of lightproof material such as paper or plastic over the reflector face to block one-half of the normal light output. This reduces the light by about one f-stop.

the light compatible with ASA 25 and ASA 64 color films. Since the flash tube must fit closely on the lens, the ringlight reflector is small and only moderately efficient. When you position the light at a short flash-to-subject distance, the illumination appears to surround the subject with 360° wraparound effect, although the actual angle of illumination for most ringflash reflectors is between 70° and 100°.

Ringflash units are available in two general sizes. The most common size (series 7) fits a maximum lens diameter of about 60mm. This size works well with most 35mm cameras equipped with a 50mm or 100mm macro lens. Much larger and more expensive ringflash units are designed as a series 9 size to fit the standard lenses on 2¼ × 2¼ format and 4 × 5 view cameras.

Unlike the rays of light from the conventional flash unit, those from the ringflash are scattered and diffused. The ringflash does not produce a distinct shadow, but may create a 360° hazy outline shadow

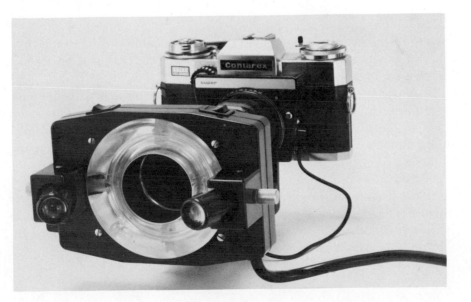

This ringflash features a circular flash tube equipped with adjustable modeling lights to assist with framing and focusing.

125

These four subjects were all photographed with ringflash to illustrate the effectiveness of this type of close-up lighting. A standard lens-mounted position was used for fungus (top left), hair (bottom left), garter snake (top, far right), and canteloupe (bottom, far right).

when it is used to photograph an object. You cannot use a ringflash to accentuate contrast, and the flash unit is best suited for subjects that have a strong color separation.

Since the light from the ringflash is nearly on axis with the lens, circular or topographical reflections of the flash tube may appear on the surface of wet or shiny subjects. Polarizing materials placed over the lamphead and the lens will reduce the contrast of the distracting reflections.

Ringflash units use one or all of the standard EF power sources. At close flash-to-subject distances (twelve inches or less), small changes in either the distance or the light output can produce dramatic exposure differences. If you must maintain accurate, near-facsimile color rendition, use a ringflash with an AC power supply. Some ringflash power

The Profoto ringlight is currently the largest studio ringlight in production. This around-the-lens flash has a separate mounting bracket that accommodates most lens sizes and camera formats (35mm to view cameras). Its 1800 watt-second power and rapid recycling make it a unique lighting tool.

Accessory brackets allow you to mount a small hot-shoe flash in any of several near-the-lens positions. You can adjust the bracket to accommodate flash units of various sizes. This bracket attaches to the filter ring of the lens, allowing the flash unit to ride along as you focus the lens at different focal lengths. The flash unit pictured has been adjusted to correct for the parallax between the lamphead and the lens-to-subject axis.

supplies feature variable power to control the light intensity. A variable power output can be important if you are going to use the flash with lenses of various focal lengths at different working distances.

Basic ringflash technique requires you to position the diameter of the reflector close to the front edge of the lens to insure that the full light output is available. The lens-mounted flash travels with the lens as you focus the subject or extend the focal length. You can also use the ringflash off-camera for some interesting lighting effects. If you place the light under a diffusion glass, you can transilluminate small objects or transparencies. The ringflash produces a soft, diffused light when you hold it off-camera and aim it at the side of a subject.

Close-up with Flash:
Close-up Equipment

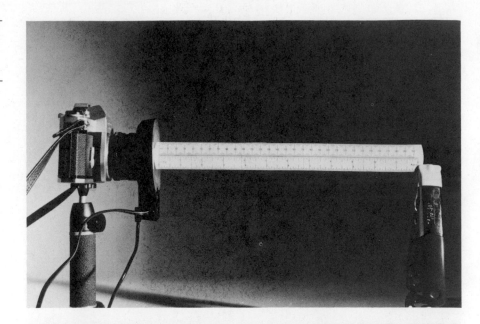

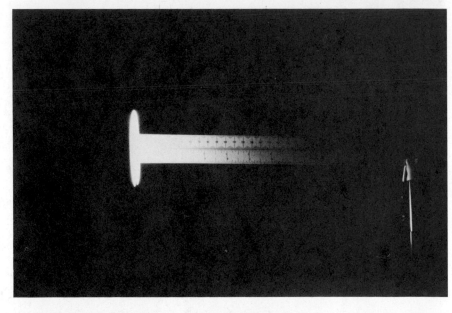

These two photographs illustrate the limited depth of light that occurs when the flash-to-subject distance is extremely close. The top photograph merely explains the setup and relationship of the white ruler to the lens axis and ringflash. The bottom photograph shows the same setup illuminated entirely by light from the ringflash. The light falls off so rapidly that even slight changes in the flash-to-subject distance may require exposure compensation. You can use the ruler as a ringflash subject to establish a basic effective exposure for a given flash at a measured distance.

The grasshopper was somewhat immobilized by a low ambient light level during this macro lens close-up. The flat light from the ringflash insured an accurate rendition of the patterning on the wings, and the brief duration of the flash minimized the effect of the light on the insect.

An off-camera ringflash created a back lighting for this close-up of a dragonfly.

Robert Holmgren, *Dripping Ice Cream Cone, 1976*

The short duration of the electronic flash is particularly useful when you are making a close-up photograph. The brief light duration effectively eliminates blur created by camera or subject movement. The intensity of the light requires a small f-stop and insures a greater depth of field.

129

Close-up with Flash: Calculating Exposures

Flash exposure is basically determined by three factors: (1) flash intensity; (2) flash-to-subject distance; and (3) lens-to-film distance. For most standard photographs, it is usually not necessary for you to be concerned with lens-to-film distance; however, in close-up photography, this distance becomes an important consideration in determining image magnification for a proper working exposure.

The image ratio of close-up photography compares the real size of the object to its image size on the film. An image ratio of 1:2 (one to two) indicates that the object is twice the size of its image on film. The first number represents the relative size of the object on film, and the second number refers to the actual size of the object. For example, an object 12mm high that also measures 12mm in height on the film would have an image ratio of 1:1. If this same 12mm-high object has a 6mm-high image on film, the ratio is 1:2. If the object image on film is increased to a height of 24mm, the image ratio is stated as 2:1. The normal 50mm lens on a 35mm camera will generally not focus closer than a 1:6 image size.

Magnification is a term that is interchangeable with image ratio. Magnification is expressed as 0.5x, 1x, 4x, and so on. The magnification factor is merely the quotient of the size of the image on film divided by the related actual object size. An image ratio of 1:2 (where the image is one-half the actual size) is expressed as a magnification factor of 0.5x.

You can quickly estimate the amount of image magnification by holding a ruler at the subject location and comparing the subject's size

A continuous light would have disturbed the nighttime activity of this harvest spider. A single burst of the flash did not alter its behavior.

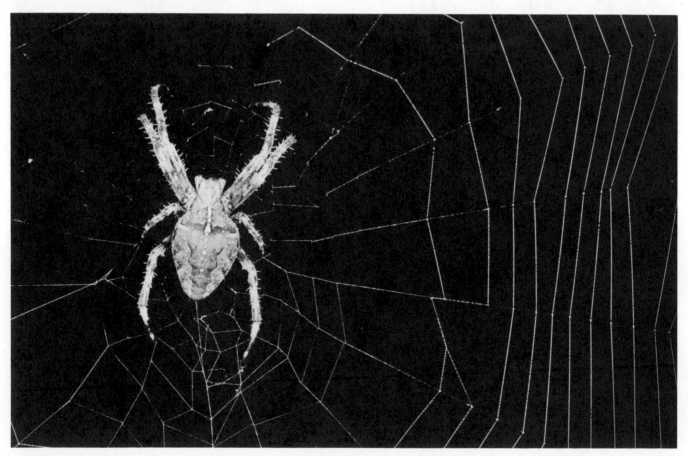

in the viewfinder to its actual size. A 35mm frame is approximately one-and-one-half inches wide and one inch in height. If two inches of the ruler fill the one-inch height of the frame, a 1:2 ratio or 0.5x magnification exists.

Electronic flash can be particularly useful for the mycologist who is photographing wild mushrooms. This form of plant life thrives in locations where the available light is minimal. You can position the portable flash at close range for effective depth of field and a good rendition of structural detail. The compact design of the ringflash was ideal for this low-angle, hand-held shot.

The f-stops engraved on the lens aperture ring are based on a diameter–focal-length relationship for a lens focused on infinity. If you focus the lens on closer subjects, the light forming the image must cover a larger area and is proportionally darker at any point on the film plane. You will require additional exposure if you accomplish close focusing by extending the lens and if the camera is nearer than eight times the focal length of the lens. You must calculate an extension factor and increase the basic f-stop for the exposure by this factor to compensate for light lost through image magnification.

You can calculate the extension factor in two ways: first, by using lens extension, and second, by using magnification.

1 When you know the total lens extension, find the extension factor by squaring the normal focal length for the format being used and dividing it into the lens-to-film distance squared:

$$\text{extension factor} = \frac{(\text{lens-to-film distance})^2}{(\text{normal focal length})^2}$$

2 If you know the magnification factor, the calculation is even simpler:

$$\text{extension factor} = (\text{magnification factor} + 1)^2$$

You can also use the following exposure factor table to determine exposure increases needed for a known image ratio.

Exposure Factors for Calculating Exposure Increases

IMAGE RATIO	MAGNIFICATION	EXPOSURE INCREASE
1:4	0.25x	½ f-stop
1:3	0.33x	⅔ f-stop
1:2	0.5x	1⅓ f-stops
1:1	life size	2 f-stops
2:1	2x	3 f-stops

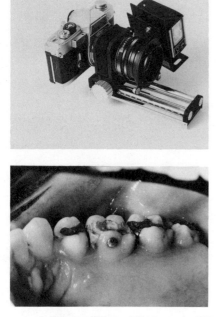

J. Freeman, *Intraoral Photograph*, 1977

A point light source electronic flash is preferable to a ringlight for most intraoral photography. A directional light with shadows will more adequately describe the form and structure of the teeth. The photographer directs the lens-mounted flash into the mouth at relatively close range. A 100mm lens on a bellows insures the best image size at a comfortable patient-to-camera distance. Some views may require the use of mirrors, with the flash and lens directed at the mirror image. The light from the flash is reflected from the mirror to the teeth with no appreciable loss of light.

Close-up Exposures with Lens-Mounted Flash

A hot-shoe flash mounted on the side of the lens or a ringflash mounted on the lens may simplify the exposure calculation for a bellows extension close-up. As you move the bellows and the lens toward the subject to increase the image size, you need more light for the exposure; however, you have also moved the lens-mounted flash closer to the subject, creating a proportional increase in light intensity. Similarly, if you compress the bellows for a smaller image ratio, you also move the light away from the subject, which decreases its intensity. When you are working with a 100mm or a 105mm lens, exposure will remain fairly constant for a range of a ratio of from 1:1 to 1:4.

Because of the typically close flash-to-subject distances involved, you can best determine a basic exposure for a lens-mounted flash system with a series of tests that use a narrow-latitude color-slide film and a subject of average reflectance. Make careful note of (1) flash-to-subject distance; (2) flash position relative to lens axis; (3) film speed; (4) lens or bellows extension; (5) focal length of lens used; (6) image magnification; and (7) flash guide number. For example, a basic f-stop of f/22 is required for a close-up photograph taken with the following equipment and film:

1 Flash-to-subject distance: eight inches
2 Flash position: 20° to the left of lens axis
3 Film speed: Kodachrome ASA 64
4 Bellows extension: 200mm
5 Focal length of lens: 100mm
6 Image ratio: 1:1
7 Flash guide number: 50

Since the inverse square law assumes a point light source, the guide number formula may not be applicable when you use a flash unit at distances closer than one foot from the subject. At extremely close flash-to-subject distances (from twelve inches down to one inch) the effective light from the flash decreases. At such close range the relative size of the reflector is increased, and as the light source becomes literally larger than the subject, not all of the light can be efficiently directed.

The following exposure table for the Ascor Ringlight illustrates how extemely close distances may require up to two additional f-stops

of light to compensate for reflector size (a longer focal-length lens also helps avoid this problem):

DISTANCE (ringlight to subject)	12″	10″	8″	6″	4″	2″	1″
EXPOSURE INCREASE (in f-stops)	+½	+½	+½	+⅔	+1	+2	+2

You can usually calculate a basic exposure for a given ringlight by using data provided by the manufacturer. You can also conduct tests, using narrow-latitude film and bracketing both exposures and flash-to-subject distances.

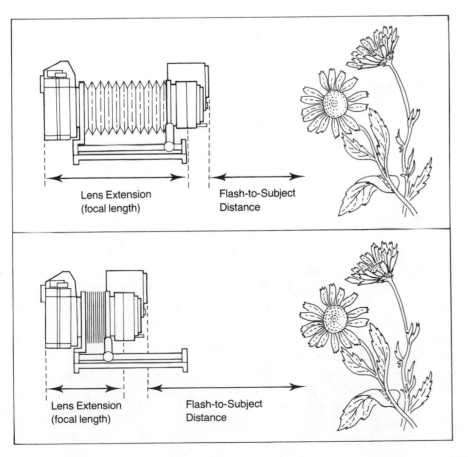

Maintain a balance between illumination and magnification with a close-up system using a lens-mounted flash. Even though the flash-to-subject distance varied from twelve inches (for the eye) to twenty-four inches (for the full face), the f-stop remained nearly constant. As the photographer increased the focal length, he moved the flash closer, matching the need for increased exposure. Narrower-latitude color films may require some exposure adjustment.

Robert Holmgren, *Knife on Face,* 1977

When you use a pocket-sized flash unit at close range, you can consider it a point light for most exposure calculations. Apply the standard formula for determining the f-stop. The impact of this photograph by Robert Holmgren relies in part on his use of off-camera lighting. The intensity of the flash assured adequate depth of field. The highly directional cross lighting emphasized the texture of the skin and the contrasting glint of the knife blade.

You can standardize exposure problems with an off-camera flash set-up.

Calculating Close-up Exposures for Off-Camera Flash

When you use the flash off-camera to light a close-up subject, the flash-to-subject distance provides the critical control of exposure. For hand-held camera work it is useful to mount the flash on a flash bracket with a movable arm that you can also extend to facilitate precise positioning of the flash unit. You can easily calculate the flash-to-subject distance after the exposure factors of film speed, focal length of the lens, and lens-to-film distance have been decided. The following steps outline a procedure for computing the flash-to-subject distance:

1 Select a minimum f-stop for maximum depth of field. For example, assume an ASA 64 film, a flash with a guide number of 56, X synch shutter speed, and a working f-stop of f/16.
2 Focus on the subject and measure the lens-to-film distance in millimeters. Measure this distance from the center of the lens to the film plane. The film plane is generally marked with a ⊖ symbol. Assume a bellows extension of 100mm with a 50mm lens.
3 Using the lens-to-film distance and the focal length of the lens being used, calculate the effective f-stop.

$$\frac{\text{lens-to-film distance}}{\text{focal length of lens}} \times \text{f-stop} = \text{effective f-stop}$$

Using our example:

$$\frac{100\text{mm}}{50\text{mm}} \times \text{f/16} = \text{f/32}$$

4 Compute the flash distance in feet using the effective f-stop and guide number.

$$\frac{\text{guide number}}{\text{effective f-stop}} = \text{flash distance}$$

$$\frac{56}{\text{f/32}} = 1.7 \text{ feet}$$

5 Position the flash at the indicated distance.

The above method requires that the flash be very carefully positioned at the exact distance indicated by your exposure calculation. Always measure the flash-to-subject distance from the front surface of the flash lamphead. In most cases, the flash-to-subject distance and the lens-to-subject distance will be different; however, remember that it is the flash distance that is varied to produce the correct exposure for each significant change in image size (magnification). Flash-to-subject distances that are less than 12 inches may require that you open the lens one additional f-stop to compensate for the decreased efficiency of the flash reflector.

Dedicated Flash for Automated Close-Up Exposures

Some dedicated flash/camera combinations can be used to take fully automated close-up photographs. The Contax 139 Quartz camera incorporates two through-the-lens metering systems. A prism sensor reads the continuous light for normal exposures, while a film plane sensor is used to determine flash exposures. The internal flash meter governs the light output of the flash and provides precise exposures with the preselected aperture. This type of flash/camera system also insures accurate exposures for close-up and macro flash photography when you use extension tubes or a bellows.

A close-up flash setup can use a handle-mount flash unit with a remote sensor carefully aimed at the subject from the camera location. The sensor has an adjustable acceptance angle from 25° down to 10° and a sighting device.

Flash Meters and Close-up Exposures

You can also use a flash meter to read a close-up flash lighting setup, although at extremely close working distances you may find it difficult to position the meter's receptor accurately. One digital flash meter has a flexible macrophotography probe attachment that is designed to function in small spaces. The photographer takes an incident reading as the flash is test-fired, then increases the indicated exposure by a bellow's extension factor to obtain the effective f-stop.

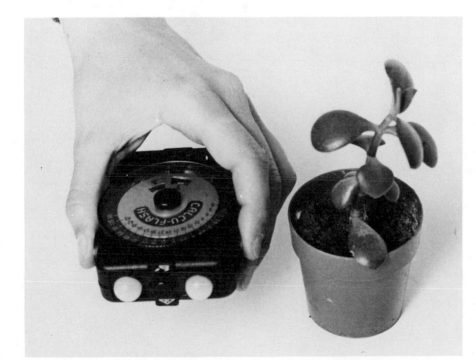

You can use some flash meters to take an incident reading of the flash lighting. Hold the meter at the subject location and aim it at the camera while you test-fire the flash. At extremely close flash-to-subject distances, you must carefully position the meter.

Copy Photography

The factors that make electronic flash lighting useful for close-up subjects make it equally suitable for copy photography illumination. You can effectively light two-dimensional items such as documents, photographs, drawings, or any flat, opaque subject by using one or two portable flash units.

If you use one flash unit to light a flat subject at moderately close range, you should aim the flash from the side, with the main axis of the light directed at the far edge of the subject. This will feather the light across the copy area, while a bounce board returns some of the light to produce a more even illumination.

For the classical lighting setup, arrange two flash units of equal light output. Aim the lights in from the sides of the lens axis to form a 45° angle with the subject plane. You can use a three-way flash connector to join both synch cords to the camera, or equip one flash unit with a photo slave to synchronize the firing. For most EF copy lighting arrangements, it is best to operate the units in the manual mode. You can calculate exposure using the flash-to-subject distance,

To copy two-dimensional material, illuminate it with either one or two electronic flash units. (a) If you use one flash, aim the flash to the far side of the material being copied. Use a bounce board to even the lighting. Use the flash in the manual mode. (b) When you use two flash units of equal light output, position the lights at a 45° angle with the copyboard. You can use a photo slave on one of the units to synchronize the firing. (c) Photographing small three-dimensional subjects or materials with important texture may require that you reduce the light output of one light to create a particular lighting ratio. A handkerchief over one of the flash units will reduce the light by one f-stop for 2:1 lighting. (d) You can place diffusion material between the flash units to soften the light. A single layer of artist's tracing paper disperses the light with little effect on the basic exposure. (e) Shiny subjects such as jewelry or tools pose a different close-up lighting problem. You can minimize reflections by placing the subject in small paper tent. Support the tent on sheet of ¼" plate glass. Place a bounce-light paper under the glass to eliminate cast shadows.

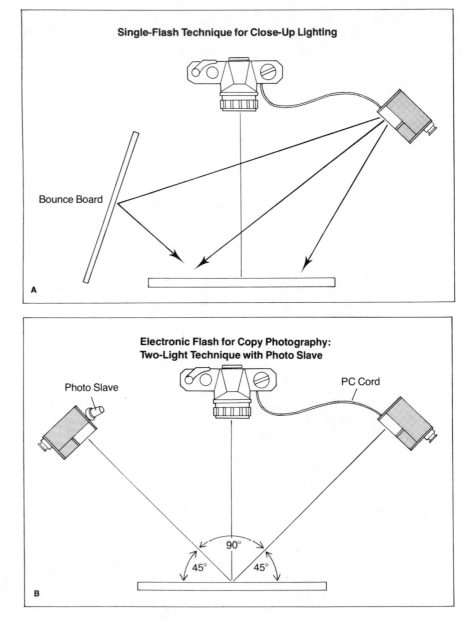

Single-Flash Technique for Close-Up Lighting

Bounce Board

A

**Electronic Flash for Copy Photography:
Two-Light Technique with Photo Slave**

Photo Slave

PC Cord

90°

45° 45°

B

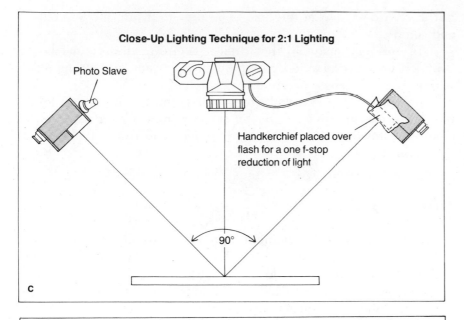

Close-Up Lighting Technique for 2:1 Lighting

Photo Slave

Handkerchief placed over flash for a one f-stop reduction of light

90°

C

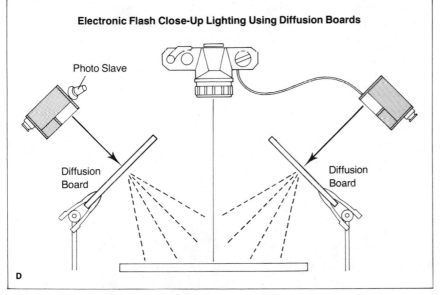

Electronic Flash Close-Up Lighting Using Diffusion Boards

Photo Slave

Diffusion Board

Diffusion Board

D

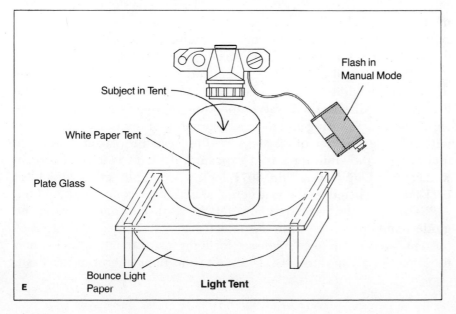

Flash in Manual Mode

Subject in Tent

White Paper Tent

Plate Glass

Bounce Light Paper

Light Tent

E

but it is wise to bracket the final exposures to insure proper contrast and color.

If you must maintain the surface texture of the original in the copy, create a partial side lighting by covering one of the lampheads with a single thickness of white handkerchief.

A subject with a curved, shiny surface may form glaring reflections. You can improvise diffusion screens from tracing paper to increase the relative size of the light sources and soften the specular reflections.

Slide Copying

You should realize that making a high-quality duplicate of a colored slide is not always a simple matter. With the right equipment and film, you can nearly match the color and contrast of a copy to the original; however, you should not expect most improvised lighting setups to produce duplicates of this quality.

Any color reversal film can be used for an experimental copying project; however, if a near facsimile dupe is needed, Kodak Slide Duplicating Film 5071 is the preferred low-contrast copy film for making slides. Fortunately, this film is now available in both one-hundred-foot rolls and 35mm cassettes. Spectral variations with different models of flash units mean that you will need some color correction to bring the duplicate into close color balance with the original. You may also need filters to obtain a good color match between the original and duplicating film emulsions. The total exposure testing procedure will generally require two or three rolls of film. It might be best to use professional duplicating services unless you plan to make slide duplicates regularly.

For some routine duplicating needs, improvised slide copying setups using electronic flash illumination may prove practical. The following description of equipment and procedure is offered as an inexpensive basic approach.

Slide copying is a 1:1 close-up photographic problem. You can buy a slide copying accessory for most bellows systems. The attachment consists of a slide holder, light diffusion plate, and adjustable bellows that encloses the system and eliminates stray ambient light. A flat-field 50mm lens visually establishes the 1:1 ratio.

Position the flash unit off-camera and aim it at the diffusion glass in front of the slide to insure even corner-to-corner illumination. The flash-to-slide distance will vary depending on the density of the slide copy film you are using and the guide number of the flash unit. A flash with a guide number of 32 (ASA 25 film) can be placed about five inches from the slide for a trial exposure of f/8. If you use Eastman Kodak Slide Duplicating Film 5071, look at the suggested starting filter packs that are listed on the instruction sheet that accompanies the film.

Calculate the basic exposure for the flash lighting by using the guide number and the flash-to-subject distance. You should increase the indicated f-stop to compensate for light lost through diffusion and filtration. Vary exposures by (1) altering the light output of the flash;

The Alpha Master Slide Duplicator uses a fiber optic "light pipe" to carry light from the flash unit in the baseboard directly to the film. You can intentionally prefog the film by using an adjustable twelve-step neutral-density filter to control exposure.

(2) changing the lens aperture; or (3) changing the flash-to-slide distance.

One way to achieve high-quality slide duplication is to use specially designed slide copiers, some of which incorporate built-in electronic flash illumination. These units rely on a system of prefogging or preflashing to control the problem of contrast buildup. This permits you to use standard film emulsions instead of the low-contrast duplication film.

One slide duplicator uses a fiber optic "light pipe" to carry light from the flash unit in the baseboard directly to the film. You can intentionally prefog the film by using an adjustable twelve-step neutral-density filter to control exposure. Another slide duplicator has a filter drawer to simplify filtration for special effects or contrast control or to eliminate color crossover. You can set the light output of the EF light source for high, medium, low, or variable intensity to control exposure. When the exposure is made, you can switch off a halogen focusing lamp in the base box.

In addition to simplifying routine slide duplication, these professional-quality copiers simplify making superimpositions, adding bands of color and lettering, creating zoom sequences, or sandwiching two or more slides together in a single composition.

Light Tents for Small Objects

A light tent helps to minimize dark reflections and to eliminate glaring specular reflections when you are photographing small shiny objects. The most common light tent is simply a cylinder of white translucent paper. You direct the flash lighting at the outside of the tent to surround the subject in a consistent wall of light. Of course, you can vary the lighting position and the height and width of the cylinder to control the quality of the light. One flash unit produces a soft directional light when aimed at a wide-diameter cylinder. A small-diameter cylinder and two opposing lights produce a more diffused illumination.

The height of the cylinder governs the dark and light specular components. When the wall of the cylinder is high, the white specular effect dominates and the reflected image of the dark opening at the top of the cylinder is minimized. The increased light area of a tall cylinder works best for dark, shiny objects, while the reduced light area of a short cylinder is best for silver subjects. You can use a high-intensity modeling light to determine the desired lighting factors before you put the camera and flash units into position.

To create a shadowless background, place the light tent on a sheet of plate glass. If you support the glass about ten inches above the copy table, you can use white paper to bounce the light up from below the subject, and eliminate background shadows.

Following page: You can use a light tent to control reflections on highly reflective objects. The tent equalizes the illumination and minimizes information reflected onto the subject from the environment. This photograph of a silver candelabrum required a light tent to illuminate the subject accurately.

Candelabrum designed and executed by John C. Marshall (Sterling silver and ebony)

140

The Behavior of Light Under Water

Using electronic flash under water requires some new information about light. You will encounter four basic illumination problems with underwater photography: reflection, refraction, absorption, and scatter.

Reflection. Natural illumination from the sun must enter the surface of the water from the air. Much of this light is lost as the water reflects the sunlight back into the air. The angle of the sun, time of day, weather, and condition of the surface of the water all affect the ambient light level in the water. Even on an ideal day with full overhead sun, the water diffuses the light and decreases contrast. Reflection is a less serious concern with artificial light sources under water; however, it does reduce the number of occasions when natural light and flash can be combined in a photograph.

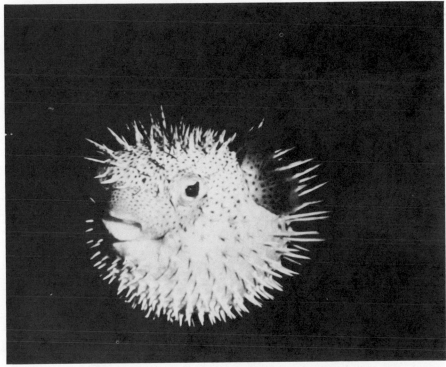

The spines on this porcupine fish make it an ideal subject for single off-camera flash lighting. The photographer exposed the photograph at night and required a battery-operated tungsten location light for focusing and composing. The effect of the focusing light is not detectable in the flash exposure because of the relative high intensity of the flash lighting.

James Gale Livers, *Porcupine Fish,* n.d. Courtesy of Ikelite

Refraction. Water is about eight hundred times denser than air. The speed of light changes at the point where the rays enter the water, and the rays are bent or refracted where this change in speed occurs. If you lower a stick into water, refraction creates the illusion that the stick is bent. Refraction also occurs as the light leaves the water and enters the flat viewing port of a diver's face mask or the camera lens port of the underwater housing.

Refraction accounts for the underwater illusion that objects appear to be about one-fourth larger and one-fourth closer than they actually are. For example, a subject at a distance of eight feet will appear to be only six feet away. These two distances, *real* and *apparent,* are the basis for the telephoto effect which causes subjects to seem closer than they are. The problem is somewhat minimized by the fact that the camera sees the same illusion the eye sees.

Absorption. Absorption is a problem that affects both natural and artificial light. As light travels through water, it selectively absorbs or reduces certain wavelengths in intensity. Longer wavelengths (reds, yellows, and orange) are almost completely absorbed in the first forty-five feet of clear tropical water. The water functions as a blue-green filter, allowing the blue and green wavelengths to predominate. This light absorption is a function of the molecular structure of the water and should not be confused with scatter. Absorbed light is totally lost, while scattered light is merely redirected.

Distilled water has the lowest absorption factor of all water. As the molecular structure of the water is changed by contamination, the light loss due to absorption increases. Since accurate color rendition with natural light is generally not possible at depths below twelve feet, even in the clearest water, some type of artificial lighting is essential for most underwater color photography.

Scattering and Water Clarity. Water clarity can be a serious concern for an underwater photographer who is using electronic flash. As light travels from the flash to the subject and back to the camera, particles in the water may deflect and scatter it. When light is diffused by scatter, the contrast may be greatly reduced. Natural bodies of water contain millions of small particles of sand, debris, and aquatic life which affect image clarity.

Backscatter is the term applied to a particularly acute problem of scatter. Backscatter may occur when the light from the flash strikes suspended particles and is reflected back into the lens. The strong illumination on the particles creates a wall of spots that may totally obscure the subject. The effect is much like trying to drive a car at night in a snowstorm: the brighter the headlights are, the more light bounces back into the eyes of the driver.

Visibility under water varies from day to day and is generally best in water near the equator. Wind and weather may also affect the problem by increasing the turbidity of the water. Visibility is usually stated in terms of how far the eye can see; however, you should divide the visibility distance by four to determine the best range for making a sharp photograph under water.

Underwater Equipment

You can use almost any camera in watertight housing to take underwater photographs, although some cameras are specifically designed for underwater photography and do not require a separate housing. Electronic flash lighting will require the camera to have an X synch shutter setting. A wide-angle lens will compensate for some of the refraction problem, is easier to prefocus, and offers more depth of field.

Although special underwater electronic flash units are manufactured, you can use any standard flash unit to light an underwater photograph, if you place it in watertight housing. Several firms will design and assemble custom underwater housings for almost any piece of photographic equipment.

Kristine Nelson, *Basket Star*, 1979

A single underwater flash will prove adequate for most light-colored subjects. The photographer shot this basket star at close range to insure that the beam of the flash covered the subject.

Underwater housings are usually made from metal, Plexiglas, or Lucite. Plastic housings have several advantages over metal ones. The plastic is lighter in weight; you can easily see your camera controls through the plastic; and you can quickly detect leaks before water damages the equipment. Metal is preferable if you are going to use the housing at depths where water pressure might crush plastic.

The more complex camera housings feature remote controls for all of the operating mechanisms of the camera. You must house the flash unit and the camera in separate containers, however, to avoid

James Gale Livers, *Underwater Photographer*, n.d. Courtesy of Ikelite

This underwater photograph illustrates the off-camera flash technique for reducing backscatter. The flash is housed in its separate waterproof case, as is the camera. A heavy-duty synch cord links the flash to a solid-state triggering device housed with the camera to insure reliable operation of the flash. It is important to test-fire equipment underwater before embarking on actual location photography. Malfunctioning electrical connections are the most common source of problems with underwater photography.

143

Underwater Flash

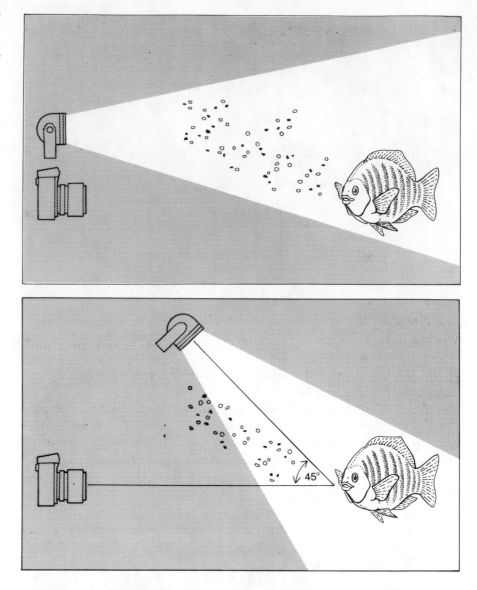

Top: The typical on-camera flash position will predictably emphasize the effect of backscatter from small particles suspended in the water. The light from the flash bounces directly back into the camera lens, decreasing the contrast and obscuring the subject. Bottom: If you position the flash off-camera at a higher lighting angle (ideally 45° with the subject-lens axis), you greatly reduce the effect of the backscatter.

lens flare from the flash. The camera and flash packages should have a neutral or slightly negative buoyancy for easy control. The final link is a waterproof synch cable that connects the flash and camera housings.

Electronic flash has become the preferred artificial light source for underwater photography. You can take black-and-white photographs at depths down to eighty-five feet in clear water if the sunlight is directly overhead; however, accurate color photography requires some type of artificial illumination. EF lighting offers a number of advantages:

1 The light from EF is balanced for daylight (5600K), which means that fast daylight color films can be used.
2 EF lighting is simple to operate. You can make repeated exposures without surfacing or changing flashbulbs under water. You can also use two or more flash units simultaneously to increase the light level.
3 The short duration of the flash helps reduce the blur caused by camera movement or a rapidly moving subject. It also de-

creases the scatter of the light caused by moving particle matter.

4 You can use electronic flash lighting at greater depths than flashbulbs, without concern for adverse pressure effects. Flashbulbs may misfire at depths below one hundred feet.

5 Electronic flash is portable and minimizes size and weight problems. An EF unit has a smaller power requirement than a continuous light source such as a standard diver's light.

Flash Techniques Under Water

The photographer must modify the standard in-air flash techniques to solve the problems of underwater lighting. He or she needs off-camera flash to avoid some of the problem of backscatter. To minimize backscatter from suspended particles, aim the flash at a 30° to 45° angle to the camera–subject axis. The ideal flash unit for underwater photography should produce a beam of light with very sharp dropoff at the edge. This tends to reduce the illumination of particles near the camera and to decrease scatter.

It is important to remember that most of the effective light from a flash unit is lost under water because of scatter and absorption. A flash guide number is based on a light-in-air exposure, so you must divide the normal guide number of a flash by four to compensate for the loss of light. This loss factor of four is an approximate starting point and will vary according to water clarity and purity. The drastic reduction in light effectiveness means that twelve feet is about the maximum distance for the average EF unit under water. Small EF units may prove useful only for close-up photographs.

Refraction creates two problems for the flash photographer. Although you focus the lens based on the apparent subject distance, you must divide the real distance into the guide number to compute the f-stop. Most flash units cover a field of view of about 70°, which is adequate for the coverage of a normal lens. Refraction reduces the angle of the light output by about 40 percent. A flash unit's light output angle of 70° in air will narrow to about 40° when the unit is fired under water. When you combine this reduced beam of light with a moderately wide-angle lens that has an angle of view of about 75°, you must carefully aim the light from the flash to insure that the center of the field or the main interest of the photograph is illuminated.

The waterproof synch (PC) cord that connects the flash housing and the camera housing is the weak link in the lighting system and the source of most firing problems under water. Normally, very small currents of relatively high voltage fire the standard flash unit in above-water situations. Under water, the moisture and the longer and heavier connecting cord increase electrical resistance. The ideal underwater triggering circuit is a low-voltage one that has its own power source and uses a solid-state silicon-controlled rectifier or solid-state switch. This type of triggering circuit cannot damage the shutter contacts, but will compensate for the effects of the wet environment. The solid-state triggering device and its power supply are usually located in the camera housing. The booster trigger circuit connects to the standard PC cord of the flash and the synch terminals of the camera and virtually

Underwater Flash

The camera and flash unit are contained in waterproof housings, which are connected with separate triggering cords. Special adjustable flash brackets simplify positioning the flash. Sidelighting is useful for delineating textured surfaces, such as the coral head.

eliminates the misfiring traditionally associated with electronic flash units.

You can operate a flash unit with a remote light sensor device in the automatic mode if the sensor is located in the camera housing and aligned with the lens-to-subject axis. An automatic flash unit that does not have a remote sensor must be used on its manual mode when it is fired under water, since light bounced back into the sensor from the interior of the housing would cause the sensor to limit the exposure prematurely.

Two flash units mounted on a bracket at 45° angles and above the lens-to-subject axis will compensate for light lost by absorption and will position the lighting to reduce backscatter. When the light level or the angle of light output is inadequate, try moving in for a close-up.

An assistant can hold a second flash off-camera if the flash is equipped with a photo slave. You can use this second light for additional side lighting or back lighting without any increase in exposure. However, you should test the master flash on the camera to determine the optimum firing range for the most reliable photo-slave distance.

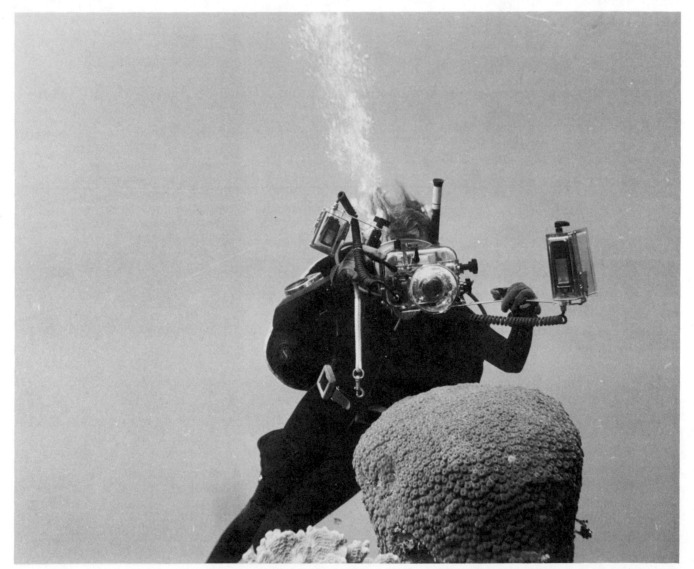

James Gale Livers, *Coral Head,* n.d. Courtesy of Ikelite

These underwater photographs of a moray eel and a grouper were made in the relatively clear Australian coastal waters. A single flash in a separate housing was held off-camera to minimize backscatter. A 35mm lens and a small f-stop were used to insure the depth of field needed for the close camera-to-subject distance.

Dan Keffler, *Grouper,* 1978

Dan Keffler, *Moray Eel,* 1978

Lighting an Aquarium

Electronic flash is the ideal indoor light source to use for photographing the interior of an aquarium. Conventional floodlights can quickly raise the water temperature and possibly kill fish and other aquatic subjects. Flash is quick and cool.

The simplest EF lighting requires you to place a single flash unit overhead and aim it at a 45° angle to the vertical front of the tank. Direct part of the light into the open top of the tank. Use two flash units of equal size and light output to provide a more even lighting. Place them at opposite sides of the camera and angle them at the standard 45° to the axis of the lens. An additional overhead flash unit will illuminate the background and simplify the composition.

As in other cases, you can control exposure by varying the light output or changing the distance of the lights from the subject. Since the density of water and glass cause some light loss, you should add one-and-one-half to two stops of light to the standard exposure calculated from the guide number of the main light.

Air-to-glass and air-to-water surfaces cause additional light loss. The amount of light lost depends on the angle between the lighting and the surface of the glass. At 45° the loss is slight. A 15° angle requires a one-stop increase. An oblique angle of 10° may require an increase of more than two f-stops.

To minimize the suspended-particle problem, be sure that the water in the tank is clear. Clean the walls of the tank and select a side that is free of scratches. Outline the area of the prefocused picture with tape on the wall of the tank, and, with camera and lights in position, guide the fish into the picture area. You can temporarily isolate the fish or trap them in the picture area by using a number of confining techniques. To calm a fish that is too active, place it briefly in carbonated water.

Do not use an opaque panel as a restraining wall, because it will carry a shadow of the subject and destroy the underwater illusion. However, you can avoid troublesome reflections on the back glass of

Off-camera flash works well for lighting this glass-tanked lion fish. The photographer minimized potential glare from the glass by the careful placement of a single flash at a 45° angle with the lens-to-subject axis. Because of the small amount of water between the camera and the subject, water absorption posed no problem; however, light loss due to the angle of the flash and reflective glass required a two f-stop increase over the exposure indicated by the flash calculator dial. A black cloth draped the camera, the tripod, and the photographer.

Ron Carraher, *Lion Fish,* 1979. Courtesy of Seattle Aquarium

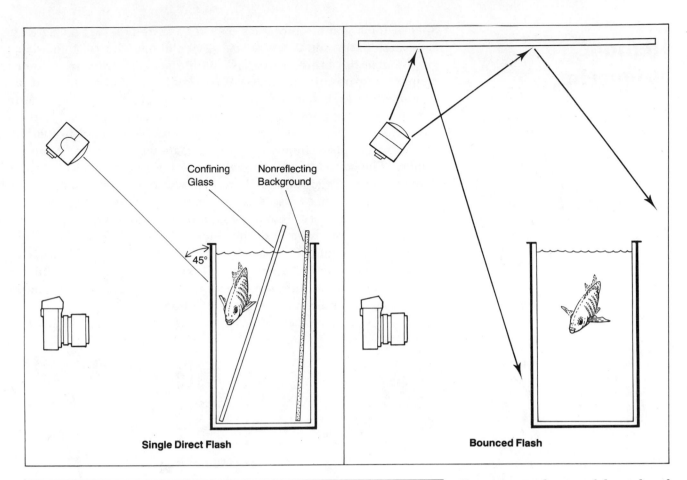

Confining Glass

Nonreflecting Background

45°

Single Direct Flash

Bounced Flash

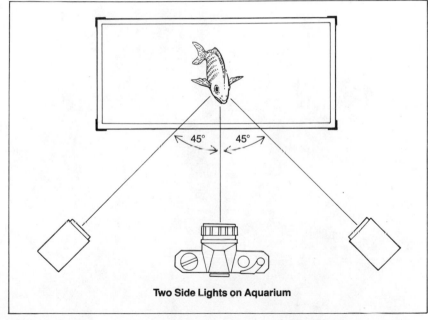

45° 45°

Two Side Lights on Aquarium

Variations in the size of the tank and the subject may require different aquarium lighting techniques. You can place a white card over the tank for a diffused effect with soft shadows. If you use a confining glass, angle it to direct possible reflections away from the film plane. You can achieve near-shadowless lighting with two matched flash units placed at the classical 45° off-camera positions.

the tank by placing an opaque background in the water at the rear of the tank and eliminating one glass-to-air surface. Choose a matte background that will contrast with the value and color of the fish.

To eliminate reflections of the camera and tripod on the front surface of glass, install a black shield over the front of the camera. This shield should be twice the size of the camera field and should have a hole cut in it to allow clearance for the lens.

Remote Triggering Devices

Special photographic problems may require remote triggering of the camera or flash unit. A triggering device allows the photographer to synchronize the firing of the flash with a specific point in time or to couple the exposure precisely with a predetermined event. The photographer's presence may or may not be required. A remote triggering device extends a photographer's control in documenting subjects that are normally inaccessible; for instance, a precise moment in the flight of a bat would prove impossible to anticipate with a manually operated camera. The sound of breaking glass can become a substitute for the photographer's finger on the shutter release of a surveillance camera. Remote firing devices also solve the problem of keeping a photographer at a safe distance from a potentially hazardous event.

Because you fire a flash unit electrically, a variety of ways exist to activate the light using mechanical or electrical devices. Nearly any measurable physical change may function as a triggering stimulus. Motion, light, sound, infrared radiation, temperature, or time can provide the basis for a remote triggering system.

This photograph of a brown bat was made in the laboratory of Dr. Harold E. Edgerton at MIT. Special triggering devices may sometimes be required to insure that the flash is fired at a crucial point of action. (Electronic flash photographs of bats in flight led to a more accurate understanding of how these creatures use their tail membrane to guide their flight and to form a pouch for trapping flying food.)

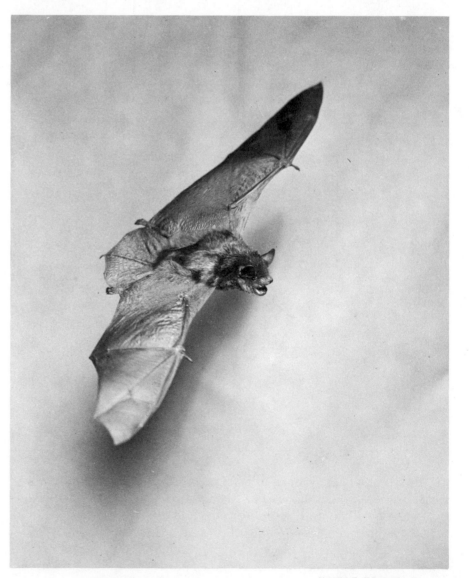

Harold E. Edgerton, *Bat*, n.d.

Sound Triggers. A sound-activated triggering device can be indispensable if you want to time the flash to fire at a precise moment. The sound trigger converts the energy of a noise into an electrical impulse that in turn fires the flash. Since sound travels at about 1100 feet per second, you can place a microphone to determine the slight delay needed to photograph the exact moment when a bullet pierces an apple or a lightbulb shatters on the floor.

You can improvise a sound triggering system from almost any tape recorder that has an external speaker or earphone outlet. You will also need an additional electronic component called a silicon-controlled rectifier (SCR). This solid-state switch should have a minimum rating of 400 volts and can be purchased at most electronic supply

 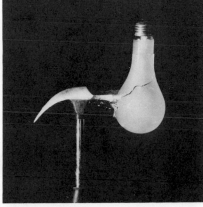

This sequence of three different breaking lightbulbs illustrates how you can vary the microphone distance of a sound-triggering device to control the exact instant of a flash exposure. The lightbulbs were suspended on black thread and swung into the fixed position of the hammer. The photographer opened the camera shutter as each bulb was dropped toward the hammer and closed it quickly after the impact. A single off-camera flash was triggered by the sound being monitored by the microphone.

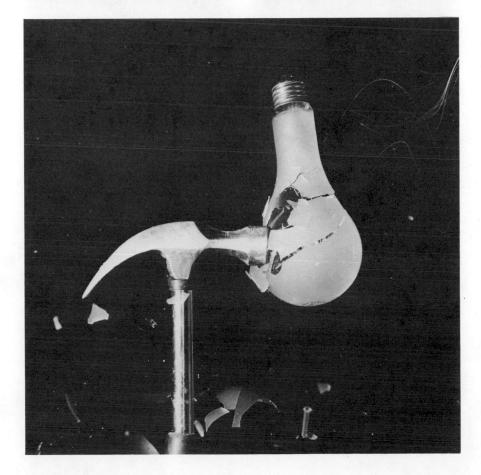

Remote Triggering Devices

stores for a few dollars. The flash PC cord (synch outlet) is first connected to the SCR and is then connected to the sound outlet on the recorder as illustrated in the wiring diagram. When you operate the recorder in the record mode, the microphone converts the sound in the environment into a series of electrical fluctuations. Each time the sound level reaches a preset peak, the impulse will close the gate of the SCR and the flash will fire.

The sensitivity of this type of trigger can be controlled by the placement of the microphone. The closer the microphone is to the sound source, the shorter the delay in firing. For best results try to eliminate background noise. Because the camera shutter must remain open during the entire sequence, it is important to work in a darkened room. Photographs of breaking light-bulbs or splashing drops of milk may require a few tests for you to determine the ideal delay needed for a particular stage of the action.

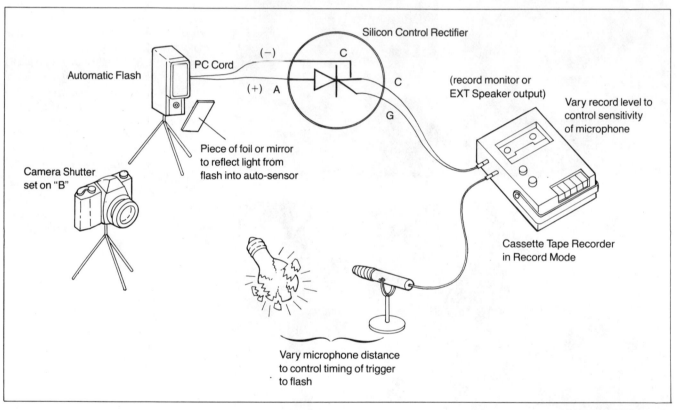

This diagram illustrates the necessary sound-triggering component you need to improvise an inexpensive but highly sensitive sound-triggering system for flash exposures. The cassette recorder must include a record monitor or external speaker output and a separate microphone with variable level control. The silicon-controlled rectifier allows the sound to close the triggering circuit of the flash.

Radio-controlled Triggers. You can also fire a flash unit on command from a radio-controlled unit. Transmitters vary in power, but you can locate them as far away as several miles from the receiver. When you broadcast a signal, the receiver closes an electrical contact to fire the flash or operate the camera's electric motor drive, which in turn fires the flash unit. With some remote control equipment, you can achieve simultaneous photography using two or more cameras. The Ritz Camera Company markets a number of remote-control units. Some units either trigger an electrical signal or activate a solenoid to operate a standard cable release mechanically. Other, more complex models allow for separate control of film advance or flash firing.

152

Mechanical Triggers. You can easily construct a number of home-made devices that will mechanically close an electrical contact and fire the flash or activate the camera. The common mousetrap is an old favorite of wildlife photographers. When a passing animal trips the string, the trap snaps shut and depresses the cable release, which fires the flash. It is a one-shot operation, but it does not require sophisticated equipment.

Photocell Triggers. A photoelectric cell is the basic component of any device that uses interrupted light as a triggering source. Depending on the design of the photo cell, the trigger fires the flash when light falls on the cell or when an existing light level is decreased or blocked. The design of the cell also determines such variables as time delay and sensitivity. You can use a pair of photoelectric cell circuits to pinpoint an exact target for the camera. Prefocus the camera on the target spot, and when a creature such as a bat flutters through the beam of light, the cell instantly fires the camera and flash. You can also use invisible infrared radiation to trigger a standard photo cell.

Specialty Triggers. Edmund Scientific Company markets a number of devices that you can use to design electrical flash triggering systems. The Edmund Whistle Switch is turned on and off with an ultrasonic sound transmitter. The company also markets a pressure-sensitive switch that closes its electrical contacts when a pressure of less than .02 psi is applied.

The Ritz Camera Company markets a motion detector. This device incorporates two photo diodes which are aimed at a target area; they close a circuit when even a slight movement occurs within their range. The detector is battery- or AC-powered and features an optional audible alarm.

You can also use time to program the operation of the flash and camera. To program a series of exposures taken at precise time intervals, use either an electrical or a mechanical timer, which will close the contacts of the motor drive on the camera and/or the flash unit.

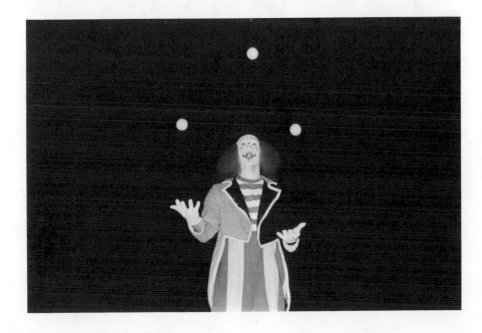

The human reflex lag varies from $\frac{1}{7}$ second to $\frac{1}{4}$ second or longer. This factor makes it difficult to capture fast action at a particular point in time with a hand-triggered exposure. To insure that the juggler was at a precise stage of action, the photographer held the camera shutter open and fired the flash manually in subdued studio light. This technique eliminated the difficulty of trying to observe the action through the camera viewfinder.

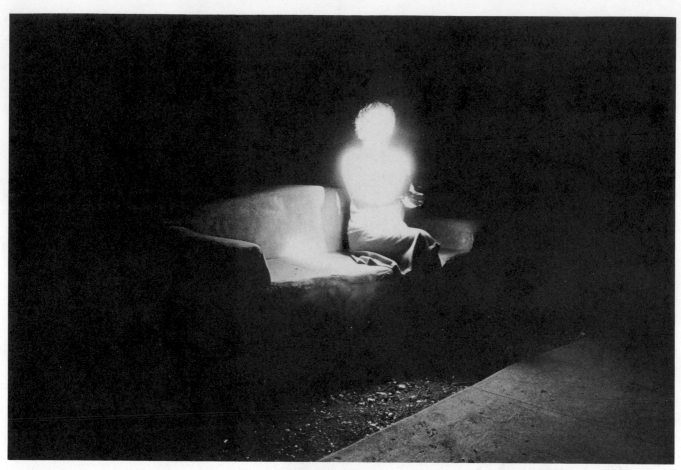

Colleen Chartier, *Connie with Flash, 1977*

The subject in this photograph participated in making the exposure by manually firing the flash at herself when the photographer signaled that the shutter was open. Foreground illumination is created by light bounced from the seated figure.

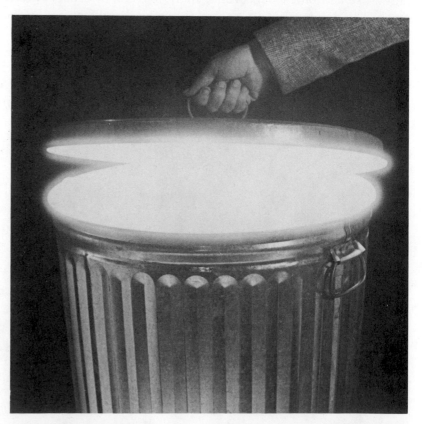

You can position a second flash in an unusual location if you can attach the photo slave to a PC cord and thus conceal the triggering device. An on-camera flash was used to trigger a flash unit in the garbage can to illustrate the theme of energy from recycled waste.

Journal of Contemporary Business, Univ. of Washington, Colleen Chartier, Photography

High-speed Flash

Electronic flash is the ideal light source for stopping subject motion or eliminating camera movement. Electrical control of the illumination turns the light on and off more quickly than most mechanical shutters can open and close, and the relatively short (1/1000 second) flash duration of the typical flash unit adequately freezes most action. You must also consider factors such as focal length of lens, direction of movement, shutter speed, camera movement, and camera-to-subject distance when you are attempting to eliminate the blur of a moving subject.

Faster subject motion will require a shorter light duration. Standard-sized portable flash units with variable power control or automatic exposure circuitry can produce flash durations as short as 1/50,000 second. A flash speed of 1/50,000 second will arrest the movement of such subjects as splashing milk, a breaking lightbulb, the flight of a pigeon, or a close-up of a jumping spider.

Since flash duration is directly related to power output, each 50

Freezing Action

Dr. Harold E. Edgerton's classic milk-drop photograph demonstrates the ability of the flash to freeze action normally invisible to the human eye. A drop of milk falling onto a thin film of milk over a glass surface sets the stage for the action. As the drop hits the surface, the unstable column of liquid segments into a crown of equidistant drops connected to the splash site by narrow fingers. Although Dr. Edgerton exposed this photograph by using special laboratory flash equipment, you can use a variable power output on a standard flash unit to shorten the flash duration to a speed of approximately 1/50,000 sec., short enough to stop the close-range movement of a splash. You can use a sound-triggering device to monitor the impact of the drop on the glass and synchronize the firing of the flash.

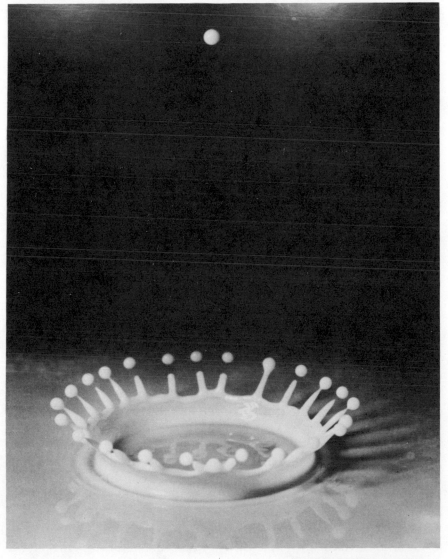

Harold E. Edgerton, *Coronet,* n.d.

percent reduction in power creates a corresponding 50 percent reduction in flash duration. You can set a variable power flash unit with a seven-stop light reduction range on 1/128 full power to achieve a light duration of 1/50,000 second. You can also produce a short-duration flash of approximately 1/30,000 second by using an inexpensive flash unit that has an automatic exposure control feature. When you fire the unit, you directly channel a part of the burst of light into the sensor from a small paper scoop taped onto the flash housing beside the sensor opening. The sensor responds as though the light were being bounced from a nearby subject. This prematurely terminates the flash and creates the "faster" light. You should open the lens aperture to compensate for the four- to five-stop decrease in illumination. When you utilize durations shorter than 1/10,000 second, you may need some compensation for reciprocity failure (see Kodak reciprocity reference chart).

Stroboscopic Photography

Normally, you use a flash unit to expose a single image on the film. If you fire the flash successively at a controlled rate, the pulsing light appears to freeze or slow down rapid motion. The word *stroboscope* combines the Greek roots *strobos* ("twirling") and *scope* ("watcher"). Although the word *strobe* has become a popular synonym for electronic flash (and a product name), in the strict sense a strobe or stroboscopic light is one that can be rapid-fired to illuminate a moving subject intermittently. You can attach some standard flash units to a motor-driven camera and rapid-fire them for short bursts of five to ten flashes per second. However, to achieve longer and more controlled rapid-fire sequences, you will do best to use special stroboscopic flash units designed to withstand the added heat created by the sustained flashing rate. Portable stroboscopic flash units with variable flash rates (usually 1 to 100 flashes per second) are commonly available on a rental basis from display or theatrical lighting dealers. The light output from such equipment is somewhat low for photography; however, the light is adequate for subjects within a ten-foot flash-to-subject range.

The duty cycle is the time that is required between flashes in order to fire an EF unit safely, without damaging the flash tube. Some manufacturers will specify the practical limits for their product when it is used in this rapid-fire mode, or they may recommend a heavier-duty flash tube. Factors that affect the duty cycle include the wattage of the unit, the size of the flash tube, and the cooling efficiency of the lamphead. If you exceed the duty cycle of a flash unit, you can overheat the flash tube and permanently damage the flash unit. Small flash units will repeat-fire more quickly when set on the automatic mode.

Each stroboscopic lighting project requires careful planning. If part of the subject remains static during the multiple firing of the strobe light—for example, a hurdler is moving but the hurdle is stationary—a partial overexposure will result. If the static object is dark-toned, the buildup of light will be less obvious.

The following considerations are useful when you are attempting to rapid-fire a flash for either single-frame or motor-driven multiple exposures:

1　The flash unit should be equipped with a power source that insures fast recycling.

2　Most flash units will recycle faster when operated in the automatic mode.

3　For a single-frame exposure, use a lens with a field of view that is sufficient to cover the length of the action.

4　Do not exceed the duty cycle of the flash unit.

5　You may need reciprocity compensation for extremely short (1/10,000 second and shorter) flash durations.

6　Base exposure on the main light of a multiple EF lighting setup, unless you have several lights aimed at the same highlight area.

Dr. Harold Edgerton explored many of the possibilities of stroboscopic photography during his pioneering work at MIT with electronic flash. Some of his most elegant images were stroboscopic studies of the movement of tennis players and golfers, photographed at rates of sixty flashes per second.

This multiple-exposure motion study of a golf swing was made by Dr. Edgerton at his MIT lab in 1938. By analyzing the spacing of the club images and the known time between flashes, you can calculate the changing velocity of the club and the ball. The strobe used for this photograph was set to fire at a rate of 100 flashes per second, with a flash duration of 1/1,000,000 sec.

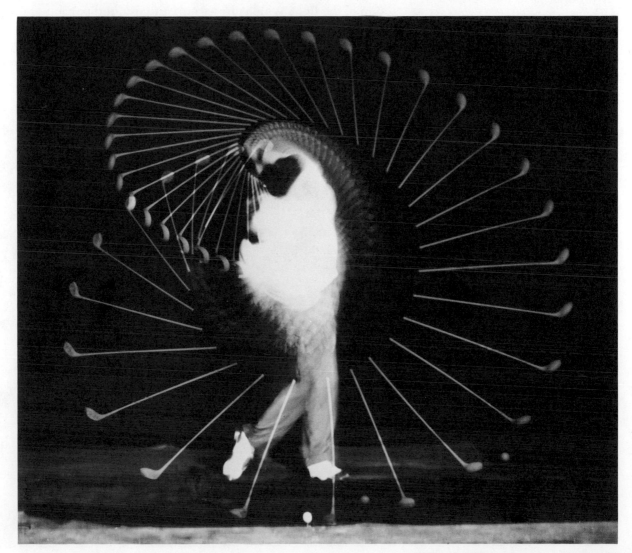

Harold E. Edgerton, *Densmore Shute,* c. 1935

Infrared Flash

You normally use an electronic flash unit to create visible light for a standard photographic exposure. In addition to the visible spectrum of energy, a flash unit creates invisible energy at both ends of the visible spectrum. Ultraviolet radiation is just beyond the relatively short wavelengths of visible violet. At the other end of the spectrum are the visible red wavelengths. The wavelengths that are longer than the visible red are termed *infrared,* meaning "below the red." The infrared region extends beyond the end of the visible region and eventually merges into heatwaves, radar, and finally radio waves. A small portion of the total infrared spectrum (between 700mm and 900mm) is photographically actinic and can be used to create both color and black-and-white photographic exposures. Since standard photographic emulsions are not sensitive to infrared radiation, you can make an infrared photograph only by using special infrared films.

Infrared film emulsions are sensitive to violet, blue, and visible red in addition to infrared. Ordinarily, you must use a red filter on the lens to block the undesired visible radiation. You may create the image formed on the film totally with infrared radiation, or you may make it by mixing infrared radiation with visible light. The most dramatic infrared results are generally associated with the most selective filtration of the light, which allows only the infrared portion of the spectrum to form the image. For this reason, infrared films are generally sensitized to the 800- to 900-nanometer portion of the infrared spectrum.

All standard flash units emit both visible light and infrared radia-

Since all flash units emit considerable infrared radiation, all you need for infrared flash photography in a darkened room are a Wratten 87 filter and infrared film. This portrait illustrates how infrared radiation penetrates the surface of the skin and begins to record a pattern of veins and arteries.

Luther Smith, *Brenda,* 1976

158

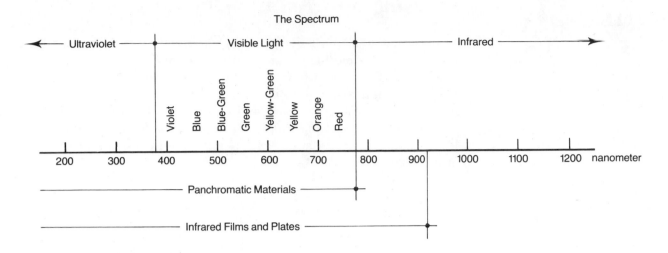

The Spectrum

← Ultraviolet ——————————— Visible Light ——————————— Infrared →

Violet Blue Blue-Green Green Yellow-Green Yellow Orange Red

200 300 400 500 600 700 800 900 1000 1100 1200 nanometer

—————————————— Panchromatic Materials ——————————————

—————————————— Infrared Films and Plates ——————————————

tion when you fire the flash tube. You can cover the flash lamphead with infrared filter material, such as Kodak/Wratten Filter No. 87 or 87C, to minimize or completely exclude the effects of visible light, but only flash units with sufficiently high guide numbers will respond to this nearly opaque filter material. EF units in the 100 or 200 watt-second range work best for this application.

Two electronic flash units are manufactured for use as primary infrared light sources. One, a portable flash unit, features an interchangeable infrared lamphead. A guide number of 80 is suggested when the unit is used with high-speed infrared film. The other infrared electronic flash unit is a handle-mount flash designed exclusively for use with infrared films. It offers two power ranges and can be operated on five different power sources. Its guide number is similarly rated at 80.

Flash tubes fired at a lower voltage emit more infrared radiation than the standard EF unit does. The infrared radiation emitted by both the EF units mentioned above is completely invisible to the naked eye. If a subject is looking directly into the lamphead, he or she can perceive the faint ruby-red glow of the flash tube, but for most applications you can use these flash units to expose infrared film without detection.

This energy spectrum shows the relatively narrow band of wavelengths that are involved in creating an infrared exposure. Although the total infrared spectrum ranges from 800 to 1200 nanometers, infrared film is designed for the more selective response indicated.

These two portraits of the same subject compare the response of infrared film and conventional film. Visible colors and values are often dramatically altered when photographed under infrared light. Infrared also minimizes the texture and wrinkles of the skin, as it literally enters the skin before reflecting.

159

Focusing Infrared

Infrared radiation must be focused at a slightly different point than that used for visible light. Lenses of recent vintage are marked with a red line, an R, or an IR to indicate the correct infrared focus point. At present, no universally accepted standard for marking this lens calibration exists; however, normal and shorter focal-length lenses usually have sufficient depth of field to insure reasonable sharpness. Mirror lenses and fluorite-crystal lenses generally require a smaller correction or no correction at all.

Filters for Infrared

When infrared radiation from the flash is the sole energy source (there is no visible light), you do not need to use filters on the camera lens. However, in bright sunlight you should use a Wratten 87C filter to reduce the effect of the ambient visible light. This nearly opaque filter is too dense for through-the-lens viewing. You must compose and focus before attaching the filter. In average daylight, use a Wratten 87 or 87A filter, and in low-level light, use a Wratten 25 filter, which permits through-the-lens viewing with reflex cameras.

This food exhibit at a state fair was located in relatively subdued light. Infrared flash provided the primary source of energy for the exposure. A wide-angle lens reduced the need for critical focusing.

Ford Gilbreath, *Southwest Washington Fair,* Chehalis, Wash., 1976

Infrared Color Photography and Flash

You can accomplish infrared color photography by using a daylight color film that has been sensitized to infrared. This special film incorporates green-, red-, and infrared-sensitive layers, replacing the blue, green, and red layers of typical color film. Use a yellow filter to block the blue to which these layers are sensitive. The visible light and the infrared radiation combine in infrared color photography to produce a modified color rendition. A yellow-positive image is recorded in the green-sensitive layer, positive magenta is recorded in the red-sensitive layer, and the positive cyan image is exposed in the infrared-sensitive layer. Secondary colors depend on the exact amounts of green, red, and infrared reflected or transmitted by the subject. An electronic flash unit is an ideal light source for indoor or nighttime infrared color film.

It is best to use a Wratten 12 filter on the lens when you are exposing color infrared film. You can use the visible light on the subject for focusing, and no shift from visible focus is required. (Detailed information on the applications, handling, and processing of infrared emulsions is available in Kodak publication M-28, *Applied Infrared Photography.*)

The Sunpak Nocto 400 Infrared flash unit is a handle-mount unit designed to emit only infrared radiation. The unit features high and low output levels. Operation of the flash is similar to that of a standard flash unit; however, the subject cannot detect the burst of infrared radiation.

Infrared Technique

A black-and-white photographic image created with infrared radiation on infrared film has a unique visual character. Contrast and sharpness are reduced by both the grain of the emulsion and the diffused edges of the image. Ordinary reflected-light relationships are often reversed; a red apple appears almost white in black-and-white infrared. Skin tones acquire a consistent value as blemishes, freckles, and even birthmarks disappear. Many subjects seem to glow with an interior source of illumination. Reflective surfaces concentrate the infrared radiation to form unusually bright hot spots.

You can calculate exposure by using the basic guide number for the film and flash divided by the distance. Test exposures may be required because the indicated infrared output of a given flash unit is generally only an estimation. Infrared images are sharpest when the aperture is f/11 or smaller. Infrared, at best, will not appear critically sharp when compared to standard black-and-white films.

To maintain proper shutter synch, a between-the-lens shutter should not be set faster than 1/500 second. Faster shutter speeds may exclude part of the usable infrared radiation.

Infrared radiation will trigger most photo-electric slave devices; thus the standard photo slave can be used to fire two or more infrared flash units in synch.

Some electronic flash meters and the automatic light sensor of a standard flash unit respond to and measure infrared radiation. When a standard flash unit lamphead is filtered to produce infrared and is being used on the automatic mode, the range of the automatic sensor is effectively cut by one half of what it would normally be with the

These two sets of comparison photos illustrate some of the differences between visible-light and infrared exposures. The pretzels acquire a rubbery, plastic surface quality when photographed with infrared flash. The apples show the near total reversal of the expected reds. Infrared film has a readily identifiable grain structure which tends to eliminate detail and soften edges.

standard light head. For example, if the calculator dial indicated that the automatic mode is set for a twenty foot maximum distance, the sensor is accurate only with infrared to a ten foot maximum distance.

For the best possible definition and contrast a subject should be illuminated with the infrared lamphead off-camera and aimed at a 45° angle to the subject-lens axis. Automatic flash settings can be used; however, reciprocity problems may occur at flash durations shorter than 1/1000. The manual mode is generally preferred. (For more comprehensive information on the use of infrared film, refer to Eastman Kodak publications N-17, *Kodak Infrared Films*, and M-28, *Applied Infrared Photography*.)

Infrared film compresses the tonal range of the subject. The narrow latitude means less depth of light and a pronounced falloff at close range. In this infrared exposure, the dark background makes the plants more obvious.

163

Lightning: Natural Flash

A flash of lightning during an electrical storm provides an interesting example of both the effect and the physics of a high-voltage light source. Lightning is a secondary effect of electrification during thunderstorm-cloud movement. There is no completely acceptable theory that explains the complex process leading to bolt lightning; however, we can describe the predisposing conditions. The thunderstorm cloud usually has a positive charge concentrated in its upper layers and a negative charge in its lower portions. The earth is normally negatively charged with respect to the atmosphere, but as the thunderstorm cloud passes over the ground, the earth becomes positively charged. The ground charge is several square miles in area and follows the storm like an electrical shadow. The air is normally a poor conductor and prevents the flow of electricity. The potential for a current flow between the positive earth and the negative portion of the cloud must build up to nearly 100 million volts before the surge of current, in the form of visible lightning, bridges the gap between the cloud and the ground in a flash that may last several seconds. Lightning occurs in many forms; however, classic streak lightning is the form seen most frequently.

You can photograph lightning with a fairly simple complement of equipment and technique. You need a sturdy tripod to accommodate the long exposure necessary to capture the exact moment of the flash. Set the shutter on T or B and use a cable release to minimize vibration. Set the focus on infinity and use a focal length appropriate to the scale of the expected display.

A time exposure of several seconds might catch more than one bolt on a single frame. Try to avoid lengthy exposures, especially with color-slide film, because of the danger of overexposing foreground areas. Low clouds may produce a bounced-flash quality of light that will illuminate foreground areas. You must also consider lights from cars or buildings as a variable affecting the longer exposures. Limiting exposures to a single lightning flash per frame will generally produce more contrast in the negatives. The short exposure time will also reduce the effects of ambient light.

The following aperture settings offer a reasonable beginning point for bracketing exposures:

ASA	Aperture
25	f/3.5
64	f/5.6
125–160	f/8
400	f/11

Some safety precautions are in order when you are photographing lightning, since over 175 Americans are killed each year by these electrical flashes. Try to shoot from inside a building, but also avoid metal conductors. Avoid locations on high ground or near water. If you feel a tingling and your hair stands on end, immediately abandon your tripod and drop to the ground.

High-Contrast Photography with Flash

Electronic flash lighting is quite useful when you are photographing a subject as a high-contrast image. The flash simplifies the problem of producing the illumination level required for most high-contrast photographic materials. Kodalith Film and Kodak High Contrast Copy Film (with 35mm) and similar high-contrast materials perform best with strong lighting contrast. You can also use conventional continuous-tone film to produce a high-contrast effect, by slightly underexposing and overdeveloping the negative and printing on a #5- or #6-grade enlarging paper.

Use the directional light from the flash to preserve surface textures and create crisp shadows that delineate form. When you render a subject in black and white without intermediate gray tones, the graphic concept depends on lighting control.

Sheila Mullen, *Optic Study II,* 1979

Sheila Mullen created a special environment of high-contrast polka-dotted materials for her series of high-contrast photographs. Strong frontal illumination eliminated cast shadows and allowed changes in the scale and direction of the pattern to structure the composition.

Some office copy machines rely on an electronic flash light source which fires a burst of light to expose each copy. Both the price of a single copy and the unique graphic character of this kind of image make this process useful for experimental photographic projects.

You can place flat originals and/or three-dimensional objects on the copy glass to produce an electrostatic print. Depth of field is limited, but since the lens is designed with a small f-stop, you can expect a reasonable two-inch depth of field beyond the copy glass. You might need a white backing paper to bounce the light from the flash back around the subject to achieve better illumination. You can make your copies on different paper stocks or reprint them on the same sheet to produce multiple-exposure effects.

Copy Machine Flash

An office copy machine can be used to make images of three-dimensional objects.

Barbara Vogel, *Feathers and Bird,* 1979

Flat images and small light-colored three-dimensional objects are best suited to the limits of the typical office copier. The design at left incorporates a photograph of a bird and actual feathers, which were arranged face down on the glass. The copy of the fresh bananas (following page) has a dark background because the reflective cover sheet was not used.

167

W. H. Fox Talbot made silhouette or shadow photographs, often called *photograms*, in 1834 when he placed such found objects as lace and leaves on photosensitive paper to produce a direct print. The sun provided a strong point light source that rendered the shadows and transparent portions of the leaves in clear detail.

You can use any standard electronic flash unit to create a photogram. Puncture a mask of lightproof material with a hole about one-eighth-inch in diameter, then place this mask over the face of the lamphead to reduce the light greatly and to produce an "action-stopping" point light source. You can vary the distance from the flash to the photosensitive paper or film to control the exposure.

Electronic Flash as a Point Light Source

Dr. Edgerton of MIT created photographs of microscopic life in pond and sea water by placing a drop of the water directly on fine-grain film and exposing a shadow image with the direct burst of light from an electronic flash point light source. The short light duration of a typical hotshoe flash unit arrests much of the rapid movement. This final enlargement of a brine shrimp (eighteen times real size) reveals the unique structure of this small creature.

Harold E. Edgerton, *Brine Shrimp,* 1979

Photo Booth Flash

The "instant-picture" photo booth is an interesting stationary camera equipped with electronic flash lighting. The twin lights arrest most subject movement and minimize distracting shadows. The conventional photo-booth portrait of a child may seem to define the limits of the machine; however, you can test other kinds of photographic ideas in photo booths. The electronic flash lighting is programmed to fire at timed intervals, which produces a strip of four exposures. The direct positive, fully processed print emerges in about two minutes. The fixed lens and the balanced lighting pose a challenge to the creative photographer.

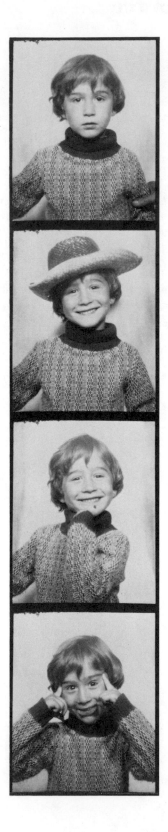

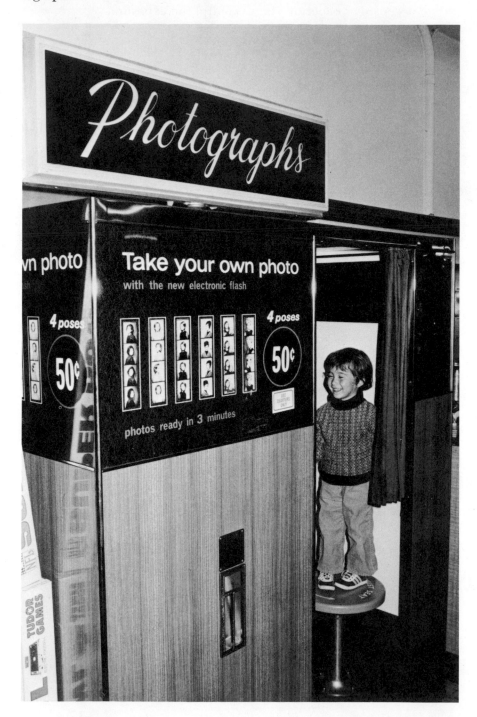

170

A proper electronic flash exposure should result in a negative that you can develop in the standard way and that you can print on enlarging paper of average contrast. However, some factors make it necessary to vary these recommended procedures. Many photographers consistently rate the light output of their flash unit too high. Overdeveloping the film by 10 to 20 percent is a regular compensation for underexposure. Tests to establish more accurate guide numbers for the flash unit might eliminate the need for this extended development time. (See p. 51.)

The falloff of the flash may result in large dark background areas in the final print. You can sometimes eliminate dust specks or distracting ambient light areas by using a shielded penlight to paint out the unexposed spots while the print is face up in the developer. If you are using extremely short flash durations (above 1/10,000 second), you might require a larger f-stop or increased development time. (For further information, refer to the Kodak reciprocity table in the reference section.)

Developing and Printing the Flash Negative

Outdoor flash exposures generally require an increase in exposure to produce normal negative density. Subject reflectivity is also an important variable in calculating a nighttime exposure. This nighttime exposure is an image in which the fence seems to float above the darker foreground areas. Many flash exposures involve some kind of lighting extremes, which the photographer must reconcile with his or her creative intent.

Ron Carraher, *Corner Fence, 1977*

Developing and Printing the Flash Negative

Colleen Chartier, *Night Sail,* 1978

This white sail at night is adequately illuminated by the light from a medium-sized on-camera flash unit. The black void of darkness around the sail becomes an important compositional element. The rigging becomes a middle-value gray which seems to alternate dark and light against the sail and the night sky.

Light or white subjects are predictable elements in a flash photograph. The shape of this dog and the lines of the leashes are easily controlled values when the subject is illuminated with on-camera flash. As the light from the flash spreads to cover the entire field of view, it reduces cast shadows and distracting background information to black. Existing ambient light is not recorded because of the small f-stop required for the flash exposure.

Courtesy of the *Journal of Contemporary Business,* University of Washington; Colleen Chartier, photography, cover detail

Flash Maintenance and Safety

Potential Problems with Flash Units
Battery Care
General Care
Troubleshooting
Safety

Potential Problems with Flash Units

The typical flash unit is an amazing light machine. Even a modestly priced unit can produce literally thousands of bursts of light if you give it only minimal care and maintenance. But as is true of any photographic equipment, improper use will damage your flash unit or cause it to break down. Continued voltage stress can eventually cause a chemical breakdown of the walls of the capacitor. If the flash tube loses its seal, air can mix with the xenon gas. A leaking low-voltage battery can permanently damage the battery contacts in the power supply.

The average user of an electronic flash unit should not attempt to carry out any serious repairs; however, some common care will extend the life of the unit.

Charge batteries before each photographic project. A dark subject will require full battery power.

174

Battery problems account for about 50 percent of flash unit malfunctions. An increase in the recycling time beyond the time specified for the flash unit may indicate that you should replace or recharge the batteries. (Recycle times should not exceed 20 seconds for alkaline batteries, 10 seconds for Ni-Cd cells, and 5 seconds for a 510v dry cell.) If you are using disposable alkaline batteries, examine their appearance at regular intervals for signs of chemical discharge through the jacket or white powder on the battery contacts. After each inspection you should wipe the batteries dry with a clean handkerchief; dirt, oil, or corrosion can resist the flow of electrical energy. Ni-Cd power cells are not technically batteries, but they can leak small amounts of corrosive materials. You can use pencil erasers to clean battery compartment contacts.

Nickel-Cadmium Batteries

To care for nickel-cadmium (Ni-Cd) batteries, follow these recommendations:

1 Avoid completely discharging the Ni-Cd battery set or pack. Such "deep discharging" can reverse the polarity of some of the cells and permanently damage the power pack. Some units have a deep discharge protection circuit.
2 Do not discharge a flash unit prior to storing it, even before a short storage period. The ready light should be glowing, indicating the capacitors are fully charged.
3 Never store an EF unit with the power supply switched on.
4 Always charge the Ni-Cd cells fully after every period of use.
5 If you do not use the EF unit regularly, switch it on for brief periods about every ninety days and recharge it.
6 Some chargers are designed to shut off automatically when the Ni-Cd pack is charged. Overcharging can create heat and can shorten Ni-Cd life.
7 Always store Ni-Cd batteries in a cool, dry place.

Overcharging can shorten the life of a Ni-Cd power pack. You can use a common electrical appliance timer to program the intended charging time and avoid a potentially destructive heat build-up.

All batteries are adversely affected by extremely cold temperatures, age, and long periods of inactivity, but a flash unit equipped with a Ni-Cd power supply is less likely than other units to have the problem of corroding batteries. Since the Ni-Cd cell continually dissipates 1 percent of its electrical charge per day at room temperature, even when the flash unit is stored, you must recharge the Ni-Cd pack every thirty to ninety days to maintain the batteries. Fasten a small gummed label on the Ni-Cd pack to note the date when the next charge is due.

A Ni-Cd cell can become fatigued if you repeatedly discharge it to the same fraction of its rated capacity. The cell has a tendency to limit its storage capacity to its usage pattern (this tendency is referred to as the cell's memory). A normal Ni-Cd cell has a rated AH (amperehour) or mAH (milliampere-hour) capacity, which states how much current you can draw from the fully charged cell multiplied by the number of hours that current will be available. A cell rated at 4 AH can thus supply one ampere for four hours or four amperes for one hour. A properly functioning cell will supply 1.2 volts for the entire

rated discharge time before it shows a serious drop in voltage. But if you partially discharge this same cell by 1 AH or 25 percent of its capacity each time you use it, it will gradually lose some of its storage capacity and will eventually perform like a 1 AH cell. This memory problem is most common with tape recorders and portable video equipment. Since most photographers do not take an exact number of photographs before recharging their Ni-Cd batteries, the memory problem seldom limits the performance of a flash unit.

There is a general relationship between the length of time it takes to recharge a Ni-Cd battery and the life of the battery. Rapid charging creates more heat than trickle charging, and you can expect it to decrease battery life. If the battery unit is slow-charged or trickle-charged, it will provide full service for a longer time. The ideal charging time is ten times the time it takes to discharge. Not all Ni-Cd chargers offer this option.

If you have any questions about your nickel-cadmium batteries or their charging time, check the manufacturer's recommendations.

Alkaline Batteries

Flash units also operate on nonrechargeable alkaline batteries. Alkaline batteries will provide the greatest number of firings if you fire them intermittently. To extend the shelf life of both carbon-zinc and alkaline batteries, store them at 40°F to 50°F (the temperature of vegetable bin in a refrigerator). Alkaline batteries can leak and damage the battery compartment of the flash unit, so check regularly for battery leakage. Always remove alkaline batteries from the flash unit before you store the unit. To avoid the risk of an explosion, never dispose of alkaline or carbon-zinc batteries in a fire.

AC Adapters

Before you use an AC adapter, check to be certain that the adapter is set for the correct voltage. The 110–120v setting is used in the United States and Canada. Remember, AC adapters are usually designed for the voltage requirements of a particular flash unit, so you should not consider them to be interchangeable.

The 510v High-Voltage Battery

The 510v battery will last longer and provide a larger total output if the current drain is small. A large current drain will result in a smaller total output. Intermittent loads are ideal. At best, you can use a battery tester to indicate whether a battery is providing its rated voltage output at a particular moment in time. A variety of conditions of use make it nearly impossible to estimate remaining service capacity, but you can use a voltmeter to measure when this type of battery has reached the end of its useful life. You must conduct such a test when an electrical load is connected.

The 510v battery is large enough to give a person a serious electrical shock. Handle it with care.

510v Rechargeable Nickel-Cadmium Power Pack

A special rechargeable 510v Ni-Cd power pack is available for some professional-sized flash units. The pack contains a set of Ni-Cd cells in a sealed power module which is the same size and weight as the conventional 510v nonrechargeable dry cell. Although this Ni-Cd power pack is initially about four times as expensive as the conventional dry cell, you can recharge it several hundred times, so it may represent a more economical power source. The power module features step-up circuitry that builds the 510v charge. Recharge time for such units is generally in the ten- to fourteen-hour range; however, the units offer the fast recycling time and predictable high flash count of the traditional 510v dry cell. The general Ni-Cd care and maintenance information also applies to this high-voltage Ni-Cd pack.

The Gel Storage Battery

This kind of battery contains a sealed electrolyte so you can install or use it in any position with no loss of capacity or danger of leakage. The battery may generate hydrogen and oxygen gas toward the end of the charge or under overcharge conditions. This small amount of gas is normally dissipated into the atmosphere. For this reason, make sure the battery is well ventilated during the recharging period.

If you are ever in doubt about battery care, be sure to follow the manufacturer's instructions.

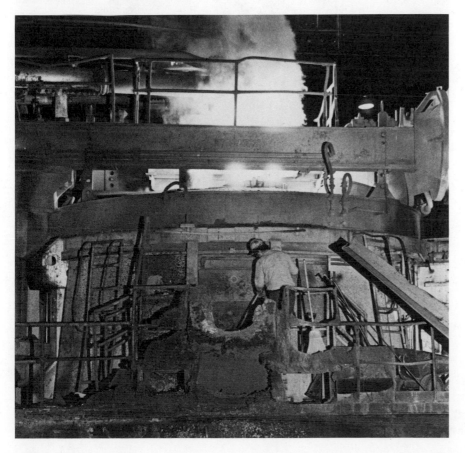

Proper exposure of a dark subject at a maximum flash-to-subject distance will test the performance of both the batteries and the capacitor of your flash unit.

177

General Care

Flash and Water Do Not Mix

The circuitry of the flash unit must be kept dry. If you accidentally drop the flash in water or if moisture enters the housing, remove the batteries and take the unit to a service center. You can often solve minor moisture problems by using an electric hair dryer or an oven set on 125°F to dry out the unit.

Salt water is extremely corrosive if it is left to dry on photographic equipment. If your equipment gets wet in salt water, immediately wash it with fresh water and then dry it. You can then use alcohol to evaporate the remaining water. If the water damage is extensive, you will probably have to take the equipment to be partially disassembled for cleaning at a repair shop. Prompt action is important, since delicate circuitry can be ruined by water in a matter of hours.

A plastic bag or an umbrella is a must to protect the flash from rain. The slightest moisture can be hazardous to the flash operation.

Replacing Modeling Lights

Do not handle the flash tube or quartz modeling lights with your bare fingers. Oily fingerprints can cause hot spots on the surface of the glass and may lead to the failure of the tube or bulb. Use denatured alcohol to clean accidentally soiled surfaces.

Capacitor Care

The quartz modeling lamp in studio flash units may require replacement. For maximum performance, avoid getting fingerprints on the surface of the quartz bulb.

The capacitor is the energy reservoir in both portable flash and studio flash units. It is important to condition the capacitors when you put a

178

new flash unit into operation or when you have been storing a unit for any time longer than thirty days. Some manufacturers recommend the following procedure:

1 Charge the battery.
2 Connect the lamphead (if it is a separate element) and switch the unit on.
3 Leave the unit on for at least five minutes before you fire the flash.
4 Refrain from rapid-flashing the unit until the capacitors have been charged or have been in service for at least thirty minutes.

Storage

If you are intending to store a flash unit for several months, you should remove the alkaline or dry-cell batteries to avoid battery leakage. Wrap the flash to protect it from dust and moisture, but do not package it in an airtight bag. Avoid temperature extremes and humidity when storing any photographic equipment.

Always leave the last flash in the flash unit. You should allow the flash unit to recycle fully after the final flash is fired, then switch the unit off if it is not in use. The ready light will continue to glow for several minutes, indicating that the capacitors are fully charged and that they will be stored in a formed condition. Leaving this last charge in the capacitors insures that they will be easier to reform the next time you recharge them.

Synch Check

It is a simple matter to check the basic synch of the camera and flash unit. With the flash on the hot shoe or wired to the synch outlet on the camera, open the camera back and tape a piece of tracing tissue over the film plane. Fire the shutter at a synch setting, aiming the flash and camera at a white surface. If the camera shutter is in synch, the burst of light will fully illuminate the paper over the film plane. A partial rectangle of light indicates an out-of-synch focal plane shutter.

You can test the camera shutter synch with electronic flash by observing the flash of light through the open camera back. Tape a piece of tissue over the film plane before you fire the shutter and flash.

PC Cord Care

The flash PC cord must have special care to survive hard use. Constant connecting and disconnecting makes the wires in the cord a vulnerable element in the electrical system. A short in the PC cord may cause the flash to rapid-fire or fail completely to fire. If you suspect that a cord is defective, unplug the cord from the camera and try firing the flash by shorting the connector with a straight pin or paper clip. If you cannot fire the unit by shorting the cord, the cord may be defective.

A cross section of the synch cord and camera flash terminal reveals a common electrical problem. The flash will not fire if the center pin of the PC cord does not make contact with the mating sleeve of the

camera terminal. Bend the pin slightly off-center to insure proper contact. It is a good idea to carry a replacement PC cord as a part of the flash system.

The synch cord or PC cord is often the weak link in the flash system. The wires are small and fragile, since they are designed to carry the relatively low amperage of the triggering current. Even normal use may subject the cord to a severe test. When the flash unit fails to fire, the PC cord and the power supply are the two most likely sources of trouble.

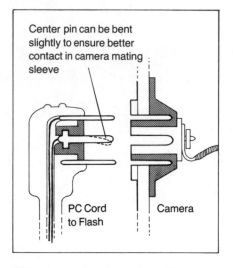

This cutaway diagram illustrates how to improve the electrical contact of a loose PC cord.

Polarity and Synch Cords

Most flash units are grounded to protect the photographer from accidental electrical shock. The shutter contacts of most cameras are grounded to the frame of the camera. Since most flash units and cameras are both negatively grounded, no polarity problem occurs if you connect a properly matched camera and flash. If you do not match the polarity of the flash and the camera, the flash unit will fail to fire, or it may misfire continously.

You can conduct a simple test to determine if a particular flash unit and connecting cord are matched in polarity with your camera. Attach the flash and camera to each other with metal-to-metal contact, either through a flash bracket or through the metal accessory shoe on the camera. Connect the PC cord to the flash unit and switch on the power supply. Touch the outer ring of the PC cord plug to any exposed metal on the camera body that is unpainted or nonanodized. If the flash unit fires, the polarity is *not* matched and you must reverse the synch cord before the flash and camera will operate properly. (If the flash completely fails to fire with this test, either the polarity is correct or the PC cord is defective.) A PC cord with an H or AC-type parallel-prong plug is simple to reverse. After you correctly attach the plug, you may find it useful to mark both the plug and the outlet with red fingernail polish to eliminate the need for future testing.

To solve a polarity problem, add an H-plug connection to a PC cord system.

No Flash or Misfiring

If the batteries are fully charged and a flash unit fails to fire, you probably have a loosened connection or a break in the synch cord. If a flash unit completely fails to operate, you can partially diagnose the problem by following these steps:

1 Unit fails to operate:
 Is battery fully charged, or is the unit plugged into AC power? Is the line fuse okay?

2 Unit fails to fire:
 Try firing the unit using the open-flash or test-flash button. If the ready light indicates that the unit is ready to flash but the tube fails to fire when the test button is depressed, you might have a defective flash tube. Plug in the synch cord and short the contacts in the tip. If the unit fires the synch cord is not defective. Plug the synch cord into the camera (using X terminal and proper shutter speed). If the unit does not fire, take the camera to a professional repair shop.

3 Unit fires by itself:
 Remove the synch cord. If the firing stops, the synch cord is shorted and should be replaced, or the synch cord polarity does not match the polarity of the unit.

A Ready-Light Test

An accurate ready light will glow to indicate when the capacitor has recharged to 100 percent of its capacity, but the ready lights on some inexpensive flash units will first glow when the capacitor has accumulated only a 70 percent charge. This partial charge could cause a one f-stop exposure error. If your exposures suggest that the flash unit is not providing the expected light output, perform a simple ready-light test. Using fresh batteries, test-fire the flash about five times, then make an exposure of an average subject as soon as the ready light first glows. Wait for the unit to recycle and make a second flash exposure of the same subject five seconds after the light first glows. Make a third test exposure, waiting ten seconds, and a final exposure after a twenty-second wait beyond the first glow of the ready light. A comparison of the exposures will reveal how long the light must glow before a full charge has reached the capacitors.

Safety

You should be aware of a few safety considerations when you are working with flash equipment.

1 Always turn off the flash unit before disconnecting or connecting power cords.

2 Do not install a fuse that has a higher amperage than that recommended for the unit.

3 Do not attempt do-it-yourself repairs unless you have a thorough knowledge of electronics. A capacitor can store a sizable electrical charge, and the accidental discharge of this stored current can inflict serious injury. A unit that is malfunctioning and refusing to flash may still have a full charge in its capacitors.

4 Do not connect power supplies and flash heads from different manufacturers unless such intermixing is recommended by the manufacturers. Flash units may have similar connecting cords or electrical plug designs; however, interconnecting unmatched components could create a grounding problem or seriously damage a unit.

5 Never attempt to recharge standard carbon-zinc or alkaline batteries (some alkaline batteries, however, are designed for recharging).

6 Never dispose of dry-cell batteries in a fire. An explosion could result from an expansion of the internal gases caused by the fire.

7 Never carry loose batteries in a camera bag. A metal object can short the battery contacts and cause a fire. Tape one end of the battery to avoid this problem.

8 The H or AC-type plug is used on some synch cords. Take care that you never accidentally plug this type of synch cord into an 110v AC household outlet.

9 Do not fire a flash unit in an oxygen-enriched atmosphere or any potentially explosive environment. Keep the flash away from any highly combustible materials.

10 The recycling whine and accompanying burst of light from a flash unit can be quite frightening to some animals—for example, caged giraffes in a zoo could seriously injure themselves in reacting to the flash—so be cautious when photographing these subjects.

11 A stroboscopic light operating on about twelve to fourteen cycles per second is very disturbing to human perception and could trigger a seizure in an incipient epileptic.

Flash units are prohibited at certain sporting events because the burst of light might affect the performance of an athlete. Similarly, some museums do not allow flash photographs because the cumulative effect of the ultraviolet from each flash could adversely affect some museum artifacts.

Choosing a Flash Unit

Portable Flash Units
Studio Flash
Flash Meters

Colleen Chartler, *Crosses*, 1979

183

Portable Flash Units

Most serious photographers regularly encounter photographic problems that can be solved best with electronic flash lighting. Since there are literally hundreds of portable flash units to choose from, you should acquire an overview of sizes, shapes, performance features, and prices before you select a unit for your particular photographic needs.

Comparison charts listing all of the new models and changes in specifications are published in periodicals such as *Popular Photography* and *Modern Photography*. The charts compare light output, size, power sources, cost, and design features. The information from such a chart can help you narrow down your choices before you visit a photo dealer for a final discussion of the equipment.

Types of Portable Flash

Portable flash units can be grouped into four overlapping categories, based on the size of the units and their physical shape.

Pocket-Sized Hot-Shoe Flash. The smallest hot-shoe flashes are pocket-sized and have an average guide number of 35 for ASA 25 film. Some models offer automatic exposure control, but these are usually limited to one distance range. Two or four AA alkaline batteries are the typical, single power option, although some units can be switched to AC current. Not all of the units in this group have the separate PC cord needed for off-camera lighting positions. This size of flash is ideal for synchro-sun, fill-flash, or frontal lighting, but it is a bit too low in output for effective bounced-flash technique.

Although some models have automatic exposure control, not all of the units in this class are equipped with energy-saving circuitry.

Standard-Sized Hot-Shoe Flash. The standard-sized hot-shoe flash represents a broad category with a considerable range in price, light output, and design features. Manual guide numbers range from 40 up to 70 for ASA 25 film. Some of the flash units in this category produce

The light output of a pocket-sized hot-shoe flash is adequate for most indoor subjects. Surrounding walls return additional light and you can generally base exposure on the manufacturer's suggested guide number. The most predictable exposure requires an on-camera flash position.

Outdoor subjects may require additional light. A professional-sized portable flash unit such as the Norman 200B provides a guide number of 320 when used with Kodak Tri-X film. The white uniforms of the marchers are visible for a distance of over 100 feet.

184

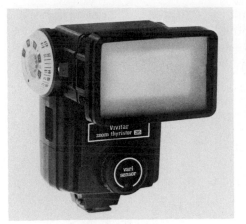

more light for their size and price than any portable flash equipment. This group offers a choice of power sources, including AC, Ni-Cd, alkaline batteries, and even, in some models, the 510v high-voltage dry cell. Several flash lighting systems are represented in this classification. Component systems supplied by two manufacturers include an array of accessories such as filters, diffusers, variable power control, bounce-card holders, and a remote auto-exposure sensor.

Lampheads for some models in this category are designed to swivel for indirect and bounced lighting. Most units offer automatic-exposure, energy-saving circuitry. One flash incorporates a variable-position Fresnel lens that allows the photographer to match the angle of illumination with the angle of view of the camera lens. The zoom flash operation is mechanically coupled to the calculator dial to insure a correct guide number.

The dedicated flash units are a special group within the standard hot-shoe category. The term *dedicated* designates a flash unit designed by a manufacturer for a specific camera line. The manufacturers have linked the circuitry of the flash to the camera to provide sophisticated exposure control. Some dedicated flash units feature through-the-lens light metering of the flash. Another offers a fully automated aperture to insure a proper flash exposure.

Handle-Mount Flash. Flash units in this category are easily identified by their head and handle design. The "potato-masher" shape balances the flash for hand-held lighting positions, while the battery compartment serves as a comfortable handle for both the camera and the flash. The guide number range of 65 to 125 for ASA 25 film makes the flash popular for many working photographers. Any of the conventional power sources will operate most of the handle-mount units.

A variety of accessories are available for these professional-oriented flash units. One handle-mount flash features a unique system of interchangeable heads that you can use to convert the basic handle for standard flash, bare bulb, infrared, or ringflash.

Professional Portable Flash. Flash units in this class are specifically designed to meet the demands of the professional photographer. The power supplies are rated from 100 to 400 watt-seconds. You carry the battery and circuitry package separately from the lamphead on your

Above: The lamphead of the hot-shoe flash units is designed to increase the distance between the beam of light and the axis of the lens and thus to minimize the possibility of the red-eye effect in color portraits.

Below: The Ascor Light 1600 II handle-mount flash unit is a good example of the system approach to flash lighting design. A variety of interchangeable accessories allows the photographer to use the same power pack with a ringlight, bare bulb, and so on. The handle of the unit also contains the Ni-Cd power pack. The lamphead swivels and tilts for bounce lighting.

Portable Flash Units

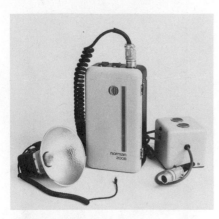

This strictly professional-sized portable flash unit features interchangeable reflectors and a simple ready light. Since light output is a primary factor, the unit offers no automatic exposure features and thus fewer circuits that can break down or require energy. The photographer carries the power pack on the shoulder or waist. Also pictured is the charger, which offers either a fast or a slow charge. The Ni-Cd power supply is designed to eliminate the problems of overcharging or deep discharging. This unit is a popular choice with wedding photographers since it offers a high light output for its size, a large number of flash firings per charge, rapid recycling, and quick recharging time.

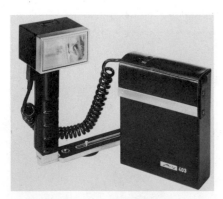

This flash unit uses a separate 510v power pack which the photographer carries on a shoulder strap. This reduces the weight of the lamp, which is generally attached to the camera.

waist or on a shoulder strap. Some lampheads have interchangeable reflectors. Since light output is the important consideration, components are designed for hard daily use and accessories are kept to a minimum. Flash units in this group are powerful enough to serve as self-contained studio lights.

A Buyer's Checklist

The following list contains some fine points that might be helpful when you are deciding which flash unit you should buy.

1 Light output: Flash units can be compared only when they are rated for the same ASA film based on manual operation. Does the unit produce enough light for bounced lighting?

2 Angle of coverage: Is the angle of light output matched to your lenses? Can the angle of light output be varied?

3 Power sources: If you intend to make regular use of the flash, you will do best with a unit that can be operated on several different power sources. Does the unit include a battery charger and an AC converter?

4 Recycle time: If you are planning to use the flash with a motor-driven camera, you need to know whether the flash will rapid-fire and recycle without overheating.

5 Ready light: How accurate is the ready light? Does it indicate a 100 percent charge in the capacitors?

6 Variable power control: Would variable power and the related changes in flash duration be useful for your photography?

7 Synch cord: Does the flash unit have a separate PC cord for off-camera lighting? Can you easily replace the PC cord?

8 Calculator dial: Is the calculator dial simple to use? Does it illuminate for low-level light and night visibility?

9 Locking device: Does the flash have a locking device on the flash foot to secure the unit on the hot shoe?

10 Automatic sensor: If the flash has an automatic sensor, can you aim it separately for bounced-flash exposures? How accurately does the sensor read the subject?

11 Accessories: Which accessories are standard equipment and which items must you purchase separately?

12 Test button: Does the flash have an open-flash or test-firing button for off-camera lighting techniques such as painting with flash?

13 Service and warranty: Are service centers indicated on the warranty card? Is the unit basically a throwaway design, or has it been designed for easy maintenance?

14 Bounced flash: Does the lamphead swivel for indirect lighting situations?

15 Film format: Do the shapes of the reflector and the illumination beam match the film format of your camera?

16 Charging time: Must you leave the Ni-Cd power pack in the flash unit for recharging, or can you charge an extra power pack separately while you continue to use the flash unit?

Portable Flash
Units Compared

	POCKET-SIZED HOT-SHOE FLASH *Braun 17B*	STANDARD HOT-SHOE FLASH *Metz/Mecablitz 34BCTI*	HANDLE-MOUNTED FLASH (Potato Masher) *Sunpak 611*	PROFESSIONAL PORTABLE FLASH *Norman 200B*
Guide number for ASA 25	28	56	80	80
Energy source: Alkaline Nickel-Cadmium 510v dry cell AC	2 AA penlights	4 AA penlights Nickel-Cadmium AC	4 C cells Nickel-Cadmium 510v AC	Nickel-Cadmium AC
Number of flashes alkaline Nickel-Cadmium 510v	190	120 to 1600 60 to 800 (per charge)	50 to 1000 40 to 800 (per charge) 70 to 5000	200 to 800 (per charge)
Recycling time (seconds)	8 to 12	0.3 to 7	0.25 to 9.5	0.33 at 50 watt-sec. 0.75 at 100 watt-sec. 1.5 at 200 watt-sec.
Exposure computer	—	yes	yes	—
Computer working ranges	—	18 inches to 30 feet	19 inches to 40 feet	—
Computer working ASA range	—	3-stop range	4-stop range	—
Correct exposure signal	—	—	yes	—
Flash duration	1/2000	1/500 to 1/40,000	1/400 to 1/50,000	1/400 at 200 watt-sec. 1/800 at 100 watt-sec. 1/1600 at 50 watt-sec.
BCPS (60° reflector)	760	1850	4000	4000
Angle of illumination horizontal × vertical	60° × 57°	65° × 45°	60° × 45°	60° standard 120° wide-angle 15° telephoto
Color temperature	5600 K	5600 K	5500 K	5600 K
Synchronization	hot shoe or PC cord	hot shoe or PC cord	PC cord	PC cord
Recharging time	—	4 hours	3 hours	90 minutes fast charge or 12 hr. slow charge
Dimensions	2¾ × 1½ × 2⅜ inches	4½ × 1½ × 3½ inches	4.8 × 3.8 × 10 inches	10 × 5½ × 3 inches
Weight	3 ounces	13 ounces	34.5 ounces	5 pounds
Special features			Variable power Remote sensor 100 % ready light	Deep discharge and overcharge protection circuits

The Vivitar 283 Auto/Thyristor flash system offers a complete array of optical and power source accessories designed to simplify flash photography.

Power Sources

When purchasing a flash unit, you should understand the differences among the basic types of power supplies.

Alkaline Batteries. Inexpensive flash units are generally powered by the familiar alkaline batteries. The alkaline battery is a refined version of the old carbon-zinc dry cell that is normally used in a flashlight. The alkaline provides from three to five times more service than a carbon-zinc battery when you compare their performance in a flash unit. Although alkaline batteries are relatively high in cost (per-flash cost based on the life of the flash unit), they remain a good choice if you do not use the flash on a regular basis. Rechargeable alkaline cells are not recommended for flash units.

AC Converter. An AC power adapter is also available for many of the inexpensive flash units. This permits you to use 110v household current to fire the flash. This is the least expensive power source and generally provides a short recycling time. Unfortunately, the power cord does restrict your movement.

Nickel-Cadmium Batteries. Nickel-cadmium batteries are a very popular power source for flash units. The Ni-Cd is technically not a battery, but serves as an accumulator and storage unit. They have the highest initial cost of any of the portable power sources, but if you maintain them with proper care and recharging, you can expect them to provide five to ten years of service.

Some flash units are designed with a Ni-Cd power pack that is not interchangeable and must be charged with a charger specifically designed for the power pack. Some flash units also use standard over-

A Ni-Cd power pack and quick charger.

the-counter Ni-Cd batteries, which can also be recharged. Their low per-flash cost and fast recharging time make them a first choice for many professional photographers.

The High-Voltage Dry Cell. The 510v battery is used by professionals who require the maximum number of flashes without recharging. This is a popular power source for wedding photography. A fresh 510v battery offers a fast recycling time and a predictable number of flashes; however, it is relatively high in cost and is not rechargeable.

The Gel-Type Storage Battery. This battery contains gelled and sealed electrolyte. It is most commonly used in hospitals as an emer-

Power Sources Compared

TYPE	ADVANTAGES	DISADVANTAGES
A/C (110v or 220v) Household current	Cheapest and most reliable. Provides the most consistent voltage for accurate exposures. Generally provides a short recycling time for some units.	Unit must remain connected to power cord, which may limit movement.
Alkaline battery	Best for a flash unit that is used irregularly. Generally provides more continuous firings per set than a set of nickel-cadmium batteries (without recharging).	Highest overall cost per flash for a regularly used unit. Can corrode terminal if left in unit too long. Not rechargeable as a flash power supply.
Carbon-zinc battery	Least expensive primary dry cell battery.	Shelf life adversely affected by temperature extremes. Can corrode power supply terminals if left in unit too long. Gives fewer flashes than the alkaline dry cell. Not rechargeable as a flash power supply.
Nickel-cadmium batteries	Rechargeable. Five- to ten-year life if properly maintained. No acid to corrode terminals. Fastest recharging time of any of the rechargeable batteries.	Highest initial cost. May not be interchangeable with other units. Can be damaged by deep discharging or by overcharging in some units. Require regular attention for maximum efficiency. Repetitively short use period may condition Ni-Cds to deliver less than the rated capacity (memory problem).
High-voltage nickel-cadmium power pack (510v)	Rechargeable. Faster recycling time than conventional Ni-Cd cells.	High initial cost. Slow (ten- to fourteen-hour recharging time). Maintenance considerations similar to conventional Ni-Cd cells.
High-voltage dry cell storage battery (510v)	Greatest number of flashes without recharging for a portable power source. Fastest recycling time for some units. Predictable performance when battery is fresh.	High cost per flash. Not rechargeable.
Gel storage battery	Rechargeable. Absence of memory characteristics. Cannot be deep discharged. Operates over wide temperature range. Lower initial cost than a nickel-cadmium battery.	Largest and heaviest power source for rated current capacity. Slower recharging time than a Ni-Cd. Less current capacity than a Ni-Cd of equal volume.

gency power supply, but it also powers video recorders and some portable flash equipment. The gel storage battery is completely rechargeable and capable of two hundred to five hundred charge-discharge cycles. If you remove only a portion of the capacity on each cycle, you proportionately increase the number of possible cycles. The battery is sealed, so it does not require additional water or electrolyte.

The gel unit is free from the adverse effects of deep discharge. You can easily recharge it, even after complete discharge. It has a wide operating temperature (140°F–76°F), although capacity decreases below 68°F. The gel-type battery loses very little capacity when in storage (2 percent to 3 percent per month at normal room temperature). Unlike the Ni-Cd, the gel-type battery has no memory problem and can deliver full rated power irrespective of previous use.

Flash Accessories

Many cameras are designed with an accessory clip or hot-shoe bracket which allows you to attach a small flash unit directly onto the camera. A true hot shoe connects the trigger circuit of the flash unit directly to the camera, so you do not need a PC connecting cord to fire the flash. A "cool shoe" or accessory clip allows you to attach the flash unit to the camera, but you must use a PC cord to connect the flash to the camera.

Directly attaching the flash unit to the camera has obvious advantages and limitations. It is quick and simple; however, the light from on-camera flash is predictably flat and shadowless. You may also be unable to avoid glare from reflective surfaces. Because the flash is nearly on an axis with the lens, on-camera flash increases the possibility of red eye.

Alternative ways of mounting the flash unit are essentially mechanical problems. Manufacturers make a number of devices that attach to the hot shoe and extend the flash unit to achieve a better separation between the camera and the light source. Some of these hot-shoe extenders are also designed to swivel and so allow you to aim the flash in a completely independent direction. You usually need a PC cord when you are using such extenders.

The basic off-camera flash bracket is designed in an L shape and attaches to the camera base. The bracket often functions as a pistol grip with a built-in cable release. There are hundreds of design variations on this concept, but the primary function of the bracket is to secure the flash and simplify aiming the lamphead for direct and indirect lighting effects. Some brackets enable you to rotate the flash unit in a 360° pattern for control of light direction and angle. Some also have a flexible arm which allows you to vary the position of the flash relative to the camera. Some brackets can be attached to the top of a tripod to accept the foot of a hot-shoe flash unit. With this accessory, you can aim the off-camera flash quickly and precisely for a particular lighting effect.

A number of new accessories, such as miniature umbrellas and soft bounce reflectors, are designed to attach either to the flash unit or

You can use a pistol-grip bracket to position the flash slightly off-camera. Some brackets are designed with a cable release to permit one-hand operation. The bracket should be sturdy but lightweight. A folding handle can be useful when you store the bracket in an accessory bag.

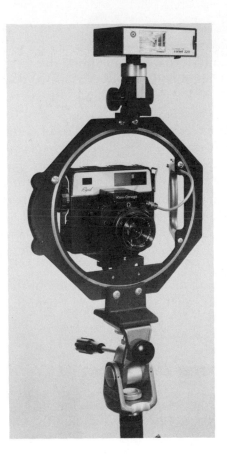

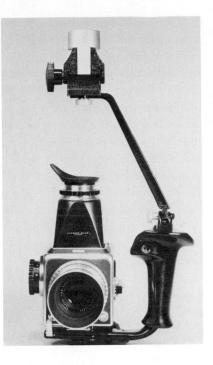

Left: Two brackets designed to facilitate precise positioning of flash lighting.

Above: This swivel head attaches to the top of a standard tripod to permit mounting a hot-shoe flash unit for off-camera lighting. You must use a PC cord or photo slave to fire the flash in synch with the camera or other flash lighting.

to the flash brackets. You should consider the size and weight of this additional equipment when you are purchasing a bracket.

Handle-mount flash units are generally equipped with a quick-release bracket that allows you to detach the flash for bounced or off-camera lighting techniques. Flash brackets also enable you to attach more than one flash unit to a single camera. You can use a bracket with two movable arms for the flash units when you wish to vary the flash-to-subject distance without changing the camera position. This type of bracket is often used in close-up photography. You can also mount a small flash unit on the side of the lens by using a bracket that attaches with a filter ring to the front threads of the lens. This type of bracket positions the flash in a nearly on-axis relationship with the lens. Such a device is used in intraoral photography.

The following checklist covers many of the fine points of evaluating a flash bracket.

1 Comfortable for one-hand operation
2 Lightweight but sturdy
3 Folds for easy storage
4 Swivel head for aiming the flash in any direction
5 Quick release feature
6 Tripod mounting socket
7 Adjustable elements of the bracket align quickly but tighten securely
8 Designed for use with 35mm and larger-format cameras

A rotating bracket is designed for mounting a flash unit in a nearly on-axis position with the camera lens. You connect the flash to the camera with a PC cord. This type of bracket is excellent for some kinds of close-up photography and is frequently used with a bellows-mounted lens for intraoral dental photography. The bracket adjusts to eliminate parallax as you aim the flash at the close-range subject.

191

Portable Flash Units

A reflex camera image is blocked when the mirror folds during the exposure. This accessory eyepiece brings light from the flash through a fiber optic back to your eye to inform you that the flash has fired.

The Polaroid SX-70 equipped with a Polatronic flash is an ideal tool for fast location color photographs. The camera's internal meter automatically sets the aperture as it monitors the flash illumination and any existing ambient light. The flash has a 1/1000 sec. flash duration and recycles in less than ten seconds. Indoors, you can use the flash at a range of 10.4 inches up to 12 feet. (A plastic accessory clips over the flash to redirect the light on close-ups in the 10.4-inches to 2-foot range. The electronic circuitry of the flash is matched to the electronics in the camera. If the film pack is empty or the flash is turned off, the system will not operate.

It is a good idea actually to attach your flash unit and camera to a bracket for a manual test before you make your final purchase.

A variety of connecting cords and devices for mounting the flash unit are available as accessories that simplify the problem of using one or more flash units off-camera. Standard PC shutter-synch cords can be purchased in lengths from six inches to thirty feet. Some of the cords are coiled or wound on spools to prevent tangling. The basic PC tip fits most cameras, although some cameras require their own special locking tip designs. You may need adapters to connect these cameras to a standard PC cord. You may also require a special plug design on the flash end of the cord for flash units with a replaceable PC cord. Other cord adapters convert a hot shoe to a PC cord or permit you to join a PC cord and an H-type synch plug. It is a good idea to purchase an extra PC cord with the necessary adapter when you are buying a flash unit.

Photo slaves and related triggering devices are described in the sections covering flash techniques and remote control and triggering devices.

Flash with Instant-Picture Cameras

Polaroid and Kodak instant cameras must be equipped with special electronic flash units designed to match the flash bar connection post which insures correct shutter synchronization.

The Polaroid 4 × 5 Land Film holder can be used with most 4 × 5 cameras equipped with spring or lock backs. Five types of Polaroid Land Film are available for this holder:

1 Type 51, high-contrast film
2 Type 52, panchromatic black-and-white film
3 Type 55 P/N, panchromatic black-and-white film that produces a positive and a recoverable negative
4 Type 57, high-speed black-and-white film
5 Type 58, Polacolor 2 film

Commercial photographers often use Polaroid films to test the exposure and direction of an electronic flash lighting setup.

Some cameras, such as the 6cm-format Hasselblad and Bronica and the 35mm Nikon, also have Polaroid backs which permit the use of Polaroid film-pack materials.

Studio flash describes a broad category of electronic flash lighting, which may include handle-mount portable flash units of less than 100 watt-seconds as well as commercial studio consoles weighing three hundred pounds that are engineered to fire several 5000 watt-second flash tubes.

To expose a typical studio portrait or product photograph, you often need less than 400 watt-seconds of power. To illuminate an area the size of the average kitchen, you might need to assemble flash lighting totaling over 2000 watt-seconds of potential light. A full-scale set in a large commercial studio may demand a light level based on 20,000 watt-seconds of stored energy.

A working photographer who regularly uses artificial light should consider the features and advantages of studio flash equipment. This section presents some of the basic characteristics of studio flash that you should examine as you evaluate your need for such a system.

Types of Studio Flash

Studio lighting divides into two basic categories: (1) self-contained or single light unit, and (2) separate power-pack lighting system.

The Self-Contained EF Light. This type of studio lighting combines the lamphead and the power pack in a single fixture that has all operating controls organized on the back panel of the light. The entire unit sits on top of the light stand. Since it is unreasonable to expect the self-contained lamphead to house the large capacitors needed for

Studio Flash

Below left: Studio flash lighting designed as a self-contained unit incorporates a power pack in each lamphead. Photo slave triggers fire the lights in synch with the main light, which is generally linked to the camera with a PC cord.

Below right: A studio flash lighting system with a separate power pack uses connecting cords to supply power to each of the separate lampheads. The lighting control panel is located on the power pack. A single power cord supplies power to the entire system, which you can fire in synch with a PC cord linked to the camera.

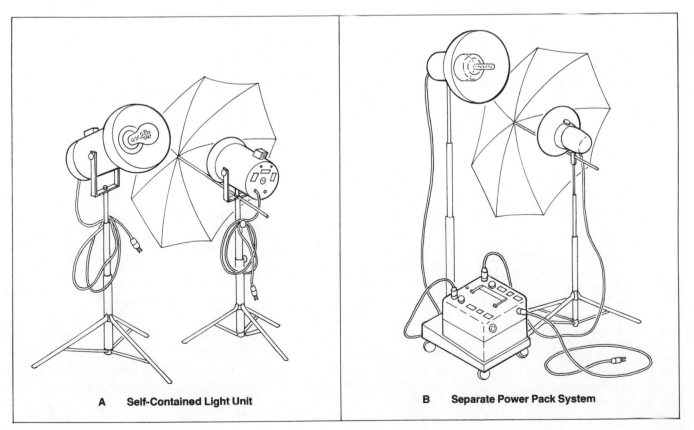

| A | Self-Contained Light Unit | B | Separate Power Pack System |

Studio Flash

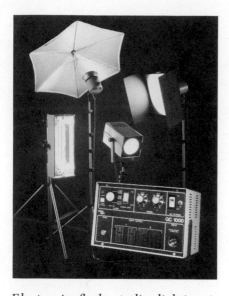

Electronic flash studio lighting is available in most of the same lamphead and reflector configurations as tungsten lighting. The Ascor Light QC studio lighting includes a strip light as a component in their basic studio line.

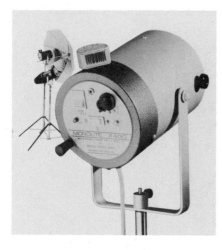

A self-contained studio flash unit such as the Bowens Monolite positions all of the power controls on the back of the lamphead. Various reflectors and snoots are also a part of the lighting system and can be used to solve specific studio lighting problems. The unit illustrated as a slave (photo-triggering device) attached to the top of the unit. You can aim the slave at the master lighting unit to insure synchronized firing.

higher levels of illumination, lights of this type are generally in the 100 to 600 watt-second class. Some of the lights in this group may be battery-operated, but 110v AC current designs are more common.

Multiple lighting setups require additional self-contained units, which are fired in synch by photo slaves.

The simplicity and compactness of this portable, location-sized lighting are obvious; however, the power output may limit subject size.

Flash with Separate Power Pack. The EF studio lighting that features a separate power pack requires an electrical connecting cable to each lamphead. All of the lighting controls are located on the power pack, which is designed for either 110 or 220v AC current. Units of this design range in size from 500 to 20,000 watt-seconds of storage capacity. Photographers generally consider the smaller sizes to be portable; however, they mount most power consoles on casters near the main light. A synch cord from the camera connects to the power pack to permit you to fire all of the lights simultaneously. You can also use various wireless triggering devices.

Size and Power

Electrical storage is directly related to capacitor size, and the weight and size of the power supply are a general indicator of the power of the flash unit. However, it may be difficult to compare the precise light output of various studio lighting systems. Since the reflectors on studio lights are interchangeable and often removed or combined with an umbrella, the common standard for evaluating the light potential for a given lighting system has become the energy stored in the capacitors. Unfortunately, this power rating in watt-seconds does not take into account such things as reflector efficiency or energy lost in connecting cables. The BCPS (beam candle power seconds) are an equally inadequate index of usable light, as they are measured from an on-axis position; thus, a high BCPS rating may fail to indicate the *total* available light. Ideally, you should conduct a series of studio tests with a given lighting system before you make a purchase.

Power Supply

Studio flash lighting is generally designed for AC electrical operation: (1) to operate the focusing lights; (2) to minimize recycling time; and (3) to provide consistent power. A built-in voltage stabilizer insures accurate exposure in spite of line voltage fluctuations (a 10 percent drop in voltage can reduce a 100 watt-second potential to 80 watt-seconds of available power). Better-quality studio lighting systems feature ratio lighting controls that allow the photographer to vary the power to the individual lampheads. With these systems, you can preset specific lighting ratios for both the modeling lights and the flash illumination. To create a given level of illumination, you need fewer EF units than tungsten lights. EF lights thus minimize the hardware.

Modeling Lamps

Secondary tungsten or quartz lights are sometimes incorporated in the flash lamphead to serve as modeling lights. You can use the modeling lights to anticipate the direction and intensity of the final EF exposure. The better-quality studio systems have modeling lights that you can vary in light level to match the ratio of the EF light output. Since the modeling lights and the EF flash tube must occupy slightly different physical positions, the accuracy of the modeling lights is an important consideration. The modeling light must be powerful enough to enable you to evaluate the effects of your lighting setup. Theoretically, you should be able to make an exposure with the modeling lights that corresponds with the intended flash exposure.

Color Temperature

EF studio lights are balanced for daylight film. The flash tube has a constant light output and color temperature, unlike tungsten lights, which gradually shift toward the red end of the spectrum as the tungsten filament decays. The daylight color temperature means that you can use the somewhat faster daylight films in the studio. EF lights are much less affected by fluctuations in the AC power supply than are tungsten lights. Most EF studio power consoles incorporate power stabilizers which insure a constant voltage.

Heat

EF studio lights eliminate the heat associated with tungsten lighting. This is a special concern for photographers who have a small studio space, who run a summer operation, or who photograph subjects that are vulnerable to high temperatures (such as food and people).

Cost of Operation

Less heat means less electricity. EF studio lights require less energy to operate than quartz or tungsten lights, and so are cheaper to use.

Triggering

You can trigger studio lighting with the same methods you use for conventional flash. A synch cord joining the power supply and the camera shutter contacts will simultaneously trigger all of the lighting when you depress the shutter.

If the synch cord proves too restrictive, use a photo-slave method for wireless remote triggering. Attach a small flash unit to the hot shoe of the camera. Mount a photo slave on the studio lighting power supply and position it so that it can "see" the light from the master flash on

A single overhead studio flash unit provided all of the illumination for this self-portrait. Some of the light bounced from the floor and the arms to add additional light to the face.

Wm. J. Murray III, *Self Portrait,* 1977

the camera. The light from the camera-mounted flash is minimal relative to the studio light level, but it does effectively trigger the exposure. A more sophisticated version of this photo-slave trigger involves placing an infrared filter over the trigger flash lamphead. The infrared light has no effect on standard film emulsions, but does activate the photo slave, which is sensitive to infrared energy.

One manufacturer makes a special infrared triggering device that is more sensitive than improvised equipment. You attach a compact infrared transmitter to the hot shoe of the camera and locate a special receiver on the power supply or a lamphead. The infrared impulse

extends over the entire working area of the studio and is reflected from the wall and ceiling. This system ensures reliable firing from nearly any camera position.

A special radio transmitter may also serve as a wireless link between the studio flash and the camera shutter. The compact transmitter fits in the photographer's pocket and connects to the PC outlet on the camera. A signal from the transmitter fires the flash when the shutter is released. The signal is coded to insure that nearby radio transmissions cannot accidentally trigger the studio lights.

Fast Exposures

The typical short exposure times of EF lighting (1/500 to 1/1000 second) tend to eliminate the loss of sharpness that is due to subject movement or camera vibration. This exposure time also insures an optimum D log E curve (that is, expanded density range and better tone rendition in the shadows).

Studio Lighting Accessories

Electronic flash lighting systems incorporate accessories that are available as optional hardware. The following list describes some of the more standard accessories.

1 Reflectors: Most studio lighting offers interchangeable reflectors. You can use different sizes and surfaces to produce particular lighting effects.
2 Umbrella: Use an umbrella to bounce the light and soften shadow edges. Umbrellas are available in various diameters and coverings.
3 Snoot: A snoot is a metal cone or tube that you attach to the lamphead to produce a spotlight or target lighting effect.
4 Cooling fans: A special cooling fan may be required on a lamphead when an accessory blocks the heat from the modeling lamp.
5 Projection head: A projection head is a lamphead that incorporates an optical system; it can be used to project a transparency from the front or rear. You can also project special masks to shape the beam of light.
6 Barn doors: Attach these adjustable metal flaps to the reflector to control the direction and spill of the beam of light.
7 Honeycomb grill or louver light: Attach this metal mesh to the face of the reflector to limit the angle of the beam of light.
8 Diffusers and filters: System-matched light diffusers and color filter holders can be attached to the lamphead to alter the quality and/or color balance of the light.
9 Soft light: A large diffusion chamber, soft light contains the lamphead and increases the effective size of the light source.

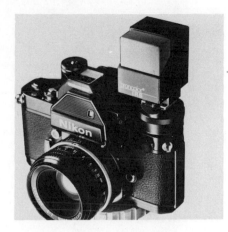

You can fire the Broncolor studio lighting system by using an infrared triggering device. An infrared transmitter mounts on the camera and a receiver attaches to the main power pack. When you trip the shutter, the burst of invisible energy triggers the studio lighting in synch with the camera.

A projection lighting unit uses optical focusing of the flash light to achieve special effects. (Courtesy Norman Enterprises)

197

Opposite page: Modeling lights enabled the photographer to position precisely the two lampheads used to illuminate this portrait. Well-designed modeling lights should provide an accurate preview of the final flash exposure.

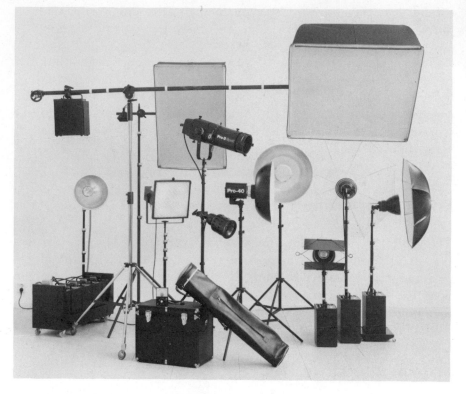

Studio lighting system by Profoto, distributed by Leedal, Inc.

Final Questions Before You Buy

The flash tube of a typical studio light may be rated for as many as 200,000 flashes. Because heat shortens the bulb life, the better-designed large units feature ventilated housing or free air circulation around the flash tube.

What is the true flash duration? Flash duration sounds like a

Control the light on both the subject and the background by using appropriate lampheads, reflectors, and barn doors.

Wm. J. Murray III, *Joleen,* 1977

Wm. J. Murray III, *Portrait,* 1977

199

Studio Flash

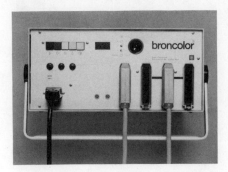

A studio lighting power pack should have a rugged but functional design. Control switches and plugs should be well-organized and constructed for continuous use.

constant you can trust; however, you need to know whether the duration is based on German standards or American specifications. The German standard uses the 0.5 peak duration. The American standard is more conservatively based on the 0.3 peak duration. Flash exposures shorter than 1/1000 second might lead to reciprocity problems with some color films, whereas units with a flash exposure longer than 1/200 second may not "freeze" the movement of some rapidly moving subjects.

If you eventually need to repair your EF lighting, can you service the power module quickly and easily? Does servicing immobilize the entire system, or can a defective component be replaced on the spot?

A well-designed EF studio system will offer accessories that extend the creative applications of the basic lighting. Stands and booms should be easy to use and compact for storage. Interchangeable lampheads and reflectors are a must.

Simplicity of operation and safety are vital considerations. It is easy to unplug or connect a properly designed unit without exposing the operator to the possibility of electrical shock. You should be sure the unit is protected against electrical overloads. Damaging overheating can result from unintended, nonstop flashing. All wiring and connectors should be made for hard use and easy to replace. Cable coverings should be able to withstand the normal abuse of studio activities, and wiring should be shielded against radio interference or accidental triggering by other remote-control devices in the area.

Give careful scrutiny to the modeling lights. Are they powerful enough to enable you to evaluate the effects of your lighting setup? Do they match the contrast of the flash light? Is the light intensity of the modeling correspondingly variable with the power settings for the flash lighting? Theoretically, you should be able to make an exposure with the modeling lights that corresponds with the intended flash exposure. Do the direction and light quality of the modeling lights visually match the subsequent EF light? The modeling lamp should provide a true replica of the flash effect.

Give a final thought to the warranty and availability of repair service for a given studio system. Down time can be costly. Parts and repair facilities are inevitable concerns.

Conventional hand-held and built-in camera light meters are not usually designed to measure the brief light of an electronic flash. Although it is fairly easy to calculate the exposure for a single flash unit, a flash meter can prove indispensable when you are determining the exposure for multiple flash lighting or for cumulative flash firings, or when you are reading combined flash and existing ambient light. You can also use a flash meter to test the rated performance of any flash unit quickly.

There are nearly as many choices of flash meter designs as there are choices of studio lighting. Since both cost and performance features vary, you should take time to make readings with several different meters in the store before you make an actual purchase.

Flash Meters

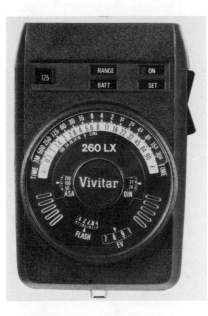

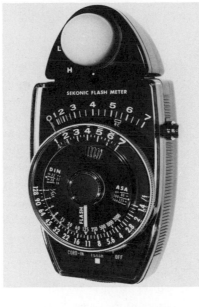

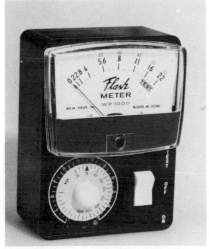

Flash meters vary in design but are similar in function and operation. The following current models are pictured: Vivitar 260 LX flash meter, top left; Sekonic flash meter, top middle; Gossen Luna-Pro SBC with Luna-flash attachment, top right; Wein flash meter WP1000, bottom left; Gossen electronic flash meter Mark II, middle; Calcu-Flash, middle right; Bowens Solid State Readout flash meter, bottom.

Flash Meters

The following points describe most of the options and differences for the flash meters that are currently available.

1 Battery power: Most meters use one or more batteries. The meter should have some provision for easy testing of battery strength.

2 Flash duration: Flash meters are usually designed to measure the typical flash duration in the 1/500 to 1/30,000 second range. This duration range is adequate for most flash lighting. A few meters are designed to read durations as short as 1/100,000 of a second.

3 Cumulative flash: Some meters can monitor a series of successive firings of the flash lighting. The meter integrates the cumulative flashes and provides a final reading based on the total light.

4 Infrared: Because of the large amount of infrared energy present with electronic flash lighting, some meters are filtered to eliminate the meter's response to infrared.

5 Incident and reflected light: Many flash meters are equipped with a diffusion cone which permits you to use the meter in either the incident or the reflectance mode.

6 Combined flash and ambient light: Some flash meters measure only the intense light from electronic flash lighting. Other meters are sensitive to existing continuous (ambient) light and to flash illumination. Meters capable of combined light readings are useful when you are using flash and existing light in a single exposure.

7 Cordless versus cord triggering: You must fire a test flash for any flash meter reading. Some meters are equipped with a PC connecting cord which you use to trigger the flash lighting when the meter is switched on. To use a meter designed for cordless operation switch it on and aim it in the required direction while you fire the flash lighting independently. Flash meters can be designed for one or both modes of operation. A photographer working alone may find the triggering cord method best for one-hand operation. Photographers who need more mobility or who have an assistant may prefer the cordless technique.

8 Needle movement versus digital LED: All flash meters fall into one of these two design categories. The digital LED-type meters have solid-state design and provide a lighted numerical readout of either the light value or the indicated f-stop for a given light reading. The size of the LED numerals depends on the meter design. The illuminated information is obviously an advantage when you are taking a reading in low-light situations. Some flash meters are based on the needle movement design. When a burst of light is directed toward the meter's sensor, a needle is activated across a linear dial, locking in position to indicate the correct f-stop or light value. The product literature often contains specific information about the accuracy of a particular light meter.

9 Accessories: Flash meters are sometimes marketed as part of a meter system which includes a variety of attachments designed to extend the capabilities of the basic meter.

Glossary

AC Alternating current.

actinic The power of light to cause chemical and physical changes.

angle of illumination The angle defining the spread of useful light thrown by a flash unit. Generally measured in both vertical and horizontal degrees.

angle of view The angle that defines the limits of view through a given lens.

ANSI American National Standards Institute (formerly American Standards Association).

aperture An adjustable opening in the lens of a camera that controls the amount of light reaching the film.

ASA American Standards Association. Indicates a film sensitivity (speed) rating system. The higher the assigned number, the more sensitive the film. ASA ratings follow an arithmetical progression.

automatic flash An electronic flash unit that automatically varies the duration of a flash to achieve consistent light output within predetermined flash-to-subject distances.

backscatter The undesirable illumination of particles in either air or water suspended along the camera's line of sight.

bare bulb The technique of using an electronic flash tube without a reflector to create a soft light and eliminate harsh shadows.

BCPS Beam candle power seconds. A standard for measuring the light output of a particular supply at a stated watt-second level. The light is measured at the center of the angle of illumination.

beam spread See **angle of illumination**.

bounced flash An indirect flash technique achieved by angling the flash to reflect from a light-toned surface for a softer illumination.

calculator dial An adjustable chart on a flash unit that can be programmed with the film speed to compute the proper f-stop for a given flash-to-subject distance.

candle power The international standard photometric unit of light intensity, as it is measured at 1/60 of the total luminous intensity of a 1-cm-square black cube heated to a temperature of 1769°C.

capacitor A device used to store electrical energy. The amount of energy stored in a capacitor is termed its capacitance. Also called a condenser.

catch light The reflection of light in the pupil of the eye that mirrors the shape of the light source.

color temperature The color of light measured in degrees Kelvin.

computer flash See **automatic flash**.

condenser See **capacitor**.

contrast ratio The mathematically stated difference between the darkest and lightest areas of a subject. The contrast ratio is dependent on both lighting ratio and reflectance ratio.

DC Direct current.

dedicated flash unit A flash unit that is designed to work with a particular type or brand of camera.

deep discharge Depletion of a battery beyond the point from which it may be predictably recharged.

diffuser A piece of material that filters the light from the flash and scatters it to produce softer illumination. Diffusers decrease light output.

DIN Deutsches Industrie Norm (German Industry Norm). German film speed designation based on a logarithmic scale. A change of 3° in the DIN value is equal to a doubling or a halving of the film speed.

discharge curve A curve shaped by the factors of time and energy output, used to measure the life of a battery.

duty cycle The number of times a given lamphead can be fired in rapid sequence without jeopardizing the life of the flash tube. Factors affecting the duty cycle include wattage of unit, size of flash tube, and cooling capacity.

ECPS Effective candle power seconds. A measure of the power output of a flash unit. Similar to **BCPS**.

EF Electronic flash.

falloff The decrease of light intensity as the light spreads from the source to illuminate a larger area.

fill flash A technique of combining flash with a main light to lighten shadow areas.

film speed A number assigned to a given film emulsion that describes its sensitivity to light. Several rating systems exist, ASA and DIN being the most common. Both assign a higher number value to more sensitive film.

flash bracket A device for mounting camera and flash together to form a portable unit.

flash decay The gradual decrease in light level that follows the peak intensity of a flash firing.

flash duration This term is generally used to describe the length of time during which a flashbulb or electronic flash unit is producing effective light.

flash meter An instrument designed to measure the light produced by an electronic flash light source. Some flash meters will measure cumulative firings.

flash synchronization A simultaneous firing of the flash unit and the camera shutter which insures full exposure of the film.

flash terminals Electrical contacts on a camera which can receive a connecting cord for synchronization with an flash unit.

flash tube A xenon-filled glass tube designed to emit light when electrical energy from a capacitor is discharged through it.

foot candle The total light from a one-candle-power point light source that illuminates a one-square-foot section when the light is placed at the center of a two-foot-diameter sphere.

ghosting A secondary blurred image caused by a combination of ambient light and slow shutter speed when you are photographing a moving subject with electronic flash.

GN Guide number.

gray card A standardized 18 percent reflectance card used to represent an average subject when you are taking a reflectance light reading.

guide number A number based on the light output of a given flash unit and a given film speed, which can be divided by the flash-to-subject distance to determine the f-stop for a normal exposure. GN = f-stop × distance.

H plug A parallel-prong electrical plug or household plug.

highlight The brightest area or areas of light on a subject.

holdover An undesirable condition that may occur in a flash tube when the tube is fired so rapidly that the glow from the arc persists between firings. A holdover effect can extend the flash duration.

hot shoe An accessory shoe containing a live electrical contact which directly synchronizes the firing of the flash with the shutter.

infrared Invisible radiation existing below visible red on the electromagnetic spectrum. It can be used to expose specially sensitized film. Photographically actinic infrared radiation is normally in the 800- to 900-nanometer range.

infrared flash A flash unit filtered to emit infrared radiation and designed for use with infrared film.

inverse square law A law of physics that states that the intensity of illumination on a subject is proportional to the inverse of the square of the distance between the subject and the light source. For example, if the distance between the light and the subject is doubled, the illumination will decrease to one quarter of the original intensity. The law is only applicable to point light sources.

IR See **R**.

Jones bracket A J-shaped bracket used for mounting a "potato-masher" flash unit to a camera.

joule A unit of measurement equal to a watt-second or forty lumen-seconds.

K Kelvin. Designates the use of a measuring system that compares color temperatures of light.

key light The primary light source or main light.

latchup The malfunction of a light-sensitive SCR device when it is exposed to an intense burst of light.

LED Light-emitting diode.

lighting ratio The mathematically stated difference between the illumination falling on the darkest and lightest areas of the subject.

M synch The shutter synchronization setting for use with regular flashbulbs. M synch is a delayed synchronization designed to fire the bulb before the shutter is fully open, so that the peak of light is synchronized with the fully opened shutter. Not designed for use with electronic flash.

main light See **key light**.

modeling light A tungsten light positioned on an axis with the flash tube and used to predetermine light direction and intensity when you are making an electronic flash exposure. May be used as a focusing light.

ms Millisecond, that is, 1/1000 of a second.

mv Millivolt, that is, 1/1000 of a volt.

Ni-Cd Nickel-cadmium. Refers to a rechargeable accumulator-type electrical power supply. Nicad® is a registered trademark for a group of nickel-cadmium products.

nm Nanometer or a millionth of a millimeter (also termed a millicron). Used to describe wavelengths in the visible light spectrum as well as infrared and ultraviolet wavelengths.

nomograph Electronic flash nomograph. A chart containing ASA and BCPS information which can be used to calculate the guide number of a flash unit.

open flash See **painting with flash**.

painting with flash A technique of using multiple firings of an off-camera flash to illuminate a subject during a single time exposure. Also called open flash.

PC A pin-contact or push-contact flash-to-shutter synch cord.

photo slave See **slave unit**.

"potato masher" A basic handle-mount flash design with a self-contained battery pack.

quench tube A secondary black flash tube that is fired to absorb excess voltage, which reduces the main light output of a flash unit. Has generally been replaced by thyristor-type circuitry, which conserves the power in the capacitor.

R Designates the infrared focusing adjustment mark found on the camera lens barrel.

ready light An indicator light on an EF unit that signals the availability of sufficient power to refire the flash.

recharging time The length of time necessary for a rechargeable battery to regain its full capacity after it has been depleted. Varies according to battery and charger.

reciprocity failure The failure of film to respond to light in the manner described by the reciprocity law.

reciprocity law Intensity of light times the time of exposure equals exposure of emulsion. $I \times T = E$.

rectifier Converts alternating current to direct current.

recycling time The period of time needed for an electronic flash unit to build up a sufficient charge to fire again after it has been triggered. Units in their prime vary from .3 sec. to 10 sec.

red eye A red glow that may occur in a subject's eyes when the flash unit is too closely aligned with the axis of the camera lens. The red color is due to the reflection of light from blood vessels in the rear of the eye and is magnified by increased dilation of the pupil in low light. The solution is to move the flash further from the camera axis.

reflectance ratio A mathematical comparison of the ability of a subject's surfaces to reflect light; for example, a black-and-white striped shirt has a high reflectance ratio.

reflector Flash reflector. A shiny, curved surface located behind the flash tube that reflects light out toward the subject. Variations in reflector surfaces, shapes, and color can control the quality and quantity of light.

remote sensor An independent light metering circuit connected to the flash unit with a cord. Allows light to be metered and regulated near the film plane and frees the flash for separate positioning.

ringflash A circular flash tube mounted around the lens.

SCR Silicon-controlled rectifier. A three-junction electronic device that is used as a miniature switch. It normally blocks the flow of current until the gate terminal receives an electric signal.

sensor A light metering circuit that regulates flash duration to allow correct exposure of the subject.

slave unit A light-sensitive triggering device that can be attached to an electronic flash to allow simultaneous cordless firing of two or more flash units. Also called a photo slave.

SPD Silicon photodiode. A silicon-type diode that can be used as either a current generator or a variable resistor. It has high sensitivity and a near-instantaneous response. Important component in most flash units.

strobe A term that technically refers to an intermittently flashing light source. Also incorrectly but commonly used to describe single-flashing electronic flash units in general.

swing light Any flash with a circular reflector which can be used in various positions off-camera.

synch cord An electrical cord used to connect a flash and camera to permit simultaneous firing.

synchro sun A technique of using electronic flash to increase the illumination in the shadow areas of a sunlit scene.

test button A pressure-sensitive button used to trigger the flash unit independent of camera firing. Also used with open flash.

thyristor A solid-state electronic switch.

transformer An electrical component used in electronic flash units to increase current to a higher voltage.

trickle charge An optional mode for recharging some flash units. The slower trickle charge reduces the possibility of overheating the nickel-cadmium power cells.

umbrella A collapsible cloth accessory used to soften shadows by bouncing and diffusing EF light. Available in many sizes, shapes, colors, and reflective surfaces.

verification light An indicator light on the flash unit that signals when the flash is providing enough light for a proper exposure.

watt A unit of power equal to the work done at the rate of one joule per second, or to the rate of work represented by one ampere of electrical current under a pressure of one volt.

watt-second A unit of energy or work equivalent to the power of one watt working for one second.

X synch The designation for an electronic flash synchronization outlet on the hot shoe or camera body.

Bibliography

Axelrod, Dr. Herbert R. *Photography for Aquarists*. Neptune City, N.J.: T. F. H. Publications, 1970.

Cooper, Joseph D. *Honeywell Pentax Manual*. Garden City, N.Y.: Amphoto, 1975.

Dalton, Stephen. *Borne on the Wind: The Extraordinary World of Insects in Flight*. Published by Reader's Digest Press, 1975. Distributed by E. P. Dutton, New York.

Eastman Kodak. *Biomedical Photography, A Kodak Seminar in Print*. Rochester, N.Y.: Eastman Kodak Co., 1976.

Edgerton, Harold E. *Electronic Flash, Strobe*. New York: McGraw-Hill, 1970.

Edgerton, Harold E., and James R. Killian, Jr. *Flash! Seeing the Unseen by Ultra High-Speed Photography*. Boston: Charles T. Branford Co., 1954. Also *Moments of Vision*. Cambridge, Mass.: MIT Press, 1979.

Freehe, Clifford L. *Clinical Dental Photography, Equipment and Technique*. Reprinted from James W. Clark's *Clinical Dentistry*, Vol. 1. Hagerstown, Md.: Harper & Row, 1976.

Hedgecoe, John. *The Photographer's Handbook*. New York: Alfred A. Knopf, 1977.

Jacobs, Lou, Jr. *How to Take Great Pictures with Your SLR*. Tucson: H.P. Books, 1974.

Lahue, Kalton C. *Petersen's Big Book of Photography*. Los Angeles: Petersen, 1977.

Norman, Bill. Pamphlet series: Burbank, Calif.: Norman Enterprises. *The Battle Between Depth of Light and Depth of Field (The Inverse Square Law)*, 1973; *Electronic Flash Guide*, 1968; *Synchro Sunlight*, 1971; *Why Umbrella?*, 1970.

Owens, William J. *Close-Up Photography*. Los Angeles, Calif.: Petersen, 1975.

Professional and Finishing Markets Division, Eastman Kodak Co. *Applied Infrared Photography*. Rochester, N.Y., 1977.

Professional and Finishing Markets Division, Eastman Kodak Co. *Basic Scientific Photography*. Rochester, N.Y., 1977.

Bibliography

Rebikoff, Dimitri, and Paul Cherney. *Underwater Photography*. Garden City, N.Y.: Amphoto, 1975.

Shipman, Carl. *How to Select and Use Pentax SLR Cameras*. Tucson: H.P. Books, 1977.

Spitzing, Gunter. *The Photoguide to Flash*. London and New York: Focal Press, 1974.

Time-Life Editors. *Light and Film*. New York: Time-Life Books, 1971.

Upton, Barbara, and John Upton. *Photography*. Boston: Educational Associates/Little, Brown, 1976.

Wallin, Doug. *Basics of Underwater Photography*. Garden City, N.Y.: Amphoto, 1975.

Flash Manufacturers and Distributors

Acme-Lite Mfg. Co.
3401 W. Madison St.
Skokie, IL 60076
(312) 588-2776

Alfon International
43 Goffle Rd.
Hawthorne, NJ 07506

AIC/Interstate Photo, Inc.
168 Glen Cove Rd.
Carle Place, NY 11514
(516) 742-7300

The Alpa Group, T.A.G.
Photographic, Inc.
800 Shames Drive
Westburg, NY 11590

AMCAM West, AMCAM
International, Inc.
20218 Hamilton Ave.
Torrance, CA 90502
(213) 323-6820

AMCAM International, Inc.
813 N. Franklin
Chicago, IL 60610
(312) 787-3507

Argraph Corp.
111 Asia Pl.
Carlstadt, NJ 07072
(201) 939-7722

Asanuma Corporation
1639 E. Del Amo Blvd.
Carson, CA 90746
(213) 636-0271

Ascor-Photo Lighting Div., Berkey
Marketing Cos.
25-20 Brooklyn Queens Expwy. W
Woodside, NY 11377
(212) 932-4040

(Avacon) Grant-Airmass Corp.
4 Laurel Hill Drive
So. Burlington, VT 05401

Bell & Howell/Mamiya Co.
7100 McCormick Rd.
Chicago, IL 60645
(312) 262-1600

Berkey Keystone, Division of
Berkey Photo, Inc.
429 Getty Ave.
Clifton, NJ 07015

Berkey Marketing Companies
25-20 Brooklyn Queens Expwy. W.
Woodside, NY 11377
(212) 932-4040

Bogen Photo Corp.
100 S. Van Brunt St.
Englewood, NJ 07631
(201) 568-7771

Bowen Mfg. Co.
431 N. Yale Ave.
Villa Park, IL 60181
(312) 834-5687

Braun North America
55 Cambridge Parkway
Cambridge, MA 02142
(617) 492-2100

Broncolor, EPOI/PTP
623 Stewart Ave.
Garden City, NY 11530

Bronica, EPOI
101 Crossways Park West
Woodbury, NY 11797
(516) 364-8030
Telex: 96-1328

Burleigh Brooks Optics, Inc.
44 Burlews Court
Hackensack, NJ 07601
(201) 489-1300

Calcu-Flash, Quantum Instruments,
Inc.
10/5 Stewart Ave.
Garden City, NY 11530

Calumet Scientific, Inc.
1590 Toohy Ave.
Elk Grove Village, IL 60007
(312) 439-9330

Canon U.S.A., Inc.
10 Nevada Dr.
Lake Success, NY 11040
(516) 488-6700

Capro, EPOI
623 Stewart Ave.
Garden City, NY 11533
(516) 248-5200

Caspeco Fontran Camera Specialty
Co.
705 Bronx River Rd.
Bronxville, NY 10708

Contax Div. Yashika Inc.
411 Sette Dr.
Paramus, NJ 07652
(201) 262-7300

Lester A. Dine, Inc.
2080 Jericho Turnpike
New Hyde Park, NY 11041

Dot Line Corp.
11916 Valerio St.
No. Hollywood, CA 91605
(213) 875-2035

Dyna-Lite Inc.
408 Bloomfield Ave.
Montclair, NJ 07042

Eastman Kodak Co.
343 State St.
Rochester, NY 14650
(716) 325-2000

Edmund Scientific Co.
Edscorp Building
Barrington, NJ 08007

EG & G Inc., Electro-Optics Div.
35 Congress St.
Salem, MA 01970
(617) 745-3200

Ehrenreich Photo-Optical
Industries, Inc., Photo Technical
Products
623 Stewart Ave.
Garden City, NY 11530
(516) 248-5200

Ehrenreich Photo-Optical Industries
West, Inc.
501 Folsom St.
San Francisco, CA 94105
(415) 362-7484

Electronic Control Service
4324 Neosho Ave.
Box 66293
Los Angeles, CA 90066
(213) 398-0598

Elinca
Foto-care Ltd.
170 5th Ave.
New York, NY 10010

Elmo Mfg. Corp.
32-10 57th St.
Woodside, NY 11377
(212) 626-0150

EPOI International Ltd., Div. EPOI
623 Stewart Ave.
Garden City, NY 11530
(516) 248-5200

Eva-Blitz, Saul Bower Inc.
114 Liberty St.
New York, NY 10006

Gallinger Bros., Inc.
1829 Flatbush Ave.
Brooklyn, NY 11210
(212) 338-6151
(516) MA3-6330

General Electric Co., Lamp Div.
Nela Park
Cleveland, OH 44112
(216) 266-2121

Giddings/Felgin Inc.
578 4th St.
San Francisco, CA 94107

Hanimex (USA), Inc.
1801 Touhy Ave.
Elk Grove Village, IL 60007
(312) 956-7540

Hasselblad Div., Braun North
America
55 Cambridge Parkway
Cambridge, MA 02142
(617) 492-2100

Karl Heitz, Inc.
979 Third Ave.
New York, NY 10022
(212) 421-5220

Hershey Division/Leedal, Inc.
1918 South Prairie Avenue
Chicago, IL 60616
(312) 842-6588

Honeywell Inc., Photo Products Div.
P.O. Box 1010
Littleton, CO 80120
(303) 794-8200

Hoos Mfg. Co.
1035 Wesley Ave.
Evanston, IL 60202
(312) 869-9787

HP Marketing Corp.
216 Little Falls Rd.
Cedar Grove, NJ 07009
(201) 857-0171
(212) 571-0945

Ikelite Underwater Systems
3303 N. Illinois St.
Indianapolis, IN 46208
(317) 923-4523

Interphoto Corp.
200 Roosevelt Place
Palisades Park, NJ 07650
(201) 947-1001

ITT Photolamp Products
133 Terminal Ave.
Clark, NJ 07066
(201) 381-2828

Jones Photo Equipment
10816 Burbank Blvd.
No. Hollywood CA 90601
(213) 466-7281

Kako Strobe America, Inc.
24-12 Jackson Ave.
Long Island City, NY 11101
(212) 392-7868

Kalimar, Inc.
5 Goddard Ave.
St. Louis Airpark
Chesterfield, MO 63017
(314) 532-4511

Kalt Corp.
2036 Broadway
Santa Monica, CA 90404
(213) 829-4787

Kling Photo Corp.
25-20 Brooklyn Queens Expwy.
Woodside, NY 11377

Konica Camera Co., Div. Berkey Marketing Co.
25-20 Brooklyn Queens Expwy. W.
Woodside, NY 11377
(212) 932-4040

The Lase Co.
5875 N. Lincoln Ave.
Chicago, IL 60659
(312) 561-7266

Lenmar Enterprises
13620 S. Normandie Ave.
Gardena, CA 90249
(213) 321-5344
(213) 532-0994

Lightning-Lite Co.
14414 Detroit Ave.
Lakewood, OH 44107
(216) 221-2559

Lumedyne, Inc.
425 Madison Street
Port Richey, FL 33568
(813) 847-5394

Magi-Sync Inc.
65 Sutton Ave.
Lawrence, NY 11559
(516) 239-8462

Magna-Flash, A&R Distributers Ltd.
460 St. Catherines St.
W. Montreal, Canada H3B LA7

Metz, EPOI
101 Crossways Park West
Woodbury, NY 11797
(516) 364-8030
Telex 96-1328

Miida Photo/Marubeni America Corp.
14 Henderson Drive
W. Caldwell, NJ 07006
(201) 227-9400

Minolta Corp.
101 Williams Dr.
Ramsey, NJ 07446
(201) 825-4000

Mitchell Enterprises
P.O. Box 1372
San Francisco, CA 94101
(415) 681-6930

Multi Blitz, H. P. Marketing Corp.
98 Commerce Rd.
Cedar Grove, IL 07009

Flash Manufacturers and Distributors

Nikon, EPOI
623 Stewart Ave.
Garden City, NY 11533
(516) 222-0200

Nissin, Lenmar Enterprises
334 Darrow Ave.
Evanston, IL 60602

Nord Photo Engineering, Inc.
529 S. 7th St.
Minneapolis, MN 55415
(612) 338-0781

Norman Enterprises, Inc.
2601 Empire
Burbank, CA 91504
(213) 843-6811

Novacon Products
1101-F3 Victoria St.
Costa Mesa, CA 92627

Novaflex, Burleigh Brooks Optics
44 Burlews Court
Hackensack, NJ 07601

Novatron of Dallas Inc.
1515 Fuller St.
Dallas, TX
(214) 321-6497

Oceanic Products
814 Castro Street
San Leandro, CA 94577

Olympus Corp. of America
4 Nevada Drive
New Hyde Park, NY 11042
(516) 488-3880

Paffrath & Kemper, GmbH & Co. KG
Postfach 41 07 07
Weyertal 46/59
5000 Köin 41
Germany

Photo Control Corp.
5225 Hanson Court
Minneapolis, MN 55429
(612) 537-3601

Photogenic Machine Co.
525 McClurg Rd.
Youngstown, OH 44512
(216) 758-6658

Polaroid Corp.
549 Tech Sq. Plaza
Cambridge, MA 02139
(617) 864-6000

Ponder & Best, Inc.
1630 Stewart St.
Santa Monica, CA 90406
(213) 829-3672

Portertown Products, Inc.
Route 1
Waterloo, IA 50701

Prinz, Amcam International
813 N. Franklin St.
Chicago, IL 60610

PRO (Photographic Research Org.)
159 W. 33rd St.
New York, NY 10016

Rapid Omega Div., Berkey Marketing Co.
25-20 Brooklyn Queens Expwy. W.
Woodside, NY 11377
(212) 932-4040

R-H Div., Interphoto Corp.
23-20 Jackson Ave.
Long Island City, NY 11101
(212) 392-7600

Ricoh/Braun North America
55 Cambridge Parkway
Cambridge, MA 02142
(617) 492-2100

Ritz Camera
11710 Baltimore Ave.
Beltsville, MD 20705

Rollei of America, Inc.
5501 South Broadway
Littleton, CO 80121
(303) 794-8200

Samigon Div., Argraph Corp.
111 Asia Place
Carlstadt, NJ 07072
(201) 939-7722

Schneider, Inc.
P.O. Box 73
Lockport, IL 60441

Sea Research & Development
P.O. Box 589
Bartow, FL 33830

Sekonic Div., Harry Gocho
Enterprises Inc.
56-01 Queens Blvd.
Woodside, NY 11377

Shares Housings Unlimited
190 Glenbrook Rd.
Rochester, NY 14616

Singer Graflite Photo Products
210 Brant Rd.
Lake Park, FL 33403

Soligor, AIC Photo, Inc.
168 Glen Cove Rd.
Carle Place, NY 11514

Speedlight Center Div., Lester
Dine Inc.
2080 Jericho Tpke.
New Hyde Park, NY 11041
(212) 343-4774

Speedotron Corp.
340 W. Huron
Chicago, IL 60610
(312) 787-8405

Spiratone Inc.
135-06 Northern Blvd.
Flushing, NY 11354
(212) 463-7832

Straitline Marketing Inc.
131-27 Fowler Ave.
Flushing, NY 11355
(212) 762-8600

Strobosol, Larson Enterprises Inc.
18170 Euclid St.
Fountain Valley, CA 92708

Subsea Products
P.O. Box 9532
San Diego, CA 92109

Sunpak Div., Berkey Marketing Co.
25-20 Brooklyn Queens Expwy. W.
Woodside, NY 11377
(212) 932-4040

T.A.G. Photographic Inc.
800 Shames Dr.
Westbury, NY 11590

Tekno, Inc. Balcar
221 W. Erie St.
Chicago, IL 60610
(312) 787-8922

Telesar, Masel Supply Co.
128 32nd St.
Brooklyn, NY 11232

Testrite Instrument Co., Inc.
135 Monroe St.
Newark, NJ 07105
(201) 589-6767

Thomas Instrument Co., Inc.
1313 Belleview Ave.
Charlottesville, VA 22901
(804) 977-8150

Tiffin Optical Co.
71 Jane St.
Roslyn Heights, NY 11577

Toshiba, Elmo Mfg. Corp.
32-10 57th St.
Woodside, NY 11377

Ultrablitz, AIC Photo Inc.
168 Glen Cove Rd.
Carle Place, NY 11514

Uniphot, Inc.
61-10 34th Ave.
Woodside, NY 11377
(212) 779-5700

Vivitar, Ponder and Best Inc.
1630 Stewart St.
Santa Monica, CA 90406
(213) 870-0181

Voigtlander, EPOI
101 Crossways Park West
Woodbury, NY 11797
(516) 364-8030

Washington Scientific Camera Co.
P.O. Box 88681
Tukwila, WA 98188

Wein Products, Inc.
115 W. 25th St.
Los Angeles, CA 90007
(213) 749-6049

Appendix

Table 1. Kodak Professional Black-and-White Films—Reciprocity Effect Adjustments

| IF INDICATED EXPOSURE TIME IS (SECONDS) | USE | | AND IN EITHER CASE, USE THIS DEVELOPMENT ADJUSTMENT |
	EITHER THIS LENS APERTURE ADJUSTMENT	OR THIS EXPOSURE TIME ADJUSTMENT (SECONDS)	
1/100,000	1 stop more	Use Aperture Change	20% more
1/10,000	½ stop more	Use Aperture Change	15% more
1/1,000	None	None	10% more
1/100	None	None	None
1/10	None	None	None
1	1 stop more	2	10% less
10	2 stops more	50	20% less
100	3 stops more	1200	30% less

* KODAK EKTAPAN Film 4162 (ESTAR Thick Base) does not require a development time adjustment for exposures of 1/1000 second.

© Eastman Kodak Company, 1977

EKTAPAN 4162
 (ESTAR Thick Base)
PANATOMIC-X
PANATOMIC-X Professional
PLUS-X Pan
PLUS-X Pan Professional
PLUS-X Pan Professional 2147
 (ESTAR Base)
PLUS-X Pan Professional 4147
 (ESTAR Thick Base)
PLUS-X Portrait 5068
ROYAL Pan 4141
 (ESTAR Thick Base)
ROYAL-X Pan 4166
 (ESTAR Thick Base)
ROYAL-X Pan
SUPER-XX Pan 4142
 (ESTAR Thick Base)
TRI-X Pan
TRI-X Pan Professional
TRI-X Pan Professional 4164
 (ESTAR Thick Base)

Table 2. Exposure* and Filter Compensation for the Reciprocity Characteristics of *Kodak* Color Films

KODAK FILMS	EXPOSURE TIME (SECONDS)						
	1/10,000	1/1000	1/100	1/10	1	10	100
Kodacolor II	None No Filter				+½ Stop No Filter	+1½ Stops CC10C	+2½ Stops CC10C + 10G
Kodacolor 400	None No Filter				+½ Stop No Filter	+1 Stop No Filter	+2 Stops No Filter
Vericolor II Professional, Type S	None No Filter				Not Recommended		
Vericolor II Professional, Type L	Not Recommended				See film instructions for speed values at 1/50 through 60 seconds' exposure times		
Ektachrome 64 Professional (Daylight) and Ektachrome 64 (Daylight)	+½ Stop No Filter	None No Filter			+½ Stop CC10B	+1 Stop CC15B	Not Recommended
Ektachrome 50 Professional (Tungsten)†	—	None CC10C		None No Filter		+½ Stop No Filter	+1½ Stops No Filter
Ektachrome 200 Professional (Daylight) and Ektachrome 200 (Daylight)	+½ Stop No Filter	None No Filter			+½ Stop CC10R	Not Recommended	
Ektachrome 160 Professional (Tungsten) and Ektachrome 160 (Tungsten)	+½ Stop No Filter	None No Filter			+½ Stop CC10R	+1 Stop CC15R	Not Recommended
Ektachrome Infrared	—	None No Filter		+1 Stop CC20B	Not Recommended		
Kodachrome II Professional (Type A)	—	None No Filter		+½ Stop No Filter		+1 Stop CC10Y	Not Recommended
Kodachrome 25 (Daylight)	None No Filter				+1 Stop CC10M	+1½ Stops CC10M	+2½ Stops CC10M
Kodachrome 64 (Daylight)	None No Filter				+1 Stop CC10R	Not Recommended	

* The exposure increase, in lens stops, includes the adjustment required by any filter(s) suggested.

† For 6118 sheet film, see supplementary data on the instruction sheet packaged with the film.

Notes: The data for each film are based on average emulsions and are rounded to the nearest ½ stop. They apply only to the type of illumination for which that film is balanced, and assume normal recommended processing. The data should be used as guides only. The adjustments are subject to change due to normal manufacturing variations or subsequent film storage conditions after the film leaves the factory.

© Eastman Kodak Company, 1977

Table 3. Kodak Professional Black-and-White Films—Reciprocity Adjustments*

KODAK FILM	ADJUSTMENTS	CALCULATED EXPOSURE TIME (seconds)					
		1/10,000	1/1000	1/10	1	10	100
Commercial 6127 and	Exposure	½ stop less	none	none	none	½ stop more	1 stop more
Commercial 4127 (Estar Thick Base)	Development	50% more	10% more	10% less	20% less	30% less	40% less
Ektapan 4162 (Estar Thick Base)	Exposure	none	none	none	½ stop more	1 stop more	1 stop more
	Development	none	none	10% less	20% less	20% less	30% less
Plus-X Pan Professional 2147	Exposure	none	none	none	½ stop more	1 stop more	1½ stops more
(Estar Base) and 4147 (Estar Thick Base)	Development	none	none	10% less	20% less	30% less	40% less
Plus-X Pan Professional and	Exposure	none	none	none	½ stop more	1 stop more	1½ stops more
Plus-X Portrait 5067	Development	none	none	10% less	20% less	30% less	40% less
Super Panchro-Press 6146,	Exposure	none	none	½ stop more	1 stop more	1½ stops more	3 stops more
Type B	Development	20% more	none	10% less	20% less	30% less	40% less
Super-XX Pan 4142	Exposure	none	none	none	none	½ stop more	1 stop more
(Estar Thick Base)	Development	none	none	none	none	none	20% less
Royal Pan 4141	Exposure	none	none	none	½ stop more	1 stop more	1½ stops more
(Estar Thick Base)	Development	none	none	none	none	10% less	20% less
Royal-X Pan 4166	Exposure	none	none	1 stop more	1½ stops more	2 stops more	3 stops more
(Estar Thick Base)	Development	10% more	none	none	none	none	none
Tri-X Pan Professional 4164	Exposure	none	none	none	½ stop more	1 stop more	2 stops more
(Estar Thick Base)	Development	none	none	none	none	10% less	20% less
Tri-X Pan	Exposure	none	none	none	½ stop more	1½ stops more	2½ stops more
	Development	none	none	none	none	10% less	20% less
Tri-X Ortho 4163	Exposure	none	none	½ stop more	1 stop more	2 stops more	3 stops more
(Estar Thick Base)	Development	none	none	10% less	20% less	30% less	40% less

* The adjustments in this table are aimed to yield a contrast index of 0.56 to 0.60.

© Eastman Kodak Company, 1977

Table 4. Guide Number Chart

ASA FILM SPEED FOR DAYLIGHT	BCPS OUTPUT OF ELECTRONIC FLASH UNIT															
	350	500	700	1000	1400	2000	2800	4000	5600	8000	12000	16000	23000	32000	45000	64000
10	13	16	18	22	26	32	37	45	55	65	75	90	105	125	150	180
12	14	18	20	24	28	35	40	50	60	70	80	95	115	135	160	201
16	17	20	24	28	34	40	50	55	65	80	95	115	135	160	190	230
20	18	22	26	30	36	45	55	61	75	90	102	120	145	170	205	240
25	20	25	30	35	43	50	60	70	85	100	120	145	170	205	245	290
32	24	30	34	40	50	55	70	80	95	115	140	165	195	230	275	330
40	26	32	38	45	55	65	75	90	110	130	155	185	220	260	310	365
50	30	35	43	50	60	70	85	100	120	145	170	205	245	290	345	410
64	34	40	48	55	70	80	95	115	140	165	195	230	275	330	390	465
80	38	45	55	65	77	90	110	130	150	180	220	260	310	365	435	520
100	43	50	60	70	85	100	120	145	170	205	245	290	345	410	490	580
125	48	55	70	80	95	115	135	160	190	230	270	325	385	460	545	650
160	55	65	80	90	110	130	155	185	220	260	310	365	435	520	615	730
200	60	70	85	100	120	145	170	205	245	290	345	410	490	580	690	820
250	68	80	95	115	135	160	190	230	270	320	385	460	545	650	770	915
320	75	90	110	130	155	180	220	260	310	370	435	520	615	730	870	1035
400	85	100	120	145	170	205	245	290	345	410	485	580	690	820	975	1160
500	95	115	135	160	190	230	270	320	385	460	545	650	770	915	1090	1295
650	110	130	155	185	220	260	310	370	440	520	620	740	880	1045	1245	1480
800	120	145	170	205	245	290	345	410	490	580	690	820	975	1160	1380	1640
1000	135	160	190	230	270	325	385	460	545	650	770	915	1090	1295	1540	1830
1250	150	180	215	255	305	360	430	510	610	725	860	1025	1220	1450	1720	2050
1600	170	205	245	290	345	410	490	580	690	820	975	1160	1380	1640	1950	2315
2000	190	230	270	325	385	460	545	650	770	915	1090	1295	1540	1830	2180	2590
3000	235	280	330	400	470	560	670	790	940	1120	1330	1585	1885	2240	2665	3170

This table is intended as a starting point only, for best results tests must be made.

Courtesy Photogenic Machine Co.

Table 5. Voltage and Frequency Used in Different Cities

CITY	VOLTAGE	FREQUENCY
London, England	240/415	50
Paris, France	120/240	50
Berlin, Germany	220/380	50
Athens, Greece	220/380	50
Jerusalem, Israel	230/400	50
Quito, Ecuador	120/208	60
U.S.A. and Canada	115/230	60
U.S.A. and Canada	120/240	60

Table 6. Angles of View

The angle of coverage of a flash unit describes the angle of spread of the light from the lamphead. This is a fixed angle for most flash units. Rectangular lampheads often have an angle of vertical coverage and an angle of horizontal coverage. More sophisticated flash units may feature a variable angle of illumination which can be adjusted to match the angle of view of a given lens.

The following table provides the angles of view for some of the more commonly used lens and camera formats.

35mm FORMAT

LENS	HORIZONTAL × VERTICAL	DIAGONAL
21mm	81 × 60	91
28mm	65 × 46	76
35mm	53 × 37	64
50mm	40 × 27	45
105mm	19 × 13	24
135mm	15 × 10	18
200mm	10 × 6	12

2¼ × 2¼ FORMAT

LENS	DIAGONAL
55mm	70.5
65mm	63
80mm	50.7
105mm	41.3
135mm	33
180mm	24
250mm	18

Table 7. Guide Number Conversion Table: DIN/ASA, Meter/Feet

FILM SENSITIVITY		GUIDE NUMBERS	
DIN	ASA	METER-SYSTEM	FEET-SYSTEM
9	6	11	36
10	8	13	43
11	10	14	46
12	12	16	53
13	16	18	59
14	20	20	66
15	25	23	76
16	32	25	82
17	40	28	92
18	50	32	105
19	64	36	118
20	80	40	131
21	100	45	148
22	125	50	164
23	160	57	187
24	200	64	210
25	250	71	233
26	320	80	263
27	400	90	295
28	500	101	331
29	650	113	371
30	800	127	417
31	1000	142	466
32	1250	160	525
33	1600	179	587
34	2000	201	660
35	2500	226	742
36	3200	253	830

Colleen Chartier, *Canoes,* 1977

Ron Carraher, *Railing,* 1978

Dave Read, *Strawberries,* 1976

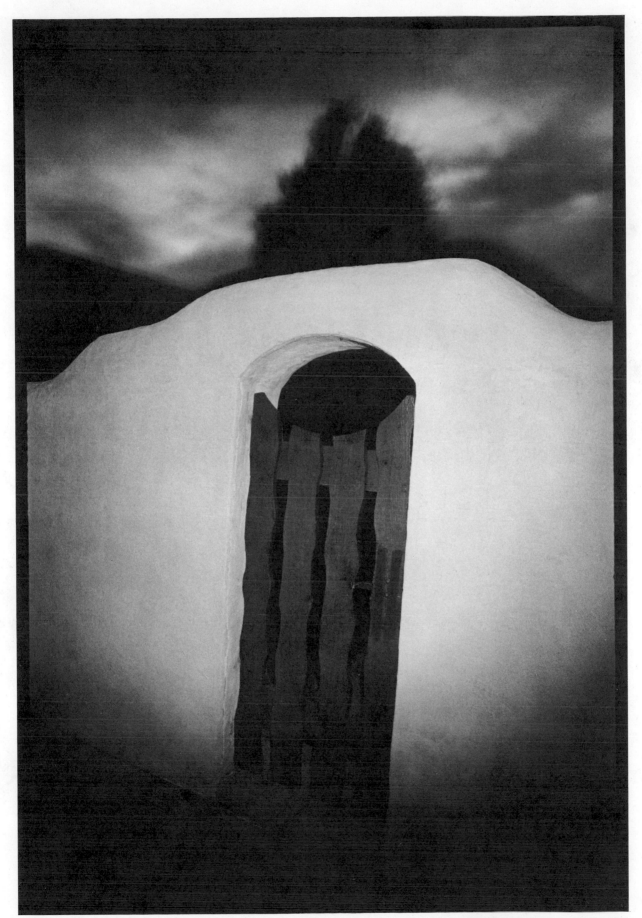

Richard Margolis, *Albuquerque,* 1976

227

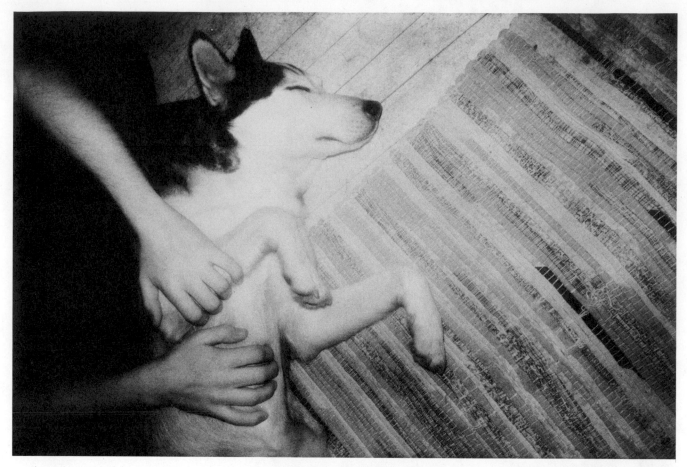

Terry Toedtemeier, *Untitled,* 1975

Colleen Chartier, Untitled, 1977

228

Richard Margolis, *Pflash,* 1976

Product Credits

p. 32, lower left, Ascor Division, Berkey Marketing Companies, Inc.; p. 35, bottom, Norman Enterprises, Inc.; p. 38, Hershey Division, Leedal, Inc.; p. 39, upper left, Hitacon Corporation; p. 39, upper middle, Braun of North America; p. 39, upper right, EPOI Photo Products Division; p. 40, Norman Enterprises, Inc.; p. 41, middle right, Rollei of America; p. 51, Braun of North America; p. 54, top, Ponder & Best, Inc.; p. 56, bottom, Olympus Corporation of America; p. 73, Norman Enterprises, Inc.; p. 90, bottom left, H.P. Marketing Corporation; p. 91, upper right, Larson Enterprises, Inc.; p. 93, Speedotron Corporation; p. 103, Ascor Division, Berkey Marketing Companies, Inc.; p. 125, bottom, H.P. Marketing Corporation; p. 127, upper right, Hershey Division, Leedal, Inc.; p. 127, bottom right, Jones Photo Equipment Co.; p. 135, upper right, EPOI Photo Products Division; p. 138, The Alpha Group, T.A.G. Photographic, Inc.; p. 185, upper left, Ponder & Best, Inc.; p. 185, upper middle, Rollei of America; p. 185, upper right, EPOI Photo Products Division; p. 185, bottom right, Ascor Division, Berkey Marketing Companies, Inc.; p. 186, upper left, Norman Enterprises, Inc.; p. 186, bottom left, EPOI Photo Products Division; p. 188, upper right, Ponder & Best, Inc.; p. 191, upper left and middle, Jones Equipment Company; p. 194, upper left, Ascor Division, Berkey Marketing Companies, Inc.; p. 194, bottom left, Bogen Photo Corporation; p. 197, upper right, EPOI Photo Products Division; p. 197, bottom right, Norman Enterprises; p. 198, top, Hershey Division, Leedal, Inc.; p. 200, EPOI Photo Products Division; p. 201, upper row, left, Ponder & Best, Inc.; p. 201, upper row, middle, Sekonic Division, Copal Corporation of America; p. 201, upper row right, Gossen Division, Berkey Marketing Companies, Inc.; p. 201, middle row, left, Wein Products, Inc.; p. 201, bottom row, left, Bogen Photo Corporation; p. 201, bottom right, Quantum Instruments Inc.; Table 4, p. 222, Courtesy Photogenic Machine Co.

Index